THE STREET ART BOOK

The Street Art Book:
60 Artists in Their Own Words

HarperCollins books may be purchased
for educational, business, or sales
promotional use. For information, please
write: Special Markets Department,
HarperCollins*Publishers*, 10 East 53rd
Street, New York, NY 10022.

First published in the United States
and Canada in 2008 by
Collins Design
An Imprint of HarperCollins*Publishers*
10 East 53rd Street
New York, NY 10022
Tel: (212) 207-7000
Fax: (212) 207-7654
collinsdesign@harpercollins.com
www.harpercollins.com

Distributed throughout the
United States and Canada by
HarperCollins*Publishers*
10 East 53rd Street
New York, NY 10022
Fax: (212) 207-7654

Library of Congress Cataloging-in-
Publication Data
Blackshaw, Ric.
The street art book: behind the scenes /
Ric Blackshaw, Liz Farrelly. -- 1st ed.
p.cm.
ISBN 978-0-06-153732-5
1. Street art. 2. Design--Social aspects.
I. Farrelly, Liz. II. Title.
ND2590.B48 2008
751.7'3--dc22
 2008027025

Art Director for RotoVision: Tony Seddon
Design: Forever Studio

Printed in China
First Printing, 2009

THE
STREET
ART BOOK

60 ARTISTS IN THEIR OWN WORDS RIC BLACKSHAW AND LIZ FARRELLY

COLLINS DESIGN

An Imprint of HarperCollins Publishers

CONTENTS

CHAPTER TWO

MAKE YOUR MARK

CHAPTER THREE

GETTING SCENE

INTRODUCTION

During the course of researching and writing this book one question has cropped up again and again, whether it be through an artist's reluctance to be labeled, or someone finding the title of the book a problem; we've found ourselves discussing with many people, "what is street art?"

We're not sure we're any closer to answering this question, but there are a number of routes you could take. We suppose the term street art has become more commonly used in recent years as people have sought to identify a lot of the art that has been flowering (literally in the case of Michael De Feo) around our cities over the past decade. There is a sense that perhaps the good old word, graffiti, just doesn't cover all that is going on and street art is a nice, easy moniker to describe visuals that aren't directly related to traditional hip-hop/graffiti culture. That's the obvious, literal interpretation of street art; a kind of, for want of a better word, compromise that very few people seem to be happy with.

This got us thinking though. With this book, as with the earlier *Scrawl* books that Liz and I were involved in, what we've actually ended up doing is stretching the definition of street art to breaking point. The only difference is that, back when we were doing the *Scrawl* books, the whole scene was so new that there weren't any categories and there were no definitions to stretch. Graffiti artists like Mode2 and SheOne sat perfectly comfortably with designers such as Swifty and Ben Drury, and the filmmakers Mike Mills and The Light Surgeons. They were all doing very different things in lots of different ways but they all had some common ground in terms of their influences, their attitudes, and their approach to work and life. Of course, as soon as you start bandying a label like street art about people suddenly don't fit anymore, and making a book like this one becomes more like a crash course in semantics.

The glut of publishing that has gone on recently on the subject of graffiti or street art is astonishing, and in most ways this is a good thing, but it has led to a narrowing of the field. As more books on the subject are published so new angles have to be found, and new ways of presenting the material. In a word, new ways of categorizing so that all this material may be fed in nice, bite-size pieces to the public. There is no worse fate for any creative endeavor than to be pigeonholed and straightjacketed like that. It leads to lazy thinking and can be a real hindrance to actually engaging with the work.

We think our only course is to widen the definition of street art, indeed stretch it to breaking point again. Go forward with the idea that street art is an all-encompassing term that describes a myriad of artistic and creative endeavors from graffiti to clothing, from graphic design to photography. It refers to a certain kind of creative person, whether they be amateur or professional, the kind of person who has their own way of doing things; perhaps they like to go against the grain, or what they have in common is a certain low-brow charm mixed with a highly-developed aesthetic sense and an obsessive attention to detail. For these people, the divide between work and play hasn't just blurred but disappeared completely. We hope that's what this book helps to do, we hope it allows people to approach the work in this book not as a labeled, boxed-off, and sorted genre, seen through a bunch of prejudices and ill-informed preconceptions. Instead, here is a constantly changing and developing world of creativity, with a lineage that includes New York City in the early 1980s somewhere on the continuum, but not at the beginning of it, and where you can be just as influenced by Godzilla as by Futura. It's art and design for the people; it's actually very, very street.

Ric Blackshaw

Above:
WILL BARRAS
Ski

Left:
KR
Exterior of the Eyebeam Gallery in New York City, painted with Krink.

Left:
NURIA MORA
Wall painting in Lanzarote, Canary Islands; taking street art into a rural setting.

Right:
LADY PINK
Lady Liberty, painted at 5Pointz, New York City. This image was used on the cover of *Time Out*.

Right:
AIKO
Ice Bunny. One-color print pasted in a park.

Right:
KOFIE'ONE
Moldy Technology. Large-scale wall piece in Los Angeles, using concrete piling.

Right:
MATT SEWELL
Painted guitar, made for the ToyLife store in Brighton, UK.

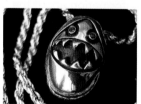

Right:
TOFER
Egg character, as a pendant.

When Ric Blackshaw and I began working on this book, our aim was to try to understand how street art has grown from being an underground, D.I.Y. image-making strategy (at the end of the last century) to become the art world's next big thing, in less than a decade.

How did it happen that a new generation of superstar artists are attracting worldwide media attention, while their pieces sell in high-profile sales at international auction houses to celebrity collectors?

Likewise, the audience for street art has grown and matured, and while an installation at London's Tate Modern—the world's most visited public art gallery—attracts thousands each day, at the other end of the spectrum, many fans have become collectors too. Thanks to the initiative of both the artists themselves and a dedicated network of galleries, affordable, limited-edition prints are for sale online and via fast-changing exhibitions and guerrilla galleries. Prints and artworks are being collected, traded, and treasured, while their value is increasing, in some cases, exponentially.

Ric and I set out to talk to artists—some familiar names, some new faces—so as to cover the widest range of practices and applications of, for want of a better term, "street art." What we very quickly discovered, was that every artist has a unique story; there's no prescription for becoming a successful artist, there's no one way to do this, and the approaches and strategies are as diverse as the practitioners who gave us answers and images.

Interestingly, a few artists decided against being in this book for a number of reasons, including not wanting to be "labeled," or to be seen as being "commercial." I'd suggest, though, that the concept of "selling out" is no longer valid in this context. With diverse, digital image-making and communication technologies at our fingertips, these days there's no need to relinquish control of your creative practice to a third party; practitioners in all disciplines remain in charge of the means of production and distribution, and in effect are managing their own careers. Artists are able to keep in touch with their fans and their collectors, they share information and create images across all media, collaborating with fellow artists and commercial organizations.

Uniquely, then, this book presents not, "how to do it," but rather, "how they did it;" the stories of over 60 artists, in their own words. And while we hold these individuals up as examples of innovation, the underlying message is that none of them followed anyone else's lead; there is no formula, there is only inspiration.

KEY TO THE INFORMATION SYMBOLS

DATA FILE
A brief biography of the artist.

SOURCE BOX
Describes the artist's inspirations.

MAKING IT
Details of the artist's working methods.

FIND MORE
Information and links to related sites.

HOW TO USE THIS BOOK

Divided into three chapters—**Ways of Working, Make Your Mark,** and **Getting Scene**—this book tackles the big questions, and pinpoints means and methods, in words and pictures provided by artists and the organizations that support them.

In **Ways of Working**, the wide range of street art activity is covered; inside or out, art or activism, personal or commissioned, from city streets to gallery walls, mural painting, exhibitions, installations, interior design, and special events.

In **Make Your Mark**, we show you the tools and media that artists use; from charcoal to spray paint, on paper and found objects, from canvas to walls, using screen-prints, stencils, and stickers.

In **Getting Scene**, we show how artists share their vision, creating collaborations and crossovers with other design and commercial organizations; also, how they connect with their audience, in stores, galleries, online communities, and via the media.

Throughout the book, there are chunks of information about the featured artists and organizations, the techniques they use, their sources of inspiration, and ways of finding out more about artists, galleries, and dedicated media.

Street art is a vast and varied arena; this book is one way in, a snapshot of the current state of play of a scene that's in constant flux. What's unique about the view from these pages, is that it comes from the artists themselves...in their own words.

Liz Farrelly

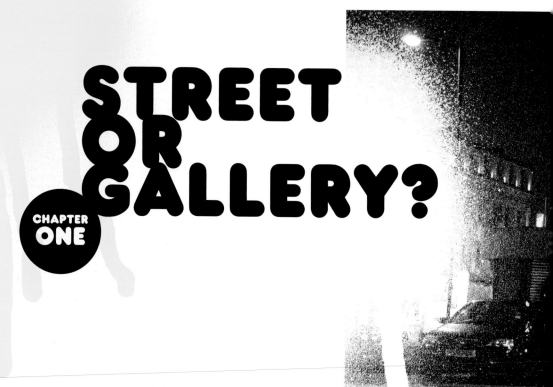

STREET OR GALLERY?

CHAPTER ONE

THE DEBATE RUMBLES ON...

Are we talking about art that comments on the urban/human condition and represents personal expression, without the rubber stamp of the art world? Does it necessarily need to be seen on the street? Or is it a case that the wider access, when pedestrians and drivers view work in the environment, is the democratizing process? These artists tackle some big questions. Do you sell your work? Are you legal or illegal? Is it street art when it's indoors? What's in a label?

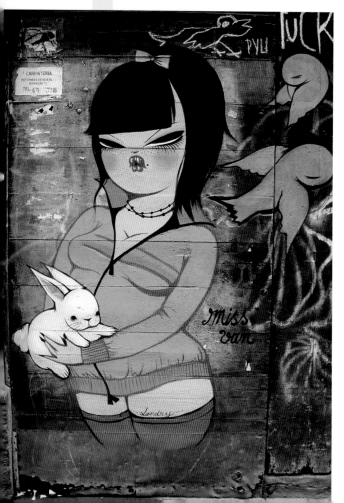

Left:
MISS VAN
Early self-portrait in Barcelona, Spain.
Opposite top:
D*FACE
Call in Sick. Large-scale billboard collage.

Opposite middle:
BLEK LE RAT
In action during *Primary Flight* at Art Basel Miami.
Opposite bottom:
SHEONE
A painted London Underground train carriage has been converted into offices and studios, and installed in Shoreditch, London.

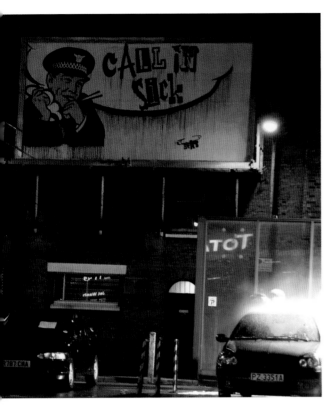

D*FACE
Can you remember selling your first painting? Did it feel like a turning point?

I gave away more pieces than I sold, I was part of the "Finders Keepers" events at the time, where we'd arrange a time and location and people would put their artworks in the street for everyone to take. For someone to even want to take a piece for free was a compliment. I don't remember the first sale; I guess it didn't feel like a turning point in that case…

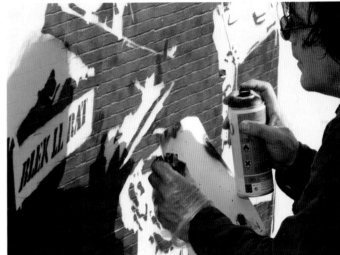

BLEK LE RAT
What drives you to produce artworks?

Since I was young, I have believed in art, and I am sure that this urban art movement is the most important movement since pop art in the 1960s, even though it has not yet been recognized by the art establishment. I am very proud to belong to this movement, which started (incredibly) over 40 years ago now in the USA.

MISS VAN
You show your work in galleries now. Do you still paint in the streets?

Painting on walls was a way to show that I was boycotting the conventional art world; at the beginning, I thought like a rebel. I also find it exciting to paint in the street because it is forbidden. Painting on walls allows me to keep my freedom; as it is illegal, there is no censorship. It is also a challenge, since each time I paint on a wall there is the risk of seeing my work erased.

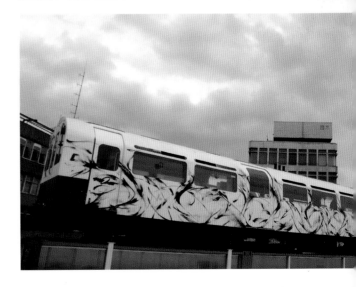

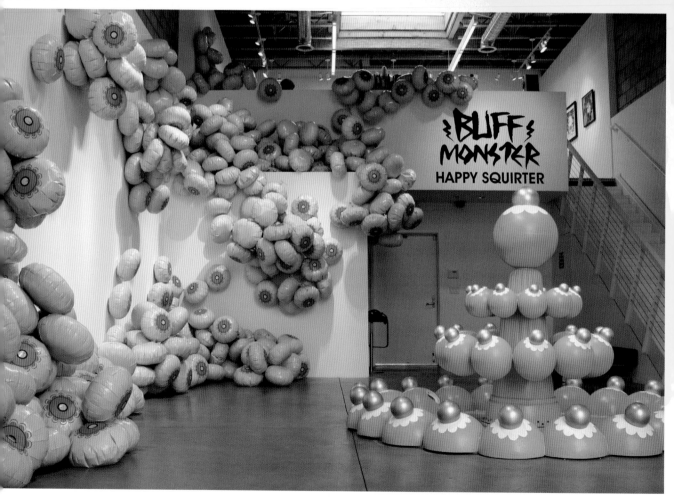

BUFF MONSTER

How do you mix the worlds of making work in the urban environment, working for commercial clients, and having gallery exhibitions?

It's all the same. I'm still making work where I have to determine if the company or gallery is someone I want to work with, and be associated with; and there are varying degrees of negotiation about terms and money. Of course, when you make street art, none of the negotiation and money issues apply.

MICROBO

How did you begin your career as a street artist?

Easy, it started for fun and simply as a game. I liked the idea of sharing my work with the public and seeing people's reactions; and the sense of freedom it gives you, especially when you are anonymous. It's a magic way to express yourself, and makes you confident and strong with yourself and your work.

Do you still call yourself a street artist?

Not at all! I've never liked the label; it's a stupid label, labels are stupid. What does it mean, "street artist?" It's too general and too restrictive at the same time. I like to paint and create things—that's all. And any place, platform, surface, architectural space, or whatever could be a "canvas to paint and experiment." I like to paint in the street, of course, because for an artist who does work for the enjoyment of people, where is the best place to publish your work but in the cities?

Opposite top left:
BUFF MONSTER
Borrowing a billboard for maximum visibility; multiple wheat-paste posters emphasize a message.
Opposite top right:
BUFF MONSTER
Untitled (Hollywood building). Edition of 60, signed. This is a four-color screen-print; the original photograph shows a 9ft (2.75m) tall Buff Monster in situ.

Opposite bottom:
BUFF MONSTER
Happy Squirter at the Corey Helford Gallery. This exhibition featured a wide range of Buff Monsters and other cute pink stuff, realized across media, including balloons and a fountain.

Top:
MICROBO
Gender Fardellus. Poster covering a wall in Milan, Italy.
Above:
MRS MUJU
Mr and Mrs Muju paint murals, inside and out, on glass and found objects.

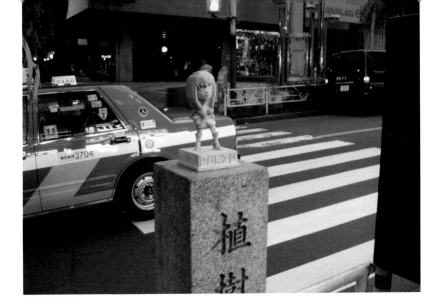

BO130
Do you call yourself a street artist?

I don't like labels, and that one just means nothing! I like "visual maintenance" better, that's what I do.

How did you begin your career as a street artist?

I got into graffiti around 1986, and got addicted to it. If by career, you mean when did I start getting paid for doing it, since 2003 I have lived off it. Nothing was planned, you know! First it was just love and passion and youthful foolishness, then you grow up, so your love and passion becomes your dream and if you believe, dreams come true!

What appealed to you about making art in the street? Was it the aesthetics, or was it the smell of rebellion that attracted you?

Freedom of expression, and the fact that you, as a kid, can run things. It's a very multilayered subculture with its own rules, codes, and networks. When I saw the film, *Wild Style*, that was the boom! And, if you look around the world now, you can see the power and effect of it.

You lived in New York City; do you think exposure to New York street art fed your development as an artist?

Well, it was even before that, back in the 1980s, during a trip with my parents to the USA, that I saw tags, pieces, and bombed trains for the first time. I remember saying to my Dad, "Wow, New York is so dirty!" A year later I was starting to get dirty myself!

RONZO
How do you feel about the term, street art?

I think we have to let go of hyped genres and see the stuff for what it is. There will always be good art and bad art. I see boring stuff in galleries and interesting stuff in the street and the other way round. As long as people walk through streets somebody will put things there to catch your attention or play with your imagination; it might be advertising, it might be graffiti, it might be art. I never wanted to paint in the style of something that was painted 25 years ago. But you can't be too hard on traditional graffiti artistry. It's not about intellectual elites who study conceptual art; it's kids who express themselves with spray paint, and it's about having fun.

Opposite:
BO130
Large-scale, cut-out poster,
pasted into the urban environment
in Milan, Italy.
Above:
RONZO
Taking his concrete statues out into
the world, this time in Hong Kong.

ON THE STREET: SOLO

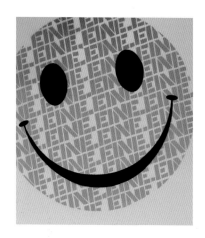

EINE

One of London's most prolific and accomplished street artists, and a skilled craftsperson too, Eine demonstrates how to crossover between media, the street, and the gallery, while sourcing inspiration from graphic design and popular culture.

When you're working on a giant scale, what are the best tactics for getting the job done?

When I have found a wall that I am going to paint, the first thing I do is measure it, then go away and work up different options that fit within those dimensions. Once I am happy with what I am going to paint, I get the ladders, the paint, the rollers, and maybe some help, and go and paint it.

First, I sketch the outline of the word onto the wall. Once I'm happy with that, we start coloring it in, then finally I will paint the black outline as sharp and crisp as I can. No secret tips, just common sense.

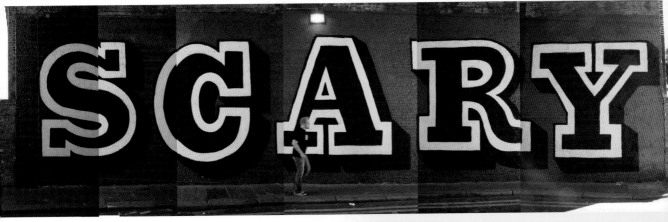

How do you choose a spot?

The best spot is one that has not been painted before—that's the goal. So it's a case of finding a wall and then working out if you can paint it without getting caught; or, if there is a chance, getting permission from the owner. There are loads of walls I would love to paint, but if you tried, you would get arrested in about five minutes and the owners would never give you permission.

How do you decide on which letters for which spot?

Sometimes I am trying to write a word or phrase with the photos that I take of the letters, so I might need a new letter for that. Sometimes the owner of the shop whose shutter I'm painting insists he wants an "N" for Nicky's Café, and other times it's to do with the shape of the shutter. →

Where did the idea of the big words come from?

Coming from a graffiti background I have always wanted to get my name in as many places and as large as possible, but in the later years of my graffiti career, the idea of constantly writing my name over and over again felt a bit boring.

With that in mind, wherever I go I am always looking at walls and spaces, thinking to myself, "I wonder if I could get away with painting that?" Or, "Could I get permission to paint that?" Or, "Wow, a giant 'Vandalism' would look amazing there!"

It has a lot to do with the shape of the wall, or what words I am working on at that moment in time. I think there is nothing better than walking around the corner on your way to work and there is a 5m [16½ft] high word painted really well, that wasn't there the day before.

DATA FILE: EINE

Based in London, UK, Eine is a prolific street artist, alternating between stencil, sticker, wheat-paste posters, and large-scale painted pieces. His most recent giant-sized letterforms defy tampering, either by taggers or the authorities. Eine is also a skilled printer; his technical brilliance has brought to life many iconic artworks by a host of his peers, including Banksy and FAILE, as until recently he was the screen-printer for Pictures on Walls, the influential printworks, gallery, and website.

www.einesigns.co.uk

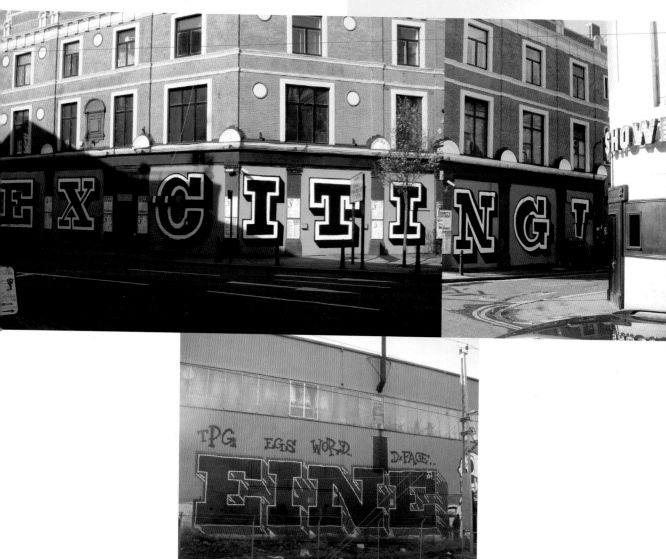

SOURCE BOX: GRAFFITI AND TYPOGRAPHY

Do you research old typefaces and type styles?

The style of art that I make now is massively influenced by the time I spent writing graffiti, which could be described as the study of letterforms, so it's natural for me to continue this.

I am interested in how the shapes of letters change when combined with different letters, and into words; and also how styles of letters change over time. There are old font styles that have been forgotten, because there are new styles being designed all the time. It's great to find an old typography book and turn those letters into something modern or into "my style." Old advertising is also a good place for inspiration.

Your single letters, which look like neon, are spot on! How did you come up with that "neon" technique?

I was looking for a new font to use as an "A-Z." I thought I could make the paint look like a glow of light against the smooth surface of the gloss black. The first one I painted worked.

These letters and alphabets are a departure from your stencil work. How did they develop from your earlier work?

The letters on the street, I feel, are in some way a continuation of my graffiti; and the letters and words I paint on canvas are made with stencils, so it's not that much of a departure. I have just finished a drawing for an exhibition called *Draw* organized by StolenSpace. I have not drawn anything apart from sketches for over 10 years. I really enjoyed it and was pleased with the result.

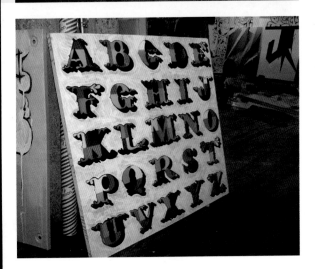

Opposite top:
EINE
Wrapping a nightclub in London's Shoreditch with giant letters.
Opposite bottom:
EINE
Eine has been commissioned to paint store shutters and walls all over London.
Above:
EINE
Eine at work during the "Open Studio" project, when a space in London was turned into a full-on painting studio. Visitors could purchase new works direct from the artists.

MICHAEL DE FEO

Working across media and scale, Michael De Feo specializes in giant wheat-pasted images, which he places in cities around the world. He was also one of the first street artists to keep his fans up to date with regular emailed newsletters.

How do you decide where to place your work?

It depends on a bunch of factors: I consider the aesthetic appeal as it relates to the work I have on hand, its visibility, and the possibility of the work's longevity.

Do you scout locations or is it more like you come across somewhere you think is cool?

It's both. Sometimes when I'm out and about I see a spot that just screams for being hit and I make a point to visit it at a later date. Other times I find locations as I wander around with my paintings. →

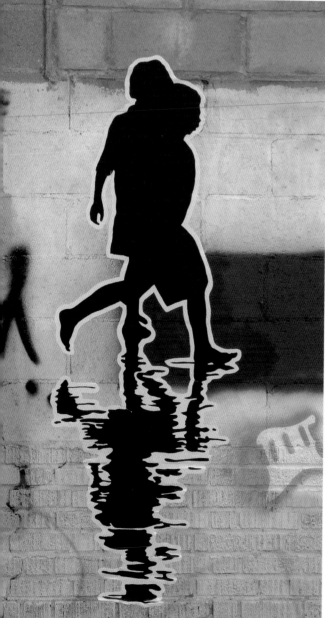

Left:
MICHAEL DE FEO
Silhouettes, in New York City.
Above:
MICHAEL DE FEO
Self-portrait painted over an old map, and then pasted onto an abandoned trailer.
Opposite:
MICHAEL DE FEO
Painting a flower in Barcelona, Spain.

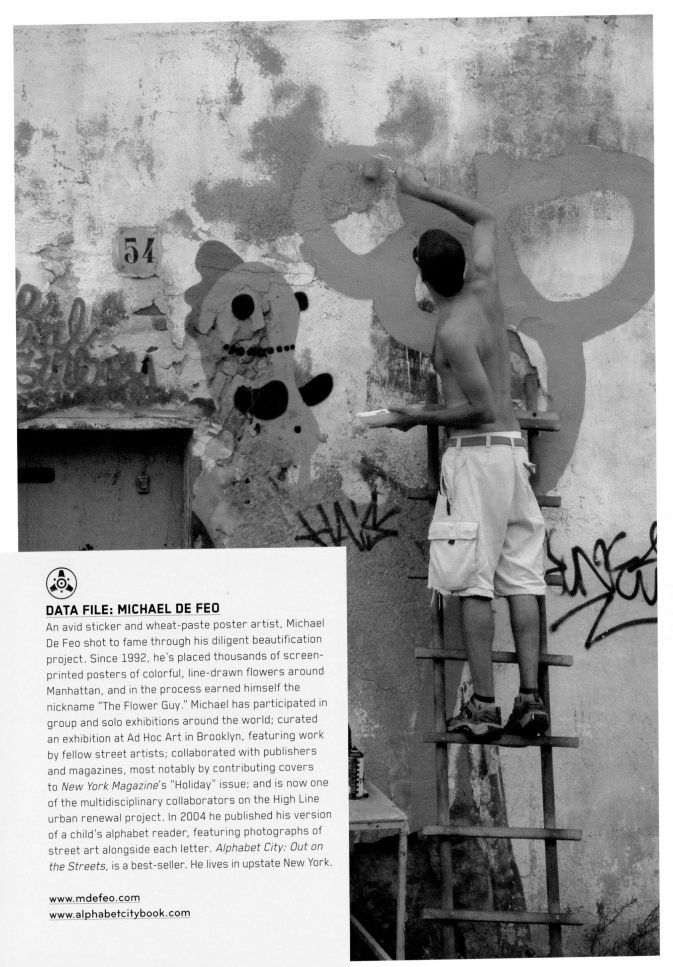

DATA FILE: MICHAEL DE FEO

An avid sticker and wheat-paste poster artist, Michael De Feo shot to fame through his diligent beautification project. Since 1992, he's placed thousands of screen-printed posters of colorful, line-drawn flowers around Manhattan, and in the process earned himself the nickname "The Flower Guy." Michael has participated in group and solo exhibitions around the world; curated an exhibition at Ad Hoc Art in Brooklyn, featuring work by fellow street artists; collaborated with publishers and magazines, most notably by contributing covers to *New York Magazine*'s "Holiday" issue; and is now one of the multidisciplinary collaborators on the High Line urban renewal project. In 2004 he published his version of a child's alphabet reader, featuring photographs of street art alongside each letter. *Alphabet City: Out on the Streets*, is a best-seller. He lives in upstate New York.

www.mdefeo.com
www.alphabetcitybook.com

How do you feel about the ephemeral nature of your work?

It's one of the most important aspects. The very idea that no one can own it and it's there for a limited time is essential to its very meaning. For me, that's part of the allure of street art. When you encounter something on the street that wasn't there before and you see that it's a one-of-a-kind piece of art, and you recognize that you're seeing something that won't last, it creates a magical experience. It's a response to the recognition of the life cycle of all living things; they're born, they live, and then they wither away and die. My flower project relates to this exact concept, especially with them resprouting elsewhere.

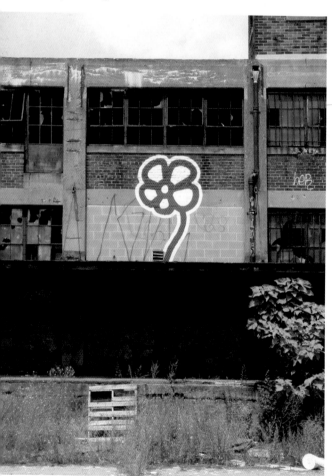

Your profile is increasing; do you still try to remain anonymous, or only for certain projects?

The name "The Flower Guy" was given to me as people began to meet me. They'd say, "Oh! So you're The Flower Guy!" The name stuck even though I've always used my real name for exhibitions, books, interviews, my website, and so on. I've always been proud of what I do and I don't try to hide. That said, I also don't like to show my face in the media. I think it gives me this false sense of security. I don't get crazy about it though, my face is in some documentaries and photos and stuff.

Your work on the High Line (a derelict elevated rail line in New York City that is being transformed into a linear park) must bring you into contact with designers, architects, and landscapers. How do they react to your work, and what do you add to the mix?

Working with the good people of Friends of the High Line has been nothing short of amazing. I find their efforts and accomplishments a true testament to "people power." They prove that every single one of us can produce change when we believe in it and join together, even in a city as large as New York. I am continually inspired by their achievements and consider it a great privilege to work with them on a variety of projects to support the High Line. How do they react to my work? I'm not sure...I suppose they like it. Sometimes I'm teaching kids via their programming or I'm contributing design or donating art. Whatever it is, we've been having fun together for a while!

FIND MORE: LE M.U.R. (MODULES, URBAN, REACTIVE)

Since January 2007, this 10 by 26½ft (3 by 8m) billboard, owned by the City of Paris, has hosted artworks by Obey, WK Interact, Babou, G, Influenza, and Swoon, with the blessing of the Mayor. The artworks change every two weeks, and each new billboard is greeted with a street party on the corner of rue Oberkampf and rue Saint Maur.

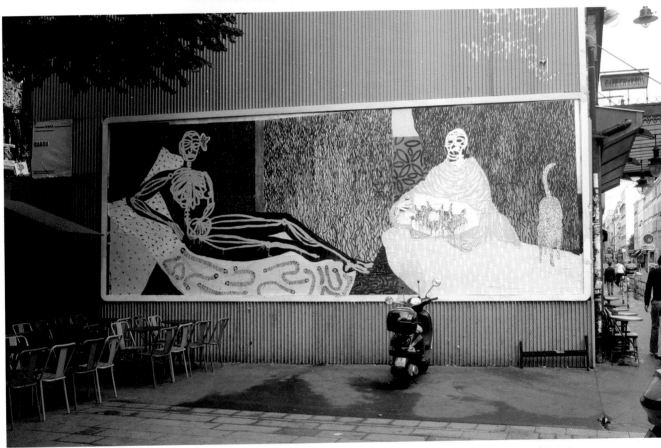

Opposite left:
MICHAEL DE FEO
A giant version of The Flower in Providence, Rhode Island.

Opposite bottom:
Michael De Feo's studio.

Top:
MICHAEL DE FEO
This painting was pasted onto a billboard for Le M.U.R., as Michael's homage to Manet's *Olympia*, painted in 1863.

Right:
MICHAEL DE FEO
Silhouette in New York City.

GALLERY INSTALLATIONS
✽✽✽✽✽✽✽✽✽✽✽✽✽✽✽✽✽

SPANK THE MONKEY, DEITCH PROJECTS, BARRY MCGEE

When street artists go large, within the confines of contemporary art galleries, they tend to break rules and create an enormous impact, especially with the art-going public, who often comment that the work is approachable and inspiring. The mix of handmade marks and unprecedented assemblages, juxtaposing humor, horror, and pathos, engages both as a grand spectacle, and in the detail. The largest group retrospective of "urban artists," *Spank the Monkey*, featured Barry McGee, Invader, Swoon, FAILE, Shepard Fairey, Banksy, and more, and was staged at the BALTIC Centre, a public art museum in Gateshead, UK, housed in a giant converted power station. With artworks dotted around the town, and literally busting out of the building, this show created a real buzz and was one of the gallery's best-attended events.

www.balticmill.com
www.deitch.com
www.redcat.org

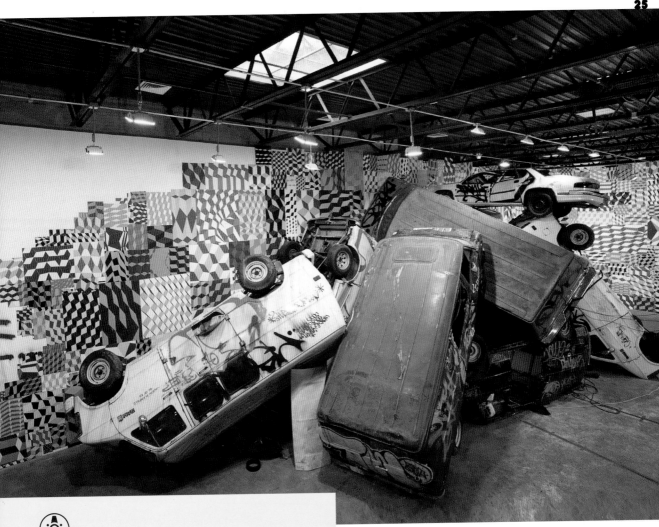

DATA FILE: BARRY MCGEE

Also known as Twist, Barry McGee began working
on the streets of San Francisco, his native city, in
the mid-1980s, making images of all sizes and on all
manner of surfaces. His work was brought to a wider
audience as part of the trio (with Stephen Powers
and Todd James) that created *Street Market*, a genre-
busting, multidimensional installation staged at Deitch
Projects, New York, and at Parco Gallery in Tokyo.
Since then he has staged solo shows and participated
in group exhibitions, from Milan, Italy to Gateshead, UK,
and LA's Redcat Gallery, always working on a giant scale.

Opposite top:
INVADER
Big Rubik at *Spank the Monkey*,
BALTIC Centre for Contemporary
Art, Gateshead, UK. External
installation view.
Opposite bottom and above:
BARRY MCGEE
One More Thing, Deitch Projects,
New York City. Two installation views
show how Barry mixes scale, adding
hand-rendered elements to a mass
of urban flotsam and jetsam.

ON GALLERY WALLS

**DATA FILE:
ANDREW MCATTEE**
Andrew McAttee studied
Fine Art at Central Saint
Martins College of Art
and Design in London,
UK. His work has
featured in numerous
exhibitions in the USA
and Europe, with solo
shows including *Suck it
and See*, *Off the Wall*,
and the recent sold-out
show, with Forster
Gallery, *Yeah, Yeah,
Yeah*. Commercial
clients include Benson
& Hedges, Nike, and
fashion designer,
Antonio Berardi.
His work has appeared
in publications such
as *The Observer*
newspaper and
Graphotism. He is
based in London, UK.

www.mcattee.com
www.forstergallery.com

ANDREW MCATTEE

Making the transition from being an artist who only works in the streets (painting graffiti style, stickering, pasting posters, or whatever format) to being an artist with gallery representation can happen in a number of ways; whether you set up a gallery with friends, or get spotted by an established gallery, it's likely that your work will change in the process.

Here, Andrew McAttee talks about how he moved from the street to the gallery. (See Chapter Three for other galleries that represent street arts.)

Describe the transition you made from being STET, graffiti artist, to being Andrew McAttee, fine artist.

The transition began when I was at art school. To better understand my own work and the work of others, I studied Art History and during that time became interested in movements such as abstract expressionism and pop art. I was seduced by the freedom of the abstract expressionists and blown away by the vivid use of color in works by the pop artists. When people look at my paintings, without knowing my history, they feel the mood is that of pop. Nonetheless, I practiced as a graffiti artist for almost 15 years, and realize there are aspects of graffiti that sometimes appear in my canvases—it's inevitable. Occasionally, a viewer recognizes my graffiti history without having any knowledge of my background, detecting the unmistakable visual vibe that stems from graffiti. My artwork is multifaceted, different disciplines feed into the work and fuse together on the canvas.

MAKING IT: WORKING WITH A GALLERY

Since I started working with a gallery the practical realization of my paintings has changed. Every detail needs to be observed, from what type of paint is used, to the type of canvas, how the stretchers are made and by whom. Deadlines need to be set and good communication with the gallery is very important. There is a rigid structure to my practice and this comes with a greater degree of professionalism and time management.

MAKING IT: SUPER-FLAT PAINTING

My paintings are very labor-intensive, each piece takes several weeks to complete and requires intense concentration and a steady hand. Layers of paint are carefully applied while surrounding areas are masked-off. The end result is a super-flat canvas surface, over which the impasto, the gestural brush strokes that feature in many of the works, are applied.

Opposite:
ANDREW MCATTEE
Genie and the Lamp; acrylic
and spray paint on canvas.

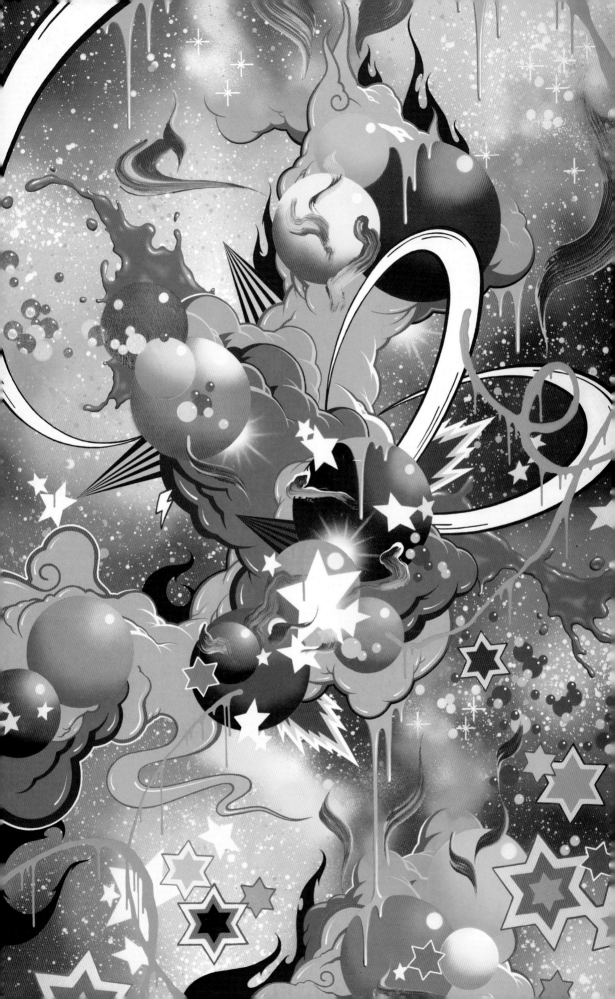

THE IGNORANCE, ARROGANCE, AND
OBSTINACY OF CERTAIN INDIVIDUALS,
WHETHER THEIR INTENTIONS WERE
GOOD OR EVIL, HAVE BEEN AT THE
ROOT OF ALL TRAGEDIES OF HISTORY.
"DOLLA LAMA"

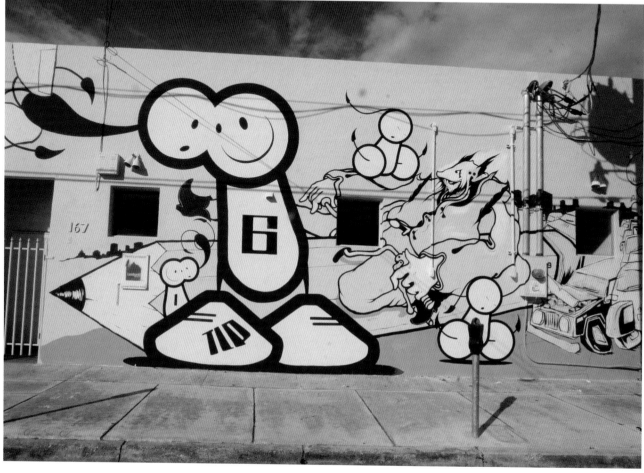

ON THE STREET: CURATED

BLACKBOOKS STENCILS AND *PRIMARY FLIGHT*

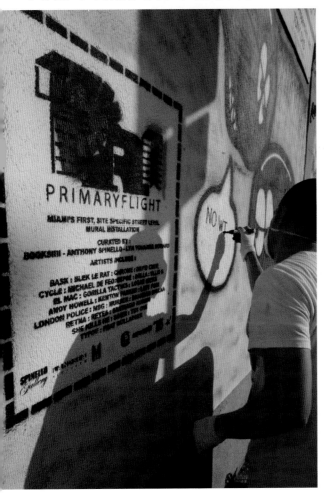

Opposite top:
DOLLA
Opposite bottom:
THE LONDON POLICE, MOURCKY,
AND WILL BARRAS
Above:
ELLIS G
Painting the *Primary Flight* logo
and information.
Top right:
DEPOE

Billed as a "curated street-level exhibition," *Primary Flight* was a temporary outdoor gallery, painted on willing walls by an impressive roll call of international street artists. During the annual art fest that is Art Basel Miami Beach, when the world's galleries and collectors invade the city, these artists enjoyed prime foot-traffic locations, and much publicity.

Blackbooks Stencils staged *Primary Flight* at Art Basel Miami Beach in 2007; here BOOKSIIII explains the process.

Tell us how you got involved; did you instigate the project?

Art Basel is a serious time of year, but if you are regularly involved in the Wynwood arts district in Miami, Art Basel may be amazing but is also something of a circus. For the past couple of years, Blackbooks, along with some other local artists such as She Kills He, Brandon Opalka, Siner, and Santiago Rubino, have made an effort to paint murals as a way to showcase work without having to deal with the hustle of the galleries. Having such a great response from the previous murals, Blackbooks invited friends to town to get up, but with a twist, executing this madness as a curated exhibition. Hence, *Primary Flight* was born. The exhibition was curated by BOOKSIIII, Anthony Spinello, and Lynn Yohana Howard. We made the exhibition move, from curating it, to all the inner workings and some documentation. The exhibition took on a life of its own soon after the artists began their murals; Miami opened up a lot more walls, and overnight the district became a safe haven for graff. →

How do you go about selecting artists to work with on such a high-profile project?

Every artist in this exhibition is a friend or a friend of a friend. There are artists who we appreciate who were invited into this exhibition, although due to scheduling or travel could not participate. Regardless, due to the familiarity the artists had with each other and the support of the local crews, *Primary Flight* was a huge success. We could not have asked for a more memorable experience.

Are all the walls in the same neighborhood, or was the "gallery" really spread out?

The walls were all in the Wynwood arts district, which runs about five blocks in length and width, containing 40-odd galleries year round, and hundreds more galleries and exhibitions, such as Nada, Scope, and Pulse, during Art Basel. Some murals were confined to specific areas and others were off on their own. The whole exhibition was designed site specific. Each wall was selected for a single artist or a group of artists. Otherwise, I don't know if the exhibition would have turned out as well. Everything needed to be organized; it needed to be traditionally curated, as if it were confined to a gallery. One major difference: the art form that has turned the heads of the world was viewed in its natural state, in the street, where no gallery, collector, or money, can alter its traditional context.

What was the "art world's" reaction? Did you get viewers understanding and appreciating some contributions more than others?

It was incomparable. It was received more than well, it was loved, by collectors, but especially by the community that lives here year round. During that time of year the foot traffic is extremely heavy, so there was a lot of interaction with the artists. There was a ton of patron and artist interaction, and artist to artist interaction. It was obvious to patrons that they could have a memorable experience throughout the exhibition instead of just viewing one or two pieces and just going home. Each artist was more than willing to converse with the viewers and this created more awareness about the art form. Either way, murals are murals, they are bound to be appreciated; they have been throughout time, regardless of genre. But during Art Basel, when you are walking from gallery to gallery, and viewing art inside, in a stuffy, pretentious world, *Primary Flight* was a breath of fresh air. It was an exhibition that did not disappear when the weekend was over, and for the most part, you can still roam from wall to wall, and view the murals.

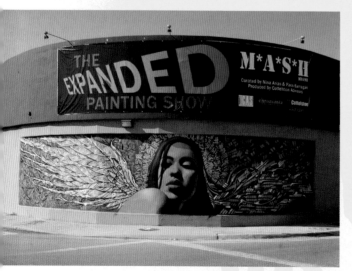

Left:
EL MAC, REYES, AND RETNA
Top:
CROME
Opposite top:
SHE KILLS HE
Opposite bottom left:
Peat Wollaeger using a
large-scale stencil.
Opposite bottom right:
DARRYL PIERCE

You show in galleries, and work with artists who cross the divide between street art and the galleries; how do you think the two worlds benefit each other? Is it the artist who is winning. How do you feel about people who cry out about "commercialization?"

Now is a great time for young artists to make money from galleries and corporations. Artists guide the visual aesthetic of the world. This is something that should not be taken lightly; design influences people, and those who work hard should be paid for it. The galleries provide opportunities. As long as they do their job honestly, sell work, and represent careers, they stand to gain a lot from the creativity of individuals or groups. I do feel, though, that graffiti does not stay the same when transferred to the gallery from the street. A tag on canvas will never hold the same power as the exact same tag on the street. There are politics and emotions involved when it is experienced on the side of an interstate; as long as graffiti continues to grace the walls of our cities, it can never become completely commercialized. It will continue to morph and grow, but trends will not be able to maintain a similar momentum. The mainstream trends will only reflect what is passé; by then, those who are in the know will have moved on, and those lost in the controversy will catch the vapors.

www.primaryflight.com
www.blackbookstencils.com

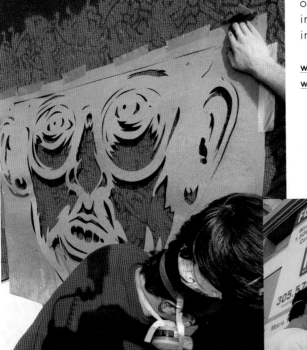

DESIGN BRIEFS

**DATA FILE:
DANNY SANGRA**

Originally from Leeds in the UK, Danny Sangra moved to London to study Graphic Design at Central Saint Martins College of Art and Design. Since then he has illustrated for various magazines around the world, worked with clothing labels in London and Tokyo, created the collective A Minute Silence, and has worked on a project for telecom company, Orange, along with Jamie Hewlett, Pete Fowler, and David Shrigley. Danny also appeared in a Sony Walkman advertising campaign. Other clients include Marc Jacobs, Gravis, Double Identity, and Mother.

www.dannysangra.com

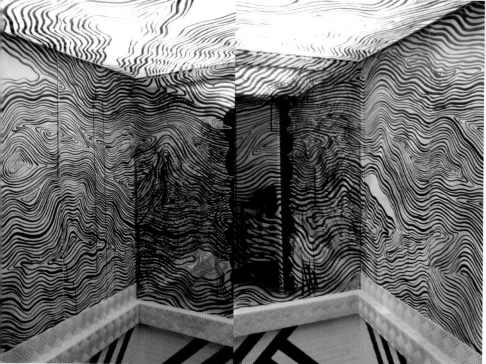

This page:
DANNY SANGRA
Painted interiors in the Magnolia Hotel, London.
Opposite top:
CHASE
Uplifting Collages. Interior installation using various media and techniques, including relief plaques, stencils, and freehand painting.
Opposite bottom:
SPETO
Hotel Fox in Copenhagen, Denmark. Hand-painted room by Speto, from Brazil.

DANNY SANGRA

Many street artists have close ties with the worlds of design and fashion, working day jobs in those industries, and often collaborating with fellow designers from these fields. The impact of a hand-painted or wheat-pasted wall can turn a store, bar, studio, or hotel room into a one-off masterpiece; a number of high-profile team efforts have caught the imagination of the media and the public (Hotel des Arts in San Francisco, Hotel Fox in Copenhagen).

Here, Danny Sangra explains how he participated in an interior design project on a London hotel.

Describe the hotel project, how did it come about?

Johnny Chatters, who I work with at the clothing label, Double Identity, has a friend who was building a hotel (Magnolia, now owned by Gordon Ramsay). He was asked to design two suites. Johnny said that he knew a kid who could do one; that kid was me, and together we designed the layout of the rooms and bathrooms. There wasn't a brief. It was just do what you want.

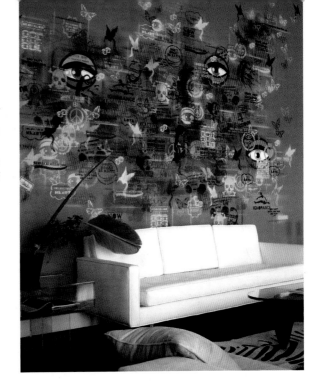

How did you plan the project? Did you sketch out ideas on paper?

I remember sitting in a restaurant, drawing what I wanted on a napkin, then taking a photo of it on my phone. Then I sent it to a designer who was drawing up the detailed plans.

Do you work differently in a specific space like this than when you're working on canvas or on a smaller scale?

I approach all projects in pretty much the same way, but when I paint a space I try and work all around it to create an environment. I never plan anything when I paint a space. I just work with the structure. You can't really do that with a canvas. You can only make a snapshot on canvas.

How does working with fashion designers and having exhibitions in boutiques affect your artwork?

That's how I started—painting the stores that I worked in. Then other people asked me to paint their stores, which then led onto painting other spaces such as design studios. I think it keeps my work fresh. I always like to do new things because I get bored. Having shows in boutiques is good for me because they are manageable, just the right size, and I always bring a crowd!

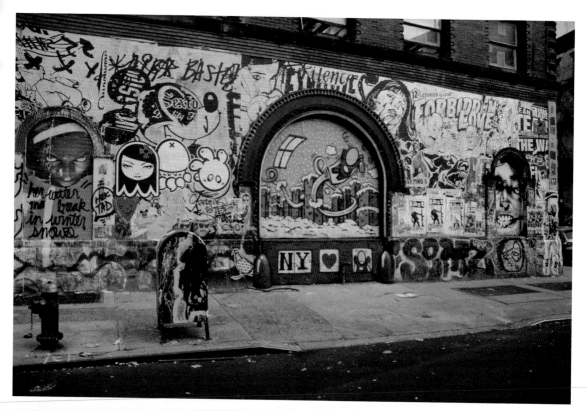

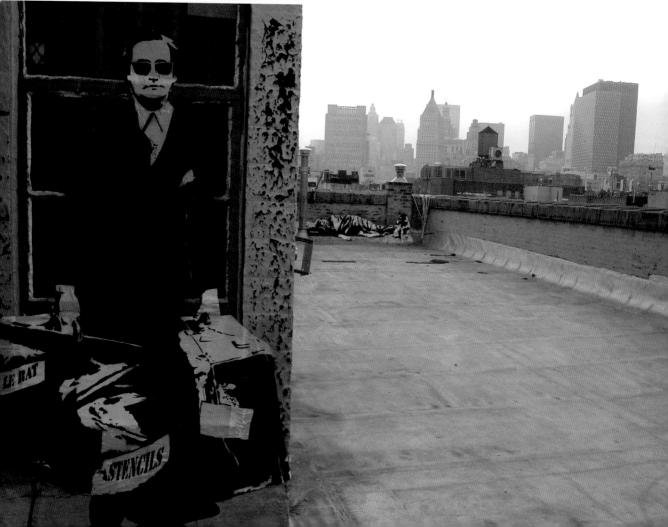

11 SPRING STREET

Sometimes called the Candle Building because candles would be lit in the windows at dusk, the rumor was that an eccentric inventor lived at 11 Spring Street in SoHo, New York. When he died, it turned out that the rumor had been true. Over the years, the building had become a mecca for street artists from around the world. It has now been purchased by property developers and converted into luxury apartments.

Here, Marc and Sara Schiller of the Wooster Collective, and Michael De Feo, explain the project.

MARC AND SARA SCHILLER

Caroline Cummings, the developer of the building, fell in love with the street art on the outside. She contacted us and, over a bottle of wine, we decided to do something to honor the history of the building. It began with a couple of artists painting the inside and ended seven weeks later with over 45 artists and over 30,000 square feet of wall space painted. Thousands of New Yorkers saw the work for free over a long warm weekend in December 2006.

MICHAEL DE FEO

I've been doing work on that building for over 15 years so, for me, it's a very special place. As long as I've been working on it, I've never known it to get buffed, so it built up quite a layering and a history. It's also the site where I created the cover for my children's street art book, *Alphabet City: Out on the Streets.*

The exterior of the building is to be cleaned, but what about the interior?

As far as I know, all the interior works are being left alone and will be covered with walls, to be entombed. However, some of the pieces may not be covered, but will be displayed in the apartments. The apartments are multimillion dollar...the three apartments are listed at $6.7, $15.1, and $17.9 million. What's not to like about the work inside that building? It's got soul.

What do you think are the reasons that street art has made the crossover into such desirable surroundings?

It's subversive, it's raw, it's magical, it's all sorts of things. People want a part of that.

www.woostercollective.com/wooster_on_spring

Opposite top:
Exterior pieces by Jace, from Reunion Island, and Lister, from Melbourne.
Opposite bottom:
BLEK LE RAT
Up on the roof, with a version of his international traveler, the *Man Who Walks Through Walls.*

This page top:
Interior wall by Judith Supine and Rekal.
This page above:
Exterior pieces by JR, from Paris, in the bays; and FAILE from Brooklyn, along the frieze.

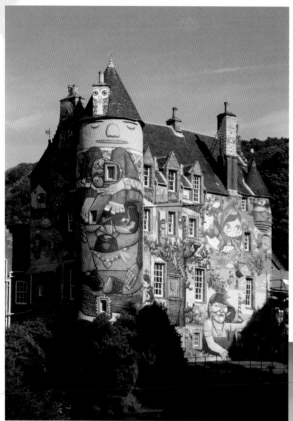

THE GRAFFITI PROJECT

A fairytale castle needing renovation provides an unexpected canvas for a group of playful artists. Sticking their necks out, the younger members of this ancient Scottish family had a novel idea for attracting more tourists to their home.

Here David Boyle, director of The Graffiti Project at Kelburn Castle, Scotland, discusses the process of using graffiti to attract new visitors.

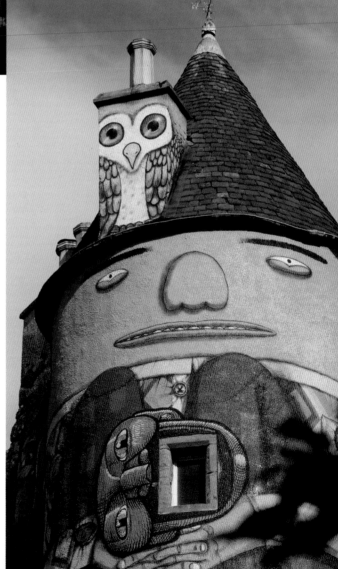

This spread:
The Graffiti Project; castle painted by
Os Gemeos, Nina Pandolfo, and Nunca.

DAVID BOYLE

The idea for the project grew out of the knowledge that the concrete harling of the building had to be stripped off, as it was damaging the stone underneath. This provided us with the amazing opportunity to use the surface of the castle (some of which was built in the twelfth century), as a vast canvas, contrasting the modern urban art form and the rural and historic building.

We chose the artists, Nunca, Nina Pandolfo, and Os Gemeos (twin brothers Otavio and Gustavo Pandolfo), because of our sheer love of their work. The artists' fantastical and surreal style blended with the mystical ideas of castles and the intrinsic feeling of fantasy at Kelburn, while the differences in culture [between the Brazilian artists and the Scottish castle] reinforced the ideas of contrast. Importantly, in what was likely to be a controversial project, the São Paulo crew's work is inclusive and appeals to a diverse spectrum of people.

Having formulated the plan, we sent the artists our proposal in the vague hope that they might agree. Once they realized we meant spraying the building and not just an exhibition inside the castle, they were very keen to be involved.

The artists spent the first few days planning and sketching ideas for the building. It was very important to them that the windows and shapes of the building were central to the design. The easiest way to approach the painting was with off-road cherry pickers, and the initial stage of painting was spent laying outlines of the design on the walls and planning the overall composition, before the many layers of block colors and details were added.

The project was always going to be controversial, and the better for it, so we never expected universal approval, but we were surprised at the huge level of support for the project both before and after the painting was done. An initial worry was getting approval from Historic Scotland [the organization that protects historic buildings and sites], which was required before anything could happen, but they were very encouraging. I think they saw it as a way of bringing the image of an historic building back into the mainstream consciousness. The project was fully sponsored, which due to our lack of a track record in that department was no easy feat, and mainly from local businesses, which also gave the project a sense of inclusion within the community.

At a distance there has been some aggression from those who see it as cultural vandalism, especially from America. The feedback from visitors of all ages, though, and from the overwhelming amount of press coverage, has been positive, either in relation to the amazing artwork or to the simple statement of a spray-painted castle. It is something you really have to visit in its setting to appreciate the scale and the intricacies of the work.

www.thegraffitiproject.net

MURALS: SOLO AND GROUP

Whether artists are commissioned to paint, or take the initiative and find opportunities to beautify a neglected wall or store shutter, or create an outdoor, temporary gallery, the large-scale, painted mural undoubtedly has impact. With influences from graffiti (the throw-ups that appeared overnight and covered entire subway carriages), agitprop techniques (agitation and propaganda), and advertising (and the subversion thereof), mural painting is one of the more high-profile strategies in the street artist's repertoire. Many hands make painting a mural speedier, and group efforts bring artists and their fans together. But remember to wear a mask if you're using spray paint.

MATT SEWELL

Painting indoors is massively different to out of doors. Indoors means you have a lot more time, which also means you sit about drinking tea and chatting more while staring at what you've just done or are about to begin. Also, painting indoors means that I can get my big brushes out; and paint it big with emulsion. Outside is a different kettle of fish completely; it usually involves spray paint, which means working quick and loose, and with lots of color.

Right:
MATT SEWELL
The Owl; emulsion, spray paint, and rollers on wood.
"Originally, this facade was painted by four artists for the Doodlebug event in Manchester, UK; but unfortunately Manchester City Council took exception to the new artwork and promptly buffed the whole thing with beige paint. So, Barney, from Doodlebug, and I went down first thing the next day with gallons of paint, a few rollers, and a couple of cans of spray paint. I made like a painter and decorator being paid by the job, and turned the structure into a big daft owl in two hours. The funny thing was, it lasted untouched for months and every day I would hear people laughing at it as we rode past on the bus into town."

Top:
ICH
Up on the roof and underground in Berlin, Germany.

ICH

ICH translates [from German] as "me." It's my super-ego, now conquering Berlin. Revenge! On rooftops to be seen only from the universe; in claustrophobic World War Two bunkers; on high buildings watching over Berlin.

DATA FILE: CHASE

Originally from Antwerp, Belgium, Chase grew up skateboarding, tagging, and hanging out with a local crew of kids who were into hip-hop and graffiti. While still a teenager, he moved to Los Angeles to pursue his skateboarding, and started looking for opportunities to paint walls, legally. Now he's involved in public mural schemes, mixing commercial design with personal projects.

www.theartofchase.com

MAKING IT: STREET MURALS

I start with the background and then I paint my way to the foreground—nothing unusual. I rarely sketch out ideas any more, instead just allowing for things to happen in the moment. Any mistakes along the way are welcomed, because in fixing them I discover new things.

CHASE

With his signature eyes and searing, bright colors, Chase's murals make a massive impact on city streets.

Right now I'm focusing on two public mural campaigns; the "Remember Who You Are" campaign, which depicts young children and the phrase "Remember Who You Are." The intent is to stimulate the public to reconsider and remember their inner child. The other campaign revolves around the "Awareness Geezers," who are best described as colorful characters who have stumbled upon spirituality and self-awareness, not by following the suggested path but guided by their sense of adventure. The fruits of their experience come in the form of uplifting messages, such as "You can't until you say you can," "Be peace," and "Go without if you don't go within." The messages are designed to inspire soul-searching conversations.

Do you see yourself as working in the tradition of graffiti, or are there other traditions and art movements that inform your art?

I don't consider myself a graffiti artist because I don't paint without permission, but my roots are obviously in graffiti. If I had not been a tagger when I was growing up, I wouldn't have been introduced to my medium of choice (spray paint) and those artists who have mastered it.

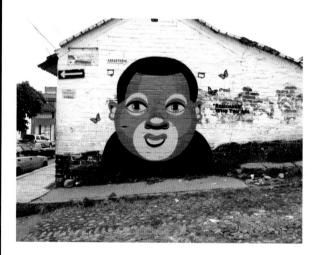

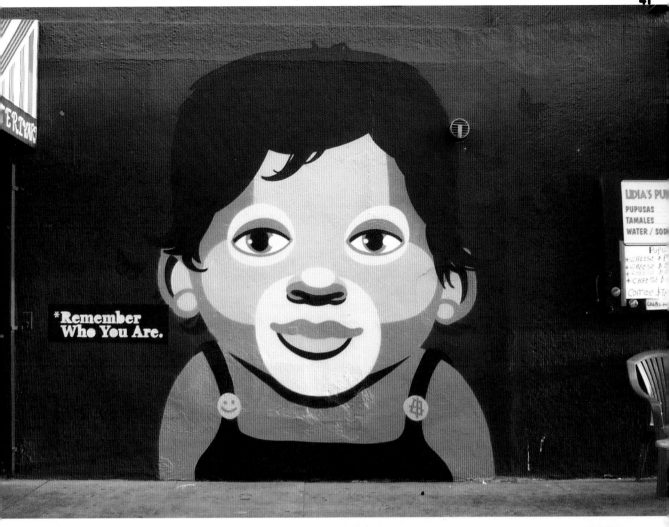

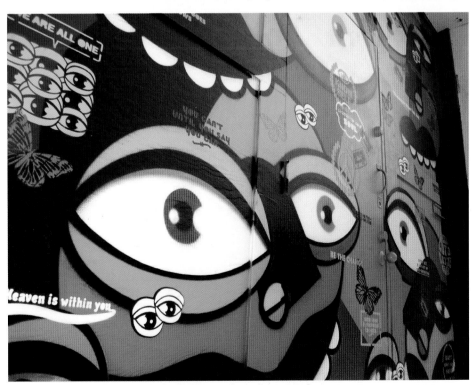

Opposite and above:
CHASE
Remember Who You Are, Mexico and Venice Beach. These highly-stylized portraits of children urge us to remember our early years and where we come from; Chase explores the "therapeutic undercurrent" in his work.

Right:
CHASE
Awareness Geezers, Hollywood, California. To counteract what he describes as "misanthropic street art," Chase instigated this mural campaign that has a "positive, good vibe message."

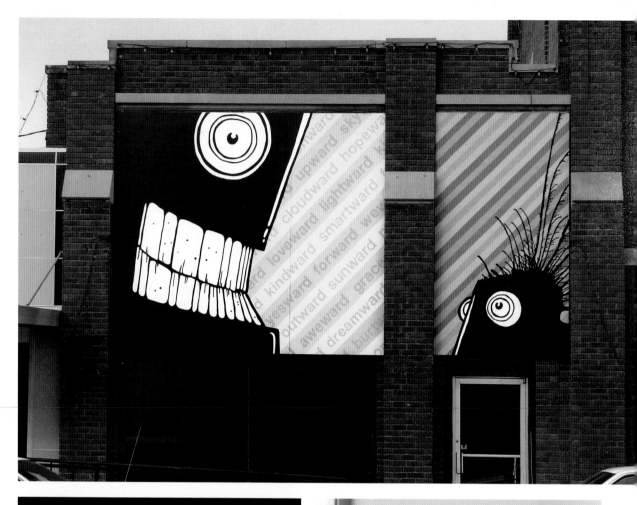

FIND MORE: SIGNAL PROJECT

Helping to develop some of the largest graffiti-
and mural-based projects in the UK, Signal work
with artists from around the world, diverse
corporate partners, and local communities,
running workshops and getting results. Check
out the website for some familiar faces.

www.signalproject.com

DATA FILE: STEFAN G. BUCHER

Originally from Germany, Stefan G. Bucher moved to California to attend the Art Center College of Design; then on to Oregon to work as an art director at Wieden + Kennedy. Back in Los Angeles, he set up his own studio, working for diverse clients from the movie, publishing, and music industries. He has designed award-winning books (D&AD Silver for *American Photography 17*), and written a few too—*All Access: The Making of Thirty Extraordinary Graphic Designers* got him interviewing the world's best graphic designers, while his Daily Monster blog has been compiled into a must-have book.

www.344design.com
www.dailymonster.com

Opposite top:
STEFAN G. BUCHER
The Monsters installed in Seward, Nebraska. Painted by: (Students) Brenda Ard, Kaylee Conrad, Jacob Cooper, Laura Knibbe, Ashley Lenz, Madelyn Lorezen, Tanon Osten, Michelle Roeber, Lindsay Souchek, Brittany Tomsick; (Faculty) Paul Berkbigler, Mark Anschutz, James Bockelman, Philip Perschbacher, Richard Wiegman, William Wolfram; (Community Volunteers) Tim Oliver, Brock Shaw, Jeff Voehl.
Opposite bottom:
Stefan G. Bucher and a student colleague painting their monsters.

STEFAN G. BUCHER AND CONCORDIA UNIVERSITY

Stefan Bucher starts off a drawing by blowing a blob of black ink through a straw onto a sheet of white paper. From there, he draws a monster a day, and showcases them on his website. Now the monsters are on the move: into a book, and thanks to a bunch of helpers, as a giant mural.

Why monsters?

The Monsters appeared to me and I didn't ask questions. I'm serious. I have no prior love for monsters, no lifelong ambition to create them. They just popped into my head, and I've learned to roll with the ideas that come to me. I love creating characters, and the blown-ink technique lets me cook up more interesting and varied characters than if I relied solely on my brain.

Why make a monster mural?

I give a lot of talks and workshops all over the USA. Usually I fly in, do my thing, and leave. It's really nice when I have the chance to create something with the people I talk to, something that stays behind after I leave, and we all made together. Why a monster mural, specifically? Most of the poor creatures are forced by my own limitations to spend their lives on paper 8½ by 11in [26.6 by 27.9cm]. When the design department at Concordia University (with some help from Jones Bank of Seward, Nebraska) invited me to paint a mural for the exterior of a painting and sculpture workshop, I had the rare chance to let two of them grow to their full size. It would've been cruel of me not to set them free.

What do you think people gain from working together on a large-scale mural?

I've been scared of doing large-format work for years. If doing this mural can save any of these students from that same fear, I'll be very happy. Beyond that, it's a joy to go from a computer screen to a big old hairy format like this—18 by 10ft [5.5 by 3m]! Your hand moves differently working at that size than it would drawing on a letter-size pad. You have to use your whole arm! Dormant muscles creaking to life! It's fun! The size is the thing.

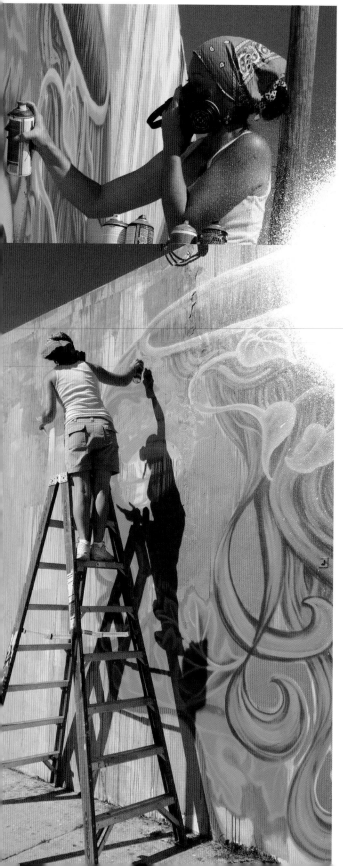

LADY PINK

When you're painting a large, street-based mural with other artists, how do you start? How do you divide up the space? How do you plan the image?

When painting a large mural with other artists I always arrive with a prepared sketch and my paint. The space is divided by seniority, or whoever has the permission papers doles out the space as they wish. Sometimes it's divided by whoever shows up first getting the prime spots; the late arrivals get to paint up a ladder or get no spot at all. Each wall is different depending on who runs it. I have a few walls that I run with my husband Smith, and we invite friends and strangers who have a history of quality work and are reliable and pleasant to be around.

People with giant egos that try to strong-arm us are not welcome, no matter how well they paint. I plan my images that go up on a wall by the size of the site, the amount of time I have to carry it out, and the impact I want it to have. Sometimes it's political and controversial, sometimes merely decorative. I choose my images by whim mostly, sometimes I spend a day or two sketching if it's a high profile project and I want it to come off. If it's just for fun, I don't worry too much. If the media is expected to cover the event, then I prepare for that.

You were part of the *Primary Flight* project in Miami; how much time did you have to paint the piece?

I was invited by the Spinello Gallery to produce a mural for the *Primary Flight* exterior exhibit, which had over 20 artists painting murals. I spent three days painting in Miami at Art Basel; I designed my piece so it would only take three days, then I stayed in Miami one last day to check out everybody else's work and some of the galleries too.

I know how fast I can paint, so I can draw a mural on paper and know how long it will take to produce. That timescale does not include weather that won't cooperate or the lack of a ladder or other artists getting underfoot. Things that slow me down frustrate me but I'm a professional and can handle all sorts of mishaps, calmly.

One of your paintings appeared on the cover of _Time Out NY_; how did you work with the art director to come up with the image? How did you choose where to paint it?

The Pink Statue of Liberty that I painted for the _Time Out_ cover had nothing to do with the art director. They weren't paying the artists, so in that situation I don't take any art direction. I sent them a photo of a wall I painted in Minneapolis for the B-Girl Summit that summer. When I was painting it in Minneapolis the police turned up twice to investigate the antigovernment propaganda that was going up. The folks inside Intermedia Arts gallery came out to tell the cops that we still live in a free country and thanks for coming by...bye-bye.

I told _Time Out_ that I wanted a chance to rock the images in New York since not many people saw it in Minneapolis. They accepted right off, they didn't try to change a thing. I knew that I'd hit a sensitive spot in the American facade. I just had to paint her here in New York. The offer to do the _Time Out_ cover was great timing too, even though I don't usually accept nonpaying jobs, I really wanted to paint that image again. I chose 5Pointz as the only place in the city that I could get away with such an outrageous mural.

5Pointz is the only nonprofit space where we can paint anything controversial since the landlord doesn't care. The walls I have were not appropriate for this piece, as those landlords don't want controversy on their walls, having any artwork up usually angers their conservative neighbors anyway.

New York isn't as liberal as it appears. I have no idea how I came up with the big-pink-ho' that is the Statue of Liberty, it just came to me. The Bush-monkey I got from some other artist who does great Bush-monkeys but more graphic, mine is more realistic. I rocked her again at 11 Spring Street but in a more sexual pose with the cross sticking out of her ass. I certainly couldn't paint that out in public, anti-government and anti-religion, way too controversial for the street. It would have been destroyed for sure.

Opposite:
LADY PINK
Working on her wall at
Primary Flight.

MAKING IT: MATERIALS
I work in different media when I paint indoors or outdoors. For interior murals, I use interior-latex paint, brushes, and sometimes an airbrush. When painting outdoors, I use exterior-latex with rollers and brushes and top it off with spray paint; it's always oil-based enamel. We prefer the European spray paints over the American paints because of quality and color selections. European paintmakers market to artists, while the American manufacturers are anti-artists, the paint sucks so badly it's practically unusable.

FIND MORE: 5POINTZ
5Pointz is a building in Long Island City, Queens, that's a "legal" wall, available for people to paint, located across the street from P.S.1., the contemporary art institute. It's called 5Points because it's intended as a place that artists from the five boroughs of New York City can come and paint. Hundreds of artists have worked on the walls, and this outdoor gallery is constantly mutating; it's a unique showcase for changing styles, and a place to see work by both newcomers and big names. 5Pointz is, however, strictly enforced; you can only paint there by permit, which you have to obtain by emailing this address: meresone@aol.com

DATA FILE: LADY PINK
Lady Pink was born in Ecuador, and grew up in New York City. She started writing graffiti in 1979, painting subway trains until 1985. With a prominent role in _Wild Style_, the 1982 movie about the scene, her position as an iconic member of the movement was guaranteed. She started exhibiting paintings while still at school, and now her work is included in the collections of the Whitney Museum, the MET, the Brooklyn Museum, and the Groningen Museum, in the Netherlands. Today she runs a mural-painting company with her artist husband, Smith, creating massive works around New York City, and beyond. Pink has mobilized artists to donate public art within culturally neglected communities, and shares her years of experience by way of mural workshops for kids and tutoring college students.

www.pinksmith.com

STREET ART ACTIVISM

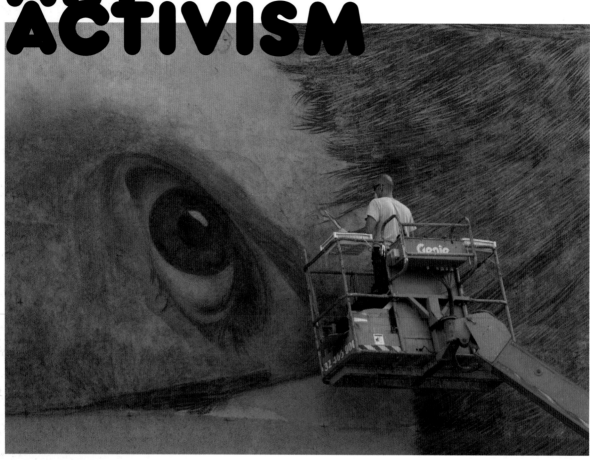

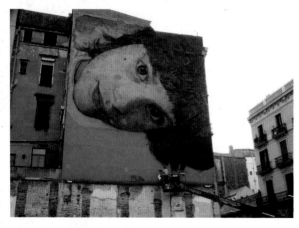

All street artists have something to say; some artists though, are more explicitly political and campaigning.

Here, three very different artists explain their unique techniques and their social and cultural motivations.

JORGE RODRIGUEZ GERADA AND "IDENTITY"

Are your pieces "legal" or "illegal?"

In Europe I no longer use advertising logos, images, or billboards. I wanted to focus instead on the universal themes and effects of advertising, and be critical of the marketing that has crept into so many facets of our lives; to use the codes of advertisers (scale, visibility). I wanted these new iconic drawings to be huge and placed in city centers, so that the need for permissions and permits became apparent early on.

Do you encounter different reactions from the public and the authorities, when you're working in different cities?

Once I was doing illegal billboard alterations in Jersey City, New Jersey, and I was arrested. The police later let me go because they agreed with me after I explained my reasons. Cheap malt liquors were a problem to the police that were patrolling the neighborhoods where I did my culture-jamming. With the "Identity" series, I now have cities around the world inviting me to make my interventions. The police still come by to ask me why I am doing what I am doing but we don't have to talk about it at their headquarters. →

SOURCE BOX: CULTURE-JAMMING

What first prompted you to make art in the streets?

When we set up Artfux we figured that there were many issues that could use media attention and all we had to do was "spin." We focused on the disproportionately high amount of damaging products (get-drunk-quick beverages and menthol cigarette brands) being advertised in poor areas. We had a clear goal and plan of action; we illegally altered tobacco or alcohol ads with new statements and images that spoke about the negative effects of these products. We sent out press releases with photos of our exploits, and received massive attention; every time a newspaper, magazine, or newscast let us stand on our soapbox to address these social ills, it was a victory.

MAKING IT: LARGE-SCALE DRAWINGS

Working on such a large scale, how do you plan an image and transfer it from your original portrait?

I go from a small photographic portrait to the final large drawing on the wall. I measure the wall and then do ratios to get the proportions correct. When I started conceptualizing the "Identity" series, I tried to avoid having to do academic drawing on such a large scale. After trying other directions and media, the only one that blended skill, effort, and visual poetry was charcoal. It's strange; I can make a huge portrait in the street in four days, but a much smaller piece of work in the studio takes me a lot longer.

Opposite:
JORGE RODRIGUEZ GERADA
Emma from the "Identity" series; drawn in charcoal in Barcelona, Spain.

The charcoal drawings raise questions about permanence and time passing; you could make them using more permanent media. Why do you choose to let them fade by working in charcoal?

The charcoal fades away and becomes a memory, like the warmth after an embrace. The blending of the charcoal and the wall surface with the wind and rain, or the sudden destruction of the wall, is ultimately the most important part of the process. My intention is to have identity, place, and memory become one. The amount of work that I do impresses people because all of a sudden they have an icon that is confirming the importance of their existence. But it is also jarring because we have become unaccustomed to think that it is worth doing a lot of work unless it fills our pockets with cash.

When you decide to showcase a person from a neighborhood, do you hope to influence the viewer's understanding of that neighborhood? Make it more human, or safer?

My idea is to show that we should all be seen with dignity. I believe that our identity should come from within, not from the brands that we wear. We should question who chooses our cultural icons and role models, our values and aesthetics. We are living in a time when corporate manipulation has become very refined. "Terrorist" manipulation is based on the premise that the individual is considered dispensable in order to change the thinking of the larger group. By giving importance to one anonymous life I want to give importance to empathy.

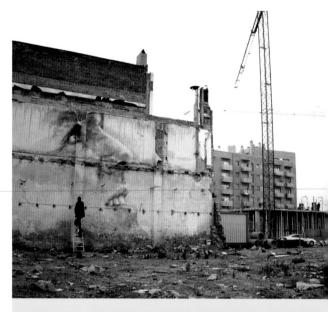

DATA FILE: JORGE RODRIGUEZ GERADA

Born in Santa Clara, Cuba, Jorge Rodriguez Gerada grew up in New Jersey, and now lives in Barcelona, Spain, with his filmmaker wife and collaborator, Ana Alvarez-Errecalde. Along with fellow students at New Jersey City University, Jorge founded Artfux, which brought culture-jamming to New York City. Artfux were included in Naomi Klein's book, *No Logo*, and mentioned in legal testimony, thus helping to bring about the banning of tobacco billboard advertising.

www.artjammer.com

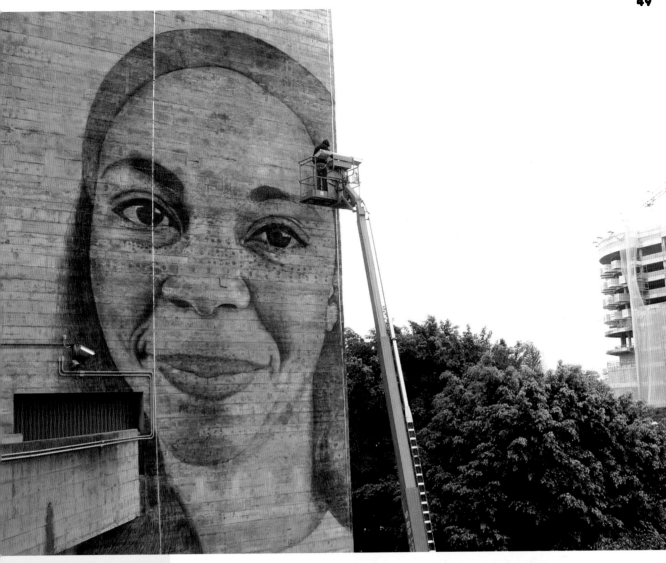

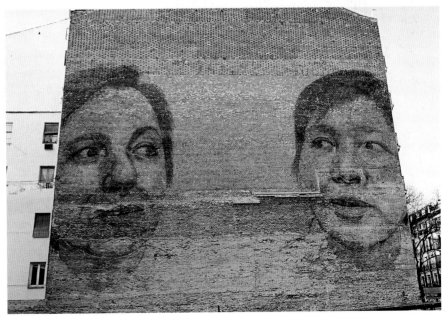

Opposite left:
JORGE RODRIGUEZ GERADA
Jordi in Barcelona, Spain. Making
art on a demolition site.
Above:
JORGE RODRIGUEZ GERADA
Sandra in São Paulo, Brazil.
A giant drawing in progress.
Right:
JORGE RODRIGUEZ GERADA
Raquel and Maria in Madrid,
Spain. A double portrait.

DATA FILE: ALEXANDRE ÓRION

Born and bred in São Paulo, Brazil, Alexandre Órion spent time at college studying for an Arts degree, and out on the street, painting graffiti. He is a self-taught photographer, and works as an illustrator for a number of Brazilian publications. He avidly documents his home city, and has developed a working method that combines photographic imagery and mark-making.

www.alexandreorion.com
www.ossario.net

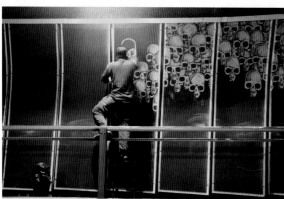

ALEXANDRE ÓRION AND "OSSÁRIO"

Raising awareness about pollution in the city, using a recognizable icon, the skull, and painting "without paint," the Brazilian artist Alexandre Órion made his local government take notice, and got startling results.

How did you come up with the idea of "reverse graffiti?"

The idea emerged around 2005. The municipality of São Paulo built a tunnel, and in a short time, its walls were completely covered by soot. It bothered me and I decided to make "Ossário." The name refers to archaeological sites; I wanted to bring a catacomb from the near future to the present, to show people that the tragedy of pollution is happening right now. All the skulls were painted by hand. I spent 17 nights working on them, averaging six hours in each shift. And the result was an intervention over 300m [c. 984¼ft] long, with more than 3,500 skulls. The skulls belong to all of us.

What sort of reaction did you get when you were working?

Every night I was working, there were at least five contacts, some with the municipality's Traffic Department, others with the State Police. But the authorities could not stop me using the city as a space for expression, because what I was doing was selective cleaning. There is no crime in cleaning. The crime here is against the environment, it is a crime against life. As I expected, the State did not let the matter rest there. What would really have prevented me continuing would have been if they removed all the soot. The State's intention was to just remove the intervention. But since the raw material was still there, I came back with more provocation. The municipal team turned up to clean the whole tunnel. Now, all São Paulo tunnels are cleaned every month.

How do you mix the two worlds of working in the urban environment and having gallery exhibitions?

The power of capital defines the territories of a city and the profiles of its inhabitants; it places boundaries between periphery and center. Not everybody is welcome in public spaces, or in galleries and museums. No matter how much the situation seems to be against this, I believe all space is public. The most severe challenge facing contemporary artists is existing between the world of the street and the world of the galleries. In as far as we break down social barriers, we are broadening the horizons of art.

MAKING IT: PAINT FROM POLLUTION
How did you develop your method for collecting soot?

Basically, paints consist of pigment and binder. The idea of collecting the soot during the *Ossário* intervention emerged from the possibility of it being reused as pigment. Initially, the work proceeded by subtraction and subsequently by addition. With the rags used for the design on the walls of the tunnel, I collected soot. Then I washed the rags, waited for the soot to decant and the water to evaporate, until all that is left is the black soot that comes out of vehicle exhaust pipes. This apparently useless but toxic substance was then mixed with a binder to make the dark paint.

Opposite and below:
ALEXANDRE ÓRION
"Ossário." While "cleaning" a design onto the walls of a tunnel in São Paulo, the city council eventually acknowledged the need to jet-clean the entire tunnel.
Above:
ALEXANDRE ÓRION
Large-scale painting made using a pigment distilled from pollution; "Ossário" features imagery ironically celebrating the culture of motor transport, trucking, and the open road.

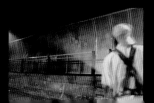

**DATA FILE:
ROADSWORTH**
A native of Montreal,
Canada, Roadsworth's
interest in visual art
started early; his
mother is an artist,
and he later trained
as a musician. His
work is politically
and environmentally
motivated—he takes
the actual road surface
as his canvas, altering
road markings to create
thought-provoking
symbols. A high-profile
legal battle saw
Roadsworth championed
by art lovers and
citizens alike, and
a truce was struck
between him and
Montreal's city council.

www.roadsworth.com

**SOURCE BOX:
ROADSWORTH**
The first stencil I
made was a bicycle
symbol, because
I've always been a
proponent of cycling
in the city. I was
inspired by Andy
Goldsworthy, to whom
the name Roadsworth
is partly an homage.
I was also inspired
by graffiti, or "post-
graffiti" culture;
cartoons, comics,
and language.
Roadsworth is also
a tongue in cheek
reference to the poet
Wordsworth, as I
feel that my work
functions, at least
formally speaking,
in a similar way
to poetry.

Opposite top:
ROADSWORTH
Dandelions
Opposite bottom:
ROADSWORTH
Footprint

ROADSWORTH

**Inspired by political beliefs to create art in the
space beneath our feet, Roadsworth subverts
street markings to create unexpected beauty.**

Where did the idea for the street markings come from?

Street markings, like the asphalt on which they
are found, are ubiquitous and universal. They
represent a language that is very functional,
dry, and almost authoritarian in tone, but
simultaneously pristine and nondescript,
thereby providing an irresistible opportunity
for subversion and satire. In most cities the walls
are often saturated with graffiti, but the asphalt
remains untouched as if it were sacred. If
capitalism is the religion of our time then the
automobile is one of its most potent relics, and
the road its medium. There is a quasi-religious
devotion to consumerism, and car culture is
its epitome.

Consumer habits are so widespread and
consistent that they are rarely questioned,
despite the undeniably dire consequences that
current levels of consumption seem to indicate.
The more roads there are, the more cars there
are. The more cars there are, the more need for
oil there is. The more need there is for oil, the
more weapons are needed. This is a simplistic
assessment of the situation, but the point is,
the road and its particular language (i.e. street
markings) is loaded with significance and
therefore ripe for reinterpretation. And because
the road seems to take itself so seriously it is
also a tempting target for satire. →

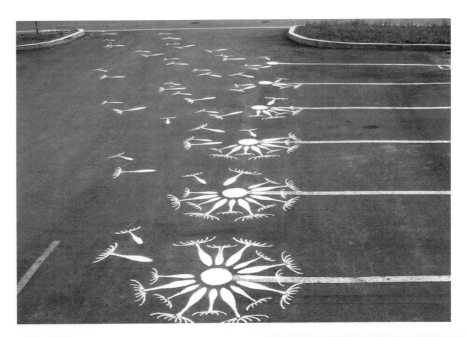

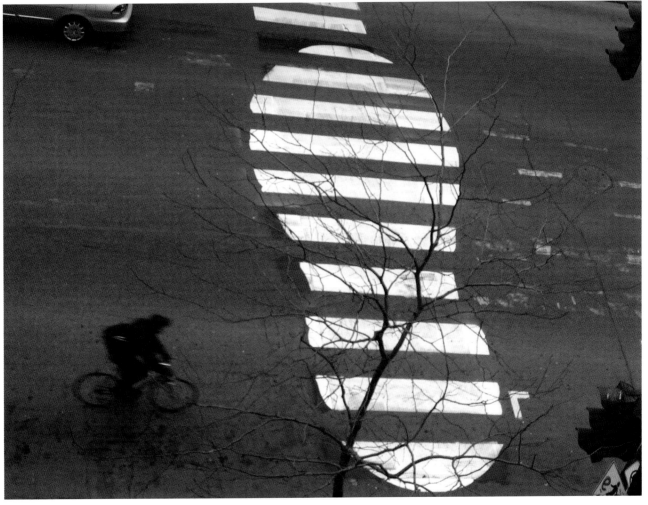

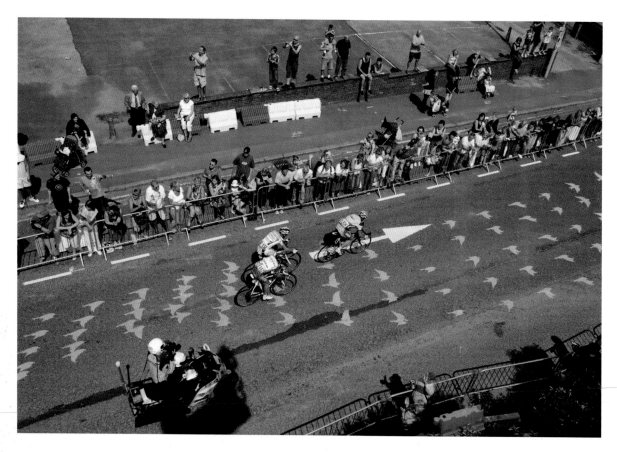

Are road markings your preferred output as an artist?

The stuff I've done on the ground, whether directly on the road, in parking lots, or in other public places, parks, and squares, represents the bulk of what I've done. There's a tendency to become typecast, the "asphalt specialist," so I get hired to do that stuff. I like the idea of people having to walk over my work to experience it, and because there is so much asphalt in the world there are a lot of potential opportunities for working on a large scale.

How did the *Tour de France* project come about?

I was contacted by the curator, Michael Pinsky, who had heard about me. He felt that my work fitted with the theme of the project he was coordinating entitled "The Lost O Project," which assembled artists from around the world.

The project inaugurated the transformation of a ring road from a car-only road to a multiuse road, where cars, bicycles, and pedestrians coexist. The art project coincided with the start of the Tour de France. My contribution was a reference to the concept of the "peloton," and the dynamics that govern it. Cyclists move in a sort of pack, and a certain amount of cooperation goes on within that pack, even between rival teams. Similar principles exist in nature, within a school of fish, a herd of zebra, or a flock of birds, which move in groups as a means of confounding potential predators and conserving energy. A flock of birds seems particularly evocative of this notion, and I liked the idea that the piece could be experienced by moving across it at speed. The viewer, whether on a bicycle, in a bus or car, participates in the illusion of movement that is created through his own movement. The piece reflects the human traffic, and the large bird population of Kent, in the south of England, where this piece was painted.

Above:
ROADSWORTH
Tour de France, Royal Tunbridge
Wells, UK.
Opposite:
ROADSWORTH
Male Plug

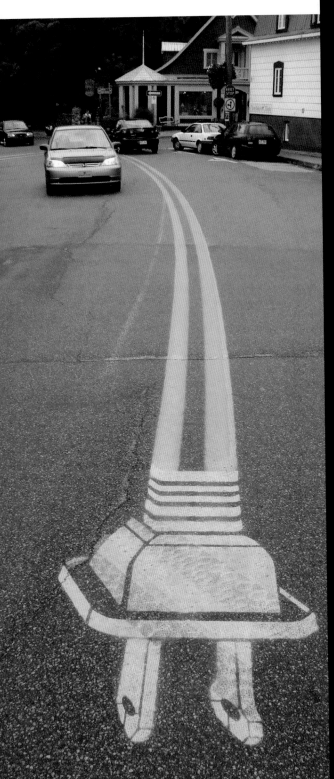

MAKING IT: STREET MARKINGS
How do you make your road markings?
What sort of paint do you use? How is it
applied to the road surface?

I make the road markings with stencils that I
cut from cardboard with an Exacto knife, or from
Masonite using a circular saw. In some cases
I draw the image directly onto the cardboard or
Masonite, while in other cases I draw the image
onto a sheet of acetate, which I then project onto
the cardboard or Masonite with an overhead
projector. For very large-scale pieces, where
stencils are not practical, I will sometimes draw
the images directly onto the ground with chalk,
tape off the drawn lines, and fill it in with a roller
brush and paint. The paint I use most often is a
traffic paint (the same that is used to paint road
markings by city councils). It comes in spray
cans, which I use in conjunction with stencils,
and in gallon canisters.

How much planning goes into one of your
road interventions?

Most of the planning involves thinking about
a concept and then matching it to preexisting
elements such as road markings, sewer covers,
cast light, shadows, etc. The conceptual aspect
involves a period of reflection on various themes
and ideas, and the act of integrating it within a
preexisting pattern is another. The latter often
involves some sketching to imagine the image
within a given setting, and some basic math
to match the dimensions of the image with
the "host" (road marking, sewer cover).
Commissioned pieces often involve more
planning because they are larger scale and
more specific.

URBAN EVENTS

BEST
IN
SHOW

VÅR

Painting with light, creating a spectacle, and leaving no negative trace; imagery on a giant scale can bring a city, and its buildings, to life.

Here, Karl Grandin of Vår explains how the Nightlife Event came about.

I originally drew the smiley-eyed owl for a T-shirt for friends, in an edition of about 10 prints. I was invited to take part in ArtBeat, a street art event sponsored by Red Bull, during the Amsterdam Museumn8 (Museum Night) in 2005, and I suggested using the Nightlife Owl. ArtBeat was a "guerilla" contribution to the official Museumn8, bringing a wide range of national and international street art and new club culture to the public. The all-night event included workshops, live art, installations, exhibitions, performances, and a street art cinema programmed in cooperation with Aaron Rose. During the event, art was beamed onto large buildings in Amsterdam with the help of the Skudi Optis crew from Berlin. The Nightlife Owl was projected onto the side of the Stedelijk Museum/Post CS building during the night.

DATA FILE: VÅR

Vår is a Swedish word meaning both "ours" and "springtime," and is the name of the partnership of Karl Grandin and Bjorn Atldax. Based in Stockholm, Sweden, but active worldwide, they work in a wide range of media, with clients including the Hove Music Festival (Norway), Sixpack (France), and art direction and design for the revolutionary jeans brand, Cheap Monday. Their artwork has also been featured on book and album covers, fabrics, posters, furniture, walls, and in magazines and movies, and has been exhibited in Europe, Asia, and the USA.

www.vaar.se
www.karlgrandin.com
www.cheapmonday.com

FIND MORE: GRAFFITI RESEARCH LAB

If you want to work with light, on a big scale, check out GRL (Graffiti Research Lab). A guerilla network, with pockets of activity around the globe, GRL are "…dedicated to outfitting graffiti artists with open source technologies for urban communication." Their favored tool is the laser-light pen, hooked up to a powerful projector, which they roll up to the parking lot of a tall building and "tag" with light. Recently invited inside New York's MOMA by curators Paola Antonelli and Patricia Juncosa, a whole array of artists worked on the hallowed interior; the plus point that they are all now "sanctioned" artists blurs the lines between legal and illegal, even more. Breathtaking, simple, and temporary…check out the results online.

www.graffitiresearchlab.com

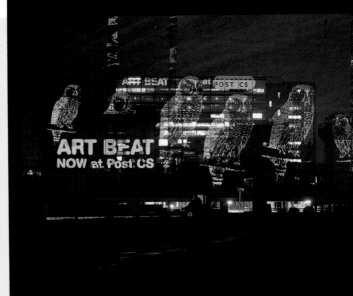

Opposite:
VÅR
Poster for the Nightlife Event.
Above:
VÅR
Nightlife installation, Amsterdam, the Netherlands.

DRAWING: DIFFERENT STROKES

CHAPTER TWO

Fine-tuning techniques and amassing influences and source material are central to any image-making practice. These street artists explain how they get started with a new piece, and how they've evolved very different drawing techniques and ways of collating and combining influences and material into new images.

IAN STEVENSON

Sometimes I know what I'm going to draw and other times things just happen. I enjoy thinking up ideas when traveling, as it's a good time to focus. Then when I'm back with the pens I can draw the idea.

What are your favorite pens?

I use many pens and they are all good for different things. Uni Poscas draw on most things and are great for doing large-scale work.

Apart from your sketch book, what do you draw on?

I walk around the streets and see what's about. Every object I find is different, and then I bring it to life in its own individual way. I enjoy that it's immediate and that the ideas cannot really be planned. Then when people walk by and see the characters, they may think about rubbish differently.

DATA FILE: IAN STEVENSON
Ian Stevenson worked as a designer and animator before realizing that computers were annoying, and turned to his felt tip pen for salvation. Now, he sits in front of daytime TV with a sketchbook on his lap, letting his pen wander with his mind. Occasionally, he ventures outside of his London home to eavesdrop on conversations, which also find their way into his sketchbook. He's recently been dubbed "an unlikely eco-warrior" for his practice of drawing on discarded objects found in the street, thus instantly turning them into desirable artworks.

www.ianstevenson.co.uk

Opposite and above:
IAN STEVENSON
Rubbish Art. Drawings on found objects in the street.
Top:
IAN STEVENSON
Lost Heroes; limited-edition postcard book, in collaboration with Concrete Hermit.

CANIS SERVO REGINA

D*FACE

<u>Do you start with ideas in a sketchbook?
How do you approach making a painting?</u>

Always an idea first—a thought, a reaction—that
goes into a sketchbook as a rough drawing or
even just a note, a line of text. Then I'll work it
up into a more refined piece that may use
many different elements, including sourced
imagery, drawings scanned and vectorized,
and composed. These, more often than not, are
then set as screens to be printed in my studio.

<u>Over the last few years your work has
evolved and become much more ambitious;
tell us about this change in your work.</u>

I've always tried to push what I'm doing, and
take it to the next level. It keeps me on my toes
and creatively fulfilled. I enjoy the challenge of
figuring out new techniques, either old or new.
I also want to push what people have come to
know as street art. To me it's art, and important
that it keeps evolving. When I create a canvas or
gallery piece, I think, "Could this sit alongside

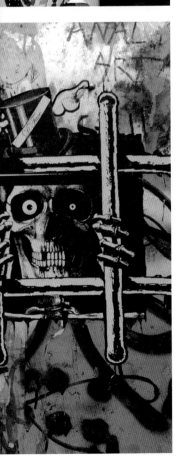

artwork from any era and hold its own?"
If I think it can, then I've achieved what
I want from my work in a gallery environment.

There is a theme in street art, one that you employ sometimes, of using already iconic images and appropriating them, or subverting them. What is it about this side of street art that attracts you?

For me, it relates to the familiar imagery that I was surrounded by as I grew up, in our cut-and-paste society. So, it's a backlash to the media and the public's fascination with celebrity and fame. People can instantly relate to the imagery, but by subverting it you release it and give it a new lease of life, direction, or association.

Hopefully, those works alter people's perceptions, or at least get people to question them. When I was subverting bank notes, this all fell into place and created a new direction for my work; having the Queen poking her tongue out, with wings sprouting from her head. It was like I was taking her over. It gave a literal meaning to my name, D*Face. That was a turning point, as it spawned so many ideas and directions for me.

Are these subversions making serious points or are they simply a bit mischievous?

It's tongue in cheek; I just want people to laugh to themselves. I don't always want to burden people with heavy political issues; I'd rather lighten their day than darken it!

There are elements of my work where I do purposefully make harder hitting statements, the *What Wars Are For* piece for example; I felt it needed to be visually articulated.

But I like to make people smile or frown, see it come full circle. They're just subversive intermissions from the media-saturated environment that surrounds us. So, these statements have become bolder, bigger, more ambitious, and perhaps more refined, but the motivation is still the same. I've always wanted to make work that communicates to the masses, not the minority.

DATA FILE: D*FACE

Top:
D*FACE
Canis Servo Regina. Another example of D*Face cleverly positioning his stickers and prints to employ "found" surface textures in the composition.
Bottom:
D*FACE
Skeleton Key. D*Face uses the urban environment to maximize the impact of these images.

MYSTERIOUS AL

When drawing and animating, Mysterious Al takes his favorite comic characters as inspiration, using them to tell his own story.

How do you go about taking an iconic character and tweaking it?

For me, the most important parts of reworking an iconic character are picking the right character, and doing it justice. The Incredible Hulk was always one of my favorite Marvel characters as a kid, and I thought he'd been having a tough time recently. He'd been overlooked for years, and then had, in my opinion, a terrible movie made about him. I always sympathized with Bruce Banner (the scientist who became the hulk after a freak accident in his lab), because he never actually liked being the Hulk and was constantly looking for a cure. He spent a large portion of his life alone and angry... And I can totally relate to that.

Tell us about what influences you? What goes into creating your "visual language?" Do you collect stuff?

I collect skulls, glow-in-the-dark toys, B-movie paraphernalia, collective nouns, and Scottish folk music. All of my work is autobiographical, so absolutely everything in my life, be it positive or negative, influences my work in some way.

What materials, techniques, and tools do you use to make your artworks?

These days most of my working process is digital; it's split into 80 percent digital, and 20 percent drawing, painting, or mark-making of some sort.

DATA FILE: MYSTERIOUS AL

Mysterious Al was an original member of the Finders Keepers team, who staged impromptu "making it and giving it away" outdoor gallery events in London, with the location only revealed at the last minute by email. He studied Fine Art Painting at Falmouth College of Art in Falmouth, UK. Now based in London, he draws, animates, and films live action for a living. Commercial projects include clients such as telecom company Orange, via agencies, 1Db, Thunderdog, Poke, and Mother.

www.mysteriousal.com

Opposite top:
MYSTERIOUS AL
Al Symmetric. Self-portrait as
a character.
Opposite bottom left:
MYSTERIOUS AL
Sulk. The personality of the Hulk is
explored by Al, in this rerendering
of a comic-book character.

Opposite bottom right:
MYSTERIOUS AL
Thing. Another superhero
is transformed by Al.
Above:
MYSTERIOUS AL
Marilyn. An icon of both cinema and
the art world—as painted by Andy
Warhol—is appropriated and adapted
with Kiss-style makeup, tears, and
paint drips.

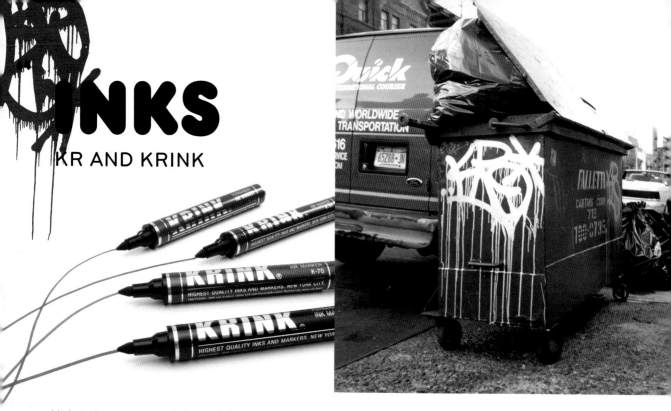

INKS

KR AND KRINK

Krink is a super-drippy ink, specially formulated by artist KR, for use on any surface. First launched in distinctive silver (there was no mistaking it!), now it's available in black and a range of new colors, packaged in bottles, applicators, and pens.

"Krink 'changed the look of vandalism' in New York, an expert on such matters, known as Earsnot, told *Juxtapoz* magazine not long ago."
Rob Walker, *New York Times Magazine*

Here, KR (AKA Craig Costello), the inventor of Krink, tells how he did it.

How and why did you invent your own ink, Krink?

I started making Krink as a tool for writing graffiti. I wanted something that was unique and that stood out among all the other styles and materials used in the street.

At the time, a big part of graffiti writing for me was creating my own way. Steal or make materials, steal the spot; everything was free, everything was a risk. Innovate, but maintain an attachment to the traditions of where I was from, New York City. I was much younger then and these ideas informed a large part of my graffiti and my style at the time.

Krink wasn't about being a brand or a business. I was making Krink and writing in the streets for years before I made it available to the public. If you told me back then, "Hey, you could sell this, people like it and the ideas behind it," I would have thought you were crazy.

The "how" was about experimenting. I had an idea of what I wanted; I just kept trying new things until I found what worked.

How did you choose, develop, and design the different packaging and applicators?

Form follows function. The function of the ink, markers, and pens dictate their design. First and foremost, they are tools and have to work well. They also need to perform the way I want them to. I make products that perform a little differently from what you find in a regular art store.

The packaging was originally done in collaboration with Alife [a clothing store and gallery on the Lower East Side]. They really helped me a lot; I was still new to using computers and layout. From the start, I knew I wanted something clean and simple. No graffiti references. Krink is about creating what you want. While it's good for writing in the streets, it's not limited to just that. I wanted the packaging to be open to everyone. I want the end user to choose to make whatever they're into and know they are using high-quality tools and materials.

Do you customize your own applicators?

It's funny, when I was younger and writing graffiti, I used to take apart existing markers and various product containers, and modify and refill them with homemade ink concoctions, to make something that was better suited to my specific needs. I didn't know it then, but what I was making and doing with these new or modified tools was so successful that other people became interested, and that is how the brand started. I design and test all the packaging and applicators.

You've recently expanded the Krink range with new colors and applicators. How did that come about?

After bringing Krink to the market, I found there was a demand for a more diverse product range. People really liked the idea of what I was doing, but the original ink and markers are a little too big and bold for most people. I have been expanding the line of Krink products, to evolve the way I have evolved. While I have a history with graffiti, I am not limited to just graffiti and neither is Krink. It's about expanding ideas and creativity.

People relate to and want to support small businesses. Krink has a history and style that is very different from a large, corporate conglomerate. The trend is toward brands that have something that people can relate to, and away from run of the mill things anyone can get at their local megastore. All our products are made in the USA; we support the local economy and we are able to communicate very easily with our production team. It costs a little more, but we are about quality.

Do you use any other paints and inks in your own artwork?

Yes, I use latex paint and other inks. I'm open to anything; it's all about the right tool for the job.

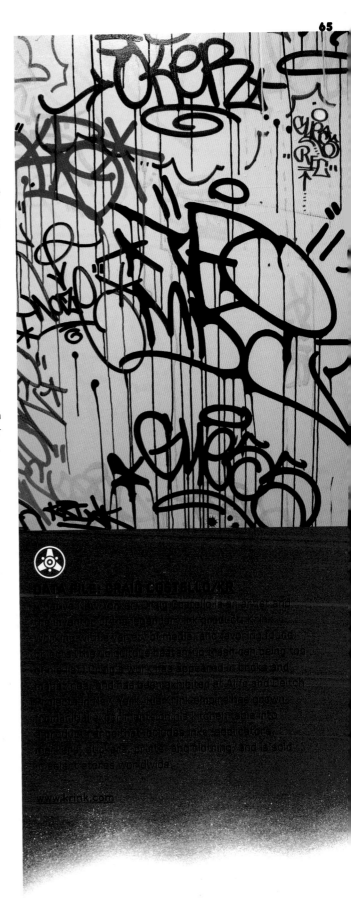

DATA FILE: KR AND KRINK

KR lives in New York City. Craig Costello, an artist and entrepreneur, is the man behind the ink product Krink. KR works with a variety of media, favoring found spaces, and he is equally at home spraying top to bottom trains. KR's work has appeared in books and publications, and has been exhibited at Alife and Deitch Projects in New York. KR's Krink empire has grown from a DIY experiment, turning a kitchen table into a product, into the production of his inks, applicators, markers, paints, sprays, and coloring, and is sold in select stores worldwide.

www.krink.com

Opposite left:
Krink marker pens.
Opposite right:
KR
Tagged and drippy dumpster
in New York City.
Above:
TEO, KR, DAZE, OKER
Tagging collaboration.

SPRAY PAINTS AND NOZZLES

The spray can has been integral to the development of graffiti and street art, not just in the scope and limitations it imposes as a paint delivery system, but also as a tool for measuring. When writers first ventured into train yards, they didn't take set-squares and protractors with them. The spray can was used as a guide to the trueness of their line. The straight edge of the can itself was used when determining outlines and borders.

Over the years, the can and nozzle have developed a mythic status; discontinued colors are talked about in hushed tones; the knowledge of nozzles and the different spray effects they produce is encyclopaedic, and jealously guarded. Finding and manipulating the right nozzle, to create a certain type of line or mark, is a skill in itself.

Top:
"Krylon cans were the best of the old school paints, other than this we used normal car paints. Stolen of course..." David Samuel.
This page and opposite top:
From Nick Walker's collection of used caps.
Opposite right:
Be prepared to make a mess.

DATA FILE: NICK WALKER

Nick Walker is a veteran of the Bristol graffiti scene and one of the UK's best-known graffiti artists. A pioneer of stencilling, Nick's work has covered many different themes, from dystopian sci-fi landscapes to erotica, and studies of the tools of the graffiti artist's trade.

web.mac.com/nickwalkerz

SOURCE BOX: NICK WALKER AND ORIGIN OF THE SPECIES

Nick Walker tells of trips to New York, with his long-suffering girlfriend, that are punctuated by stop-offs at hardware stores. He'll buy all sorts of aerosol items, from cleaning fluids to lubricants, just to acquire the nozzles, bring them home and discover what sort of effects they produce.

His love of the tools of his trade has become a source of inspiration too. One regular collector enquired about purchasing the installation in progress on the floor of his studio. Nick asked, "Installation? That's just my floor!" That got Nick thinking about the large jar of used nozzles on a shelf in his studio, and the beauty of this discarded detritus, the result of the painting process. For Nick, each nozzle held a story, a key to a past painting, with layers of color sustained from hours of use. He began to photograph these nozzles, producing large-format images, as giclée and durotran light-box prints. The project, "Origin of the Species," is a testament to the role that the humble nozzle has played in his life and career.

Above:
Belton Molotow can.
Below:
Spray paint cans used at the "Open Studio" event in London, UK.

MAKING IT: DAVID SAMUEL ON USING SPRAY CANS AND NOZZLES

Selling all sorts of paint and nozzles through The RareKind Gallery, David Samuel gives his opinion on the street art staples: spray paint and nozzles.

Do you find that artists and writers have favorite brands and colors?

Most writers have always had a preference, since the days of using car paints. Now spray paint is made especially for us to paint with. The main brands are Belton Molotow, MTN, and Montana.

What are the special qualities of the different brands?

Belton Molotow is the best, the color range is amazing, you can work with three or four caps easily with no complications, the color is flat matte, and the pressure is perfect.

Can you identify the actual paint used in different artworks?

With my eagle eye and nerdiness for graffiti, I can name most brands, even the car paints...

Tell us about your preferences for materials and techniques too.

Belton Molotow is my chosen brand, alongside a stock cap, black dot, and a banana cap.

Different writers/artists use nozzles from different aerosol products to customize their spray cans. How can nozzles be tampered with for various effects?

Years ago, we used to take nozzles off all types of products, oven cleaner, hairspray, and more. We would heat up pins and stick them in the nozzles to make them wider, and stick Stanley knife blades in them, to make "italics." Nowadays, we have a selection: fats, ultra fats, soft fats, mediums, medium fast, medium soft, skinnys, black dots, gray dots, NY fats, German fats, italic... loads and loads.

www.rarekind.co.uk

STOCK CAP **BLACK DOT SKINNY** **BANANA CAP** **FAT CAP**

Above:
Caps and the marks they make. "These are my favorites. Stock caps, the black one—good for sketching and quick tags. Skinny caps, the black dots, perfect for outlining pieces. Bananas, gray cap, perfect for filling pieces. Fat cap, pink dot, used for quick filling and covering large spaces." David Samuel.

Below:
"This cap was made by a Brazilian called Ramone—he paints the maddest shapes and bunnys. He outlines every line he paints with this cap, making everything stand out. His style reminds me of old school acid rave flyers. He makes them from caps from household products and a syringe. Syringes come in different sizes, -5 to +10, and he uses different ones for different effects. I've never seen a cap like this, absolutely amazing, it produces the skinniest line." David Samuel.

FIND MORE: PAINTS
All the paint brands have really useful websites, which include information about techniques, usage, and stockists. Brands especially formulated for artists include:
Molotow www.molotow.com
Monster Colors www.monstercolors.com
Montana Cans www.montana-cans.de
Montana Colors www.mtncolors.com
Sabotaz www.sabotaz.com and www.sabotazusa.com

These sites stock a wide range of materials and tools for artists:
www.blackbookstencils.com
www.bombingscience.com
www.theseventhletterstore.com
www.turntablelab.com
www.fourthehardway.com

PAINTING: MULTIPLE MARKS

Paint is the stuff of painting. Experimenting with all kinds of paint, and the surfaces and objects they put it on, is second nature to street artists, for whom found surfaces are a fact of life when painting out of doors. Back in their studios, they continue to experiment, often combining different types of paint (from fine art materials to hardware store stock); other mark-making media (pastels, pens, crayons, and more); technology (computers, laser printers, ink-jet plotters), found paper, and fabric, and all manner of surfaces and objects (from traditional canvas, to scavenged wood and metal).

Here, a cross-section of artists explain their techniques, offer some insights into their experiments, and demonstrate the super-varied end results achievable with paint.

DATA FILE: DALEK
Dalek lives in Brooklyn, USA. At college he took some Art History classes and started painting untutored. In the early 1990s, while living in Chicago, he became interested in graffiti, and began tagging and painting walls; which is when he adopted the tag name, Dalek. Featuring his Space Monkey characters (an influence from teenage years spent in Japan), Dalek's paintings are brightly colored, complex, abstract, and detailed, boasting an incredible surface finish; and have been exhibited worldwide.

www.dalekart.com

DALEK
Dalek's obsessive imagery and pristine surface are unmistakable.

How do you describe your technique?

PreGeoArchitexturalComtoontasticAbstraction.

Why do you work on board as opposed to canvas?

Canvas is weak. I work on top of a painting; lots of weight; lots of heavy erasing. Canvas would get shredded.

How do you achieve that super-slick, can't see the brushstroke, surface?

Takes a while; anywhere from six to 30 coats per color.

Opposite:
DALEK
Untitled. Paint on board.

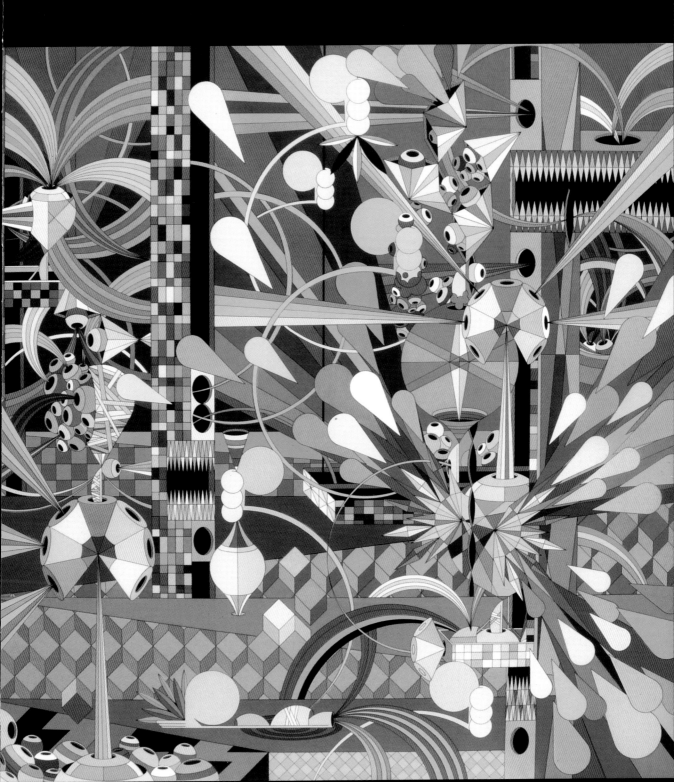

O.TWO

Using identifiable street art elements, O.Two has created a highly abstract and painterly visual language.

Describe your painting process and how it evolved.

The process comes from the tools in my hand, spray paint, permanent marker, brush, ink, or the cursor on screen. Mostly, it's aerosol paint. The pressurized contents of an aerosol make for a versatile tool, no surface is out of bounds. It evolved from painting illegal graffiti and having little time to communicate what I needed to get over. I stripped down the elaborate fill-ins and ornate motifs associated with conventional graffiti customs and worked on the typography. I approach a wall with an empty mind, and just let the surface bring out the piece. What goes up on a wall are the raw components of studied letterforms and gestures that have been made before, but they are always slightly different, calibrated for the space into carefully rehearsed acts of spontaneity.

How does working on canvas differ from painting murals and installations on a larger scale?

Working on canvas is different. Given more time, I can build up layers of information, so I'm left with a condensed form of what I might put on a wall, but on a much smaller surface area. I can't spend too long on a canvas piece, because it's easy to overwork things when you have the luxury of warmth, loud music, and light.

Why do you experiment with unusual surfaces?

I just apply my work to different surfaces, like I would without thinking about it on the street. Graffiti, by its nature, is layered onto all manner of surfaces, textures, and materials. In some instances I'm trying to replicate this, but in others it has more to do with the themes I'm working with. There's always scope to work on more than just the "flat plane" of a canvas; I work mainly in two dimensions, canvas, paper, vertical surfaces, and so on, but I'll paint whatever I feel is appropriate.

If I paint a skate deck, it's because I grew up revering them as a vehicle for art and for expression. If I paint a goat's skull, it's because I see it as a compelling surface on which to work. As soon as an artist adds paint to an object or surface they completely transform its purpose, meaning, and relevance, it becomes a vessel. Why do you think kids paint subway cars?

The mirrored pieces I paint are to do with ego and identity. A graffiti writer tags and writes pieces to see his or her work up as a reflection of themselves in a public domain; it validates their presence in the city. The mirrored film also suggests metallic surfaces, such as New York Subway cars. I didn't have the opportunity to paint the "6 Line," but that doesn't stop me from fantasizing.

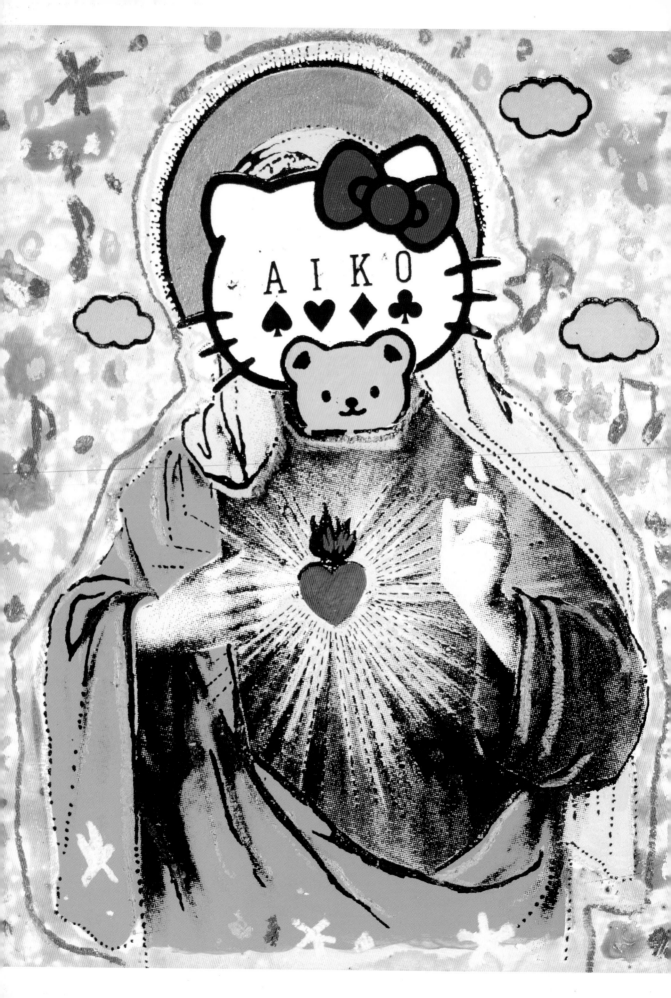

DATA FILE: AIKO
Aiko was born in Tokyo and currently resides in New York City. Being an immigrant from Japan, Aiko has been discovering American pop imagery and then recreating it in new and innovative ways. Aiko's work walks that thin, fragile tightrope between acceptance and disdain, beauty and danger, unconsciously mirroring the day-to-day life of an average Brooklyn resident. Since breaking out on the fine art scene she has exhibited in such galleries as Merry Karhowsky (Los Angeles, Berlin), Joshua Liner Gallery (New York), New Image Art Gallery (Los Angeles), Iguapop Gallery (Barcelona), and Leonard Street Gallery (London).

www.ladyaiko.com

AIKO

Collecting found images, and mixing them with unique surfaces and a wide range of media, Aiko produces one-off pieces for galleries, series of prints (for walls and the streets), and now, a jewelry range too.

You combine various imagery in your compositions, mixing visual languages from popular culture, from comics, children's books, cute illustrations, and vintage advertising. How do you collect your material? Do you have favorite sources for characters?

I have been traveling and collecting images from different sources. I really don't spend much money buying expensive books to make collages, mostly I find pieces of paper on the street, take pictures of classic signs, rip off wall advertisements, spend time in thrift stores in the countryside. All these images are part of my experience of everyday life.

The use of chaotic, multiple viewpoints in your work is unique; how did you develop this way of mixing imagery?

I mix culture, music, words, emotions into a canvas to create interesting stories.

The surfaces of your paintings look very "finished." How do you construct a painting? Do you work on canvas or board?

I work on different surfaces, I love adding texture onto a surface—paint, chalk, crayon, dirt, and oils—whatever I can use that I find around me. I work on canvas, paper, fabric, found wood, and found metal. I adapt to any surface, it creates interesting results in the street or the gallery.

Opposite:
AIKO
Kitty
Above:
AIKO
Bunny
Right:
AIKO
Wet Paint. Painted onto a cupboard door.

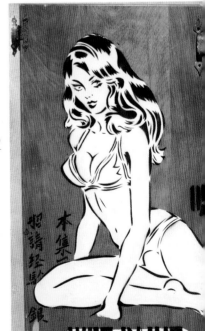

WET PAINT

KOFIE'ONE

An alchemist with paint, Kofie'One reveals the tools of his trade, which feed his unique aesthetic.

What materials do you use when you paint on walls?

American and European brands of spray paint, water-based house paints, and acrylics. I also use a variety of mini-rollers and foam brushes, but it truly depends on the wall, the surface, and its location. One of my key ingredients is the gray water I use for cleaning brushes and thinning out paints, it adds an aged look.

Do you work with other materials and techniques when you show in galleries?

I have different approaches with every medium I play with. I don't paint in oils, but I do paint in enamels when I work on found metal. My gallery work focuses more on my found paper assemblages, illustrations, and watercolors. My live art is usually produced using acrylics in a watercolor effect. My exterior pieces are primarily house paints, applied with mini-rollers, with some spray paint added for detail; it's all based on my ever-changing moods.

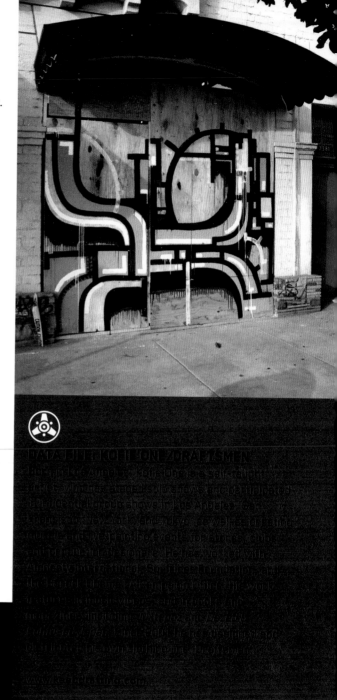

SOURCE BOX: KOFIE'ONE ON ARCHITECTURE, DESIGN, AND RETRO STYLING

I've always had a strong affinity with architecture and industrial design, but without wanting to pursue it in an academic manner, and my work obviously shows that. Generally, my work is a mash-up of the past and present; I'm influenced by retro design styles and techniques.

Above right:
KOFIE'ONE
Beverly Panels

BUFF MONSTER

You paint on wood and metal, and incorporate other elements into your artworks; how do you choose what to add?

It just depends on what I have at hand, and how much time I have to make a surface to paint on. I love heavy metal music, so it's fitting to paint on metal.

DATA FILE: PHIL
ASHCROFT/ZPHLASH
Having studied illustration
and graphics at Central
Saint Martins College of
Art and Design, London...

PHIL ASHCROFT

Having perfected a meticulous hand-painting style, albeit one that incorporated visible drips and brush strokes, Phil Ashcroft discovered digital image-making, and now combines the two, while still outputting via "paint."

Painting on canvas and board, Phil Ashcroft's images are extremely precise—he makes extensive use of masking tape to achieve straight lines and to render his trademark color-graded skies—while his subject matter is more tongue-in-cheek, influenced by a healthy obsession with sci-fi and horror.

Before discovering digital imaging, via programs such as Photoshop and Adobe Illustrator, he would paint and repaint canvases over and over again. The painstaking process involved photographing each stage; often he would retrace his steps to an earlier version.

"Now I work out the color and composition and save different versions, choose one and paint that. I like to keep the happy accidents that the Mac generates, but I also miss the mistakes I'd make while hand-rendering," he says. So when the hi-tech is feeling too finished, he swoops back to canvas and camera.

The differences between the canvas version and the digital image are, on first viewing, very subtle. But, as your eyes adjust they become marked. You begin to see the paint drips and small anomalies that could only be produced by hand.

Left:
BUFF MONSTER
Super Creamy Pink; acrylic, silk-screen, and spray paint on wood.
Above:
PHIL ASHCROFT
Yeti Over Mount Fuji

NURIA MORA

Combining geometry and pattern, found paper, and paint, the juxtaposition with surface is paramount to Nuria Mora.

How did you develop your aesthetic for your street-based works?

By working with the city surface, with all those lines that compose the city.

What materials do you use when working on outdoor walls?

Latex paint, masking tape, and some brushes.

The spots where you paint and construct are very atmospheric and aged; how important is the existing surface?

It is the most important part of my work. It's the first step; if the surface isn't interesting, I don't paint. The work is then given the opportunity to have another viewpoint—that of the passing pedestrian.

Tell me more about your 3-D pieces; what made you start building? Where do you find your materials from?

I wanted to show a new part of the same language. Working with Eltono, we were just transforming our 2-D works into 3-D pieces, but with the same meaning.

DATA FILE: NURIA MORA

Spanish artist Nuria Mora paints rural and urban walls, from the busy streets of Tokyo to deserted villages on the Atlantic island of Lanzarote. She has exhibited from Los Angeles to Paris, and collaborates with Eltono, Nano 4814, and Sixe in the group El Equipo Plástico.

www.nuriamora.com
www.equipoplastico.com

Top:
NURIA MORA
The headquarters of Tagtool in Austria, painted by Nuria.
Right:
NURIA MORA
Wall painting in Madrid, Spain. The found textures and architectural details of walls are crucial to Nuria's compositions.

**DATA FILE:
WILL BARRAS**
A founder member of
Scrawl Collective, Will
Barras exhibits all over
the world in solo and
group shows. Now based
in London, he studied
graphic design in Bristol,
UK. His distinctive
illustrative style is
unmistakable, but over
the years his paintings
have become increasingly
abstract, while still
retaining some figurative
elements.

www.willbarras.com

WILL BARRAS

Developing from drawing and graffiti to painting, through live painting events and working as a commercial illustrator, Will Barras shows how experiments in scale and media can feed a career that combines personal work with commissions.

From as early as I can remember, I always liked to draw, but all I drew as a kid were cars. I left college and began to get work as an illustrator. After a year or two I found that I was spending all of my time in front of a monitor.

My friends Steff Plaetz and Duncan Jago had begun to paint on canvas, and I also had some friends (particularly Damien Neary/Feek and Graham Dews/Paris) who painted graffiti. So I painted with them and began learning to use different media and work on a larger scale. I never really took to spray paint, but I enjoyed using pens and brushes and mixing it up a bit. As for subject matter, I was really into rap music, BMX, and snowboarding, plus I had been making flyers for club nights and started live painting in nightclubs.

Painting, as opposed to drawing, really started in nightclubs, where we would staple a load of card to the wall and paint live. Then I started trying to paint canvas, eventually working in interior and exterior spaces, while the commercial work helped me improve my drawing skills. I think over time you begin to develop your technique

Below:
WILL BARRAS
Cruel Sea
Bottom:
WILL BARRAS
Storm

and a narrative starts to form in your subjects. Commercial work pays my rent, and makes me a better draughtsman. Over time the personal work has meant that I get a different kind of commercial work now; I tend to have more open briefs and painting projects, so the two things feed off each other.

When I'm painting a large-scale mural, I usually start by making shapes and creating an abstract composition, which leads me to drawing objects, characters, and landscapes out of it, but, as time goes on I've started to mix this process up a bit."

TEAMWORK

The very nature of working on a large-scale project, whether an outdoor mural or a gallery installation, means that often, more than one artist is involved. Collaboration is an important part of street art activity; live painting events showcase a number of artists, literally jamming—making it up as they go along—intertwining complementary styles, remixing elements and introducing signature characters to each other!

Here, a team that often work together, Microbo and Bo130, talk about how they combine their creative obsessions.

MICROBO
A versatile painter, Microbo represents cosmic themes using a range of natural and found materials.

For two artists who paint and work together so much your styles seem very different. Microbo is fluid and organic; Bo130 is seemingly more rigid and planned. Would you agree?

We are different, which is good and complementary, which is really, really good.

When you paint together how is the process different from when you paint alone?

When you paint with somebody else it's a challenge because you have to think more about what you do. It's a completely different approach. You have to consider what the other painter likes to do, what palette of colors they use, and most importantly, you have to try and combine the different styles to create a harmony for the entire work, so that one painter can enrich the work of the other, and vice-versa.

This page top:
BO130
Mixed media on wood. Part of an installation at the Jonathan LeVine Gallery, New York.

This page bottom:
MICROBO
Avaricious Flu; mixed media on wood. Part of *The Neverending Story* installation at PAC, Milan, Italy.
Opposite top:
BO130 AND MICROBO
Visual Marriage; mixed media on wood, a collaborative painting.

BO130
What is your work about?

Aliens! About feeling like an alien!

Are characters significant for you?

I like faces; they're all the same and all different. The faces in my art represent people who are aliens in their hometowns, those who always feel out of place...like me.

Your paintings are getting more complex. Explain the development of your style over the years.

Constant evolution, constant research; some stuff is getting complicated, other stuff is getting simpler. I am still on a quest. Characters are getting less cartoon-y and more intense. I'm leaving space for other stuff, taken from what's around me, stuff that happens, inspirations, pop culture. I work in layers; different media and lots of layers; colors are everything!

Do you favor surfaces other than traditional canvas? What are your favorite materials to paint on and why?

I don't have any prejudice about materials; anything can work, you just have to look at it with different points of view and choose the right tools according to the material. Wood is probably the one I enjoy the most; you can shape it the way you prefer, it's strong and when aged wood has very interesting features.

You often paint with Microbo, but your styles seem very different. Microbo, fluid and organic; Bo130, more rigid and planned. Do you agree?

Strangely enough, I only plan a little. First, I try to visualize everything in my head. Then I start to plan the execution, but there is a lot of improvisation as the work progresses; layers get on top of each other and perhaps that gives a less "flowy" effect. In comparison to Microbo, I use a lot of printed material and type; that can give a less organic effect. When we paint together, it's all about micro and macro... OGM/Metropolitan/Pop Culture and Fanta/Microbiology.

Painting together, is the process different from painting solo?

For us, it comes in a very spontaneous way. Living and sharing everything together makes it the most enjoyable thing to do, and most of the time we're happy with the results. If it's a freestyle painting, you just have to be ready for everything; if it's a more specific project, you plan a little more.

STICKERS: ALL SIZES

Stickers have had a massive impact on the street art scene, opening up the aesthetic to simpler, smaller imagery, that is either hand-drawn, laser printed, or professionally produced. Stickers can be "got up" easily and quickly, so that leaving your mark is a lot simpler and less dangerous to detection. The "guerrilla" tactics of stickering caught the imagination of advertising and branding professionals who sometimes commission campaigns from sticker artists, and sometimes, simply ape what they see.

Below:
D*FACE
Pop Tart. One of D*Face's most popular prints, this time displayed on the street free of charge.
Opposite top:
D*FACE
Boat Race. D*Face has been steadily increasing the scale of his sticker interventions.
Opposite bottom:
D*FACE
Dog House. A wheat-paste intervention is cleverly positioned on a building to create maximum impact.

D*FACE

One of the earliest exponents of sticker art in London, D*Face created a high-profile character that subverted ads and entertained.

The first things we saw by D*Face were stickers; is that how you started out doing street art?

Yeah, that was the seed. I'd dabbled with painting graffiti as a kid and that led me into skateboarding, those two things really set what would become a fundamental direction in my life. Both teach you to look at your surroundings with different eyes. I was born and bred in London, so I grew up surrounded by the urban sprawl, skating spots like Meanwhile, Latimer Road, and the South Bank. All these places had graffiti gracing the walls; the two things coexisted.

An illustration and animation course changed my life. It connected all the things I was into and gave me a direction to channel my energy and work. I left with a degree and landed work in the so-called creative industry, which instantly struck me as incredibly restrictive, but gave me access to all sorts of equipment, from photocopiers to marker pens to computers.

I stayed late, siphoned off all sorts of equipment and started drawing these dysfunctional characters to put up in the streets, to fill my walk to the train or bus or across town. At first they were hand-drawn stickers; it meant that I could get the look and finish I wanted in advance of putting them up on the street. And it was easy to pop them up, making them as visible as possible. That was the start.

It was a creative release and cured the boredom of my job. The stickers ran and I enjoyed seeing them last, and connecting paths across London. As stickers became the norm, an everyday activity, posters fixed my appetite, and the rush came from doing more and going bigger. I think

I'm slightly obsessive; I don't tend to do things in half measures. I can't leave home without a pocket of stickers, they've become that much a part of my life.

Can you explain the ideas behind your early sticker campaigns?

I never saw tagging as street art; for some people stickers took over from tagging, but for me I wanted to put something up that would be appreciated by a wider audience. With tagging, it's pretty much a language only appreciated by those who speak it. I wanted to leave these dysfunctional characters around town for people from all walks of life to see; to make people smile or frown, to appreciate or hate, but either way, to cause a reaction, and create a subversive intermission from the media-saturated environment that surrounds us. It was simple: black-and-white, bold, line graphic characters. Black and white because white vinyl could be acquired for free and the black marker pens, particularly the Pentel N50 or N60, I took from work. Also black and white had the most impact,

and stood out from the street grime and fly-posters. Before the characters, I had made a whole series of works on the idea of "Instant;" it was a play on advertising selling the impossible, like genius or success.

JON BURGERMAN

Developing a world of colorful, surreal characters, Jon Burgerman found that stickers are the perfect medium for getting his invented critters seen. Now his characters appear on clothing and accessories too, and his stickers are his calling card.

What's the appeal of stickers?

For me, it's that they're small, portable, can be colorful and detailed, and can be placed on almost anything (or anyone).

Were stickers your entry-level activity into the world of street art?

Yes they were, and at the time I was oblivious to any other sticker artists. I just thought that stickers would be a good format for my work, which even back then was graphic, colorful, and bold. As I explored different places to put my work, I noticed other people's stickers. My eyes slowly began to open and I learned there was a whole scene out there waiting to be discovered.

Where did the idea to sell sticker packs come from?

I used to give stickers away via my website. All you had to do was send me a stamped, addressed envelope. I'd even post them for free overseas. I didn't even mind when the demand began to increase; but when I started seeing the same people asking over and over, I thought that was cheeky. Eventually, it began taking up too much time, as back then I hand-cut every single sticker, thousands of them!

How crucial have stickers been in building your career?

In some way I put everything down to the stickers. People have kept them, collected them, exhibited them, written about them, blogged about them; and in turn mentioned me and my work. I know I've received jobs and commissions directly from people who've seen my stickers, which is great, especially as I'm not really into heavy bombing with them. For me it's not about quantity, it's about strategic placement.

What makes the perfect sticker?

Anything really, as long as it's sticky.

This spread:
JON BURGERMAN
Various characters as
die-cut stickers.

SOLO-1

Another artist who has made a major impact using stickers is Solo-1; he was also one of the first sticker artists to be commissioned as part of a guerrilla advertising campaign, to spread a client's message.

What's the appeal of stickers?

For me, they are a stamp to say "I'm here." It's not a new concept but they look good always. As a kid, I could never fill those sticker books up, so as an adult I guess I'm a bit obsessive.

How have stickers helped to build your reputation?

Everyone took notice of my stickers in London because I put close to a million up and got repetitive strain injury for the privilege. My reputation, I like to think, is hard working. I'm trying to communicate that I'm around, so if you see it you know I can get certain jobs done. The UK Post Office was forced to withdraw their range of stickers because of me. There is no doubt, like my teacher used to say, "There's always going to be someone who spoils it for the rest."

What makes the perfect sticker?

The perfect sticker is the last one in the pile that goes up, followed by the anxiety of wishing you had packed more.

Is graffiti for its own sake, or as a means to an end?

I think for me it's been a means to an end, and a way of communicating. It's an enjoyable, cheeky pastime that means *you* take part in your city and don't have to look at what *they* tell you to look at. If you don't like something, then add your own thing; we must take part in our surroundings. The New World Order wants us to go to work, watch the computer screen, and go home via the shops. Go and express yourself as much as possible.

How does stickering relate and feed into your other artwork?

My stickers are there for my friends to see, the pieces I do for myself and the paintings I make are a more controlled version of those pieces.

You've created street campaigns for commercial companies; describe how that works.

Because of the nature of the work—being illegal—I am unable to disclose who and where. It's a weird thing, being part of a system that can pay for things legal or otherwise, and it opened my eyes to how this world operates behind the scenes; and we, the public, have no idea. With a check book, a company can break any law they want, and if caught it's just a case of damage limitation. My work has to be secretive because for me, in the bigger picture, there is no company paycheck; I got sick of the heat from the local councils' legal departments.

Above:
SOLO-1
"Ecko Unlimited asked me to design a limited-edition T-shirt, and I based it on the U.S. Postal Service sticker."
Opposite top:
SOLO-1
Hand-drawn onto "found object" labels borrowed from the Royal Mail.
Opposite bottom:
SOLO-1
Hand-drawn and colored, on U.S. Postal Service labels.

DATA FILE: SOLO 1

On the scene since 1990, Solo 1 is best known as a prolific sticker artist placing hundreds of stickers every week in his hometown of London, UK, as well as in various locations on his global travels. He also makes photographs, brightening up the inner city, and runs workshops for people of all ages, teaching them how to paint and affect their own environment.

STICKERS: MULTIMEDIA

For some artists, paper or vinyl just aren't enough. They're happier experimenting with found objects; some want their interventions to be more permanent and vandal-proof; or just to "go big." In the process, they're creating unique, eye-catching objects. The message is, there are no rules, use your imagination and whatever materials you can... and you may end up creating a signature intervention that everyone will recognize as yours.

INVADER

Perhaps the most renowned user of "nontraditional" materials is Invader, making pixels from tiles, Rubik's Cubes, and light.

Why did you start using tiles?

Because I realized that they were the perfect medium to give life to digital pixels. Also, I knew that nobody used tiles in street art before, so I thought it was my job to do it!

What are the advantages of tiles over other media?

It is a perfect material because it is permanent. Even after years of being outside the colors don't fade.

So you are aiming to make your work more permanent and vandal-proof?

In a certain way, yes.

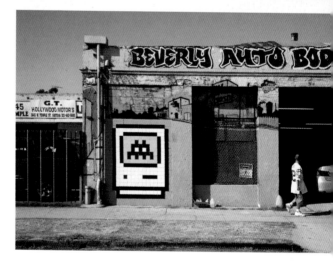

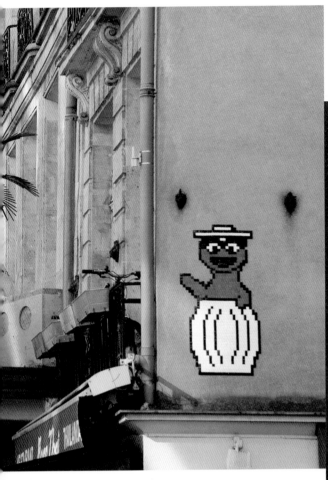

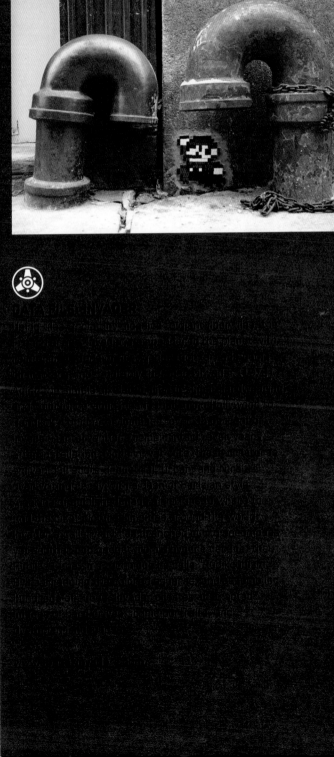

Top:
INVADER
Paris, France.
Above:
INVADER
Los Angeles.
Top right:
INVADER
Super Mario in tiles, in New York.

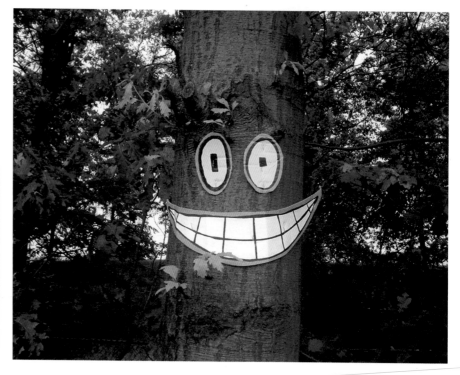

DATA FILE: CKOE
Ckoe makes animations,
draws comics, paints
and arranges giant 3-D
installations, makes
"solid stickers," and
has amassed a family
of cute characters.
He lives in Eindhoven,
the Netherlands.

www.ckoe.net

CKOE

Ckoe makes "solid stickers" for
unlikely locations...

How do you find your "spots?"

I walk or cycle through the streets and see
nice spots. Sometimes I look for metal to put
magnets onto, and nice trees for my "parasite
stickers." I search for other stickers that can be
the head of the parasite. I always need a reason
to add or leave something on the street.

How did you come up with the idea for
"solid stickers?"

When I was a student my first home was a
really small, crappy room, so I spent a lot of
time wandering the city. The sticker scene
was coming up, really growing, and the idea
of the MDF stickers came as a reaction to
the overdose of stickers, that they were all
the same. I wanted to make something different,
so I started drawing on some MDF I had lying
around. I drew different pictures because
I didn't want every sticker to be the same.
As a bonus, I was able to use a wider range
of surfaces than if I'd just used regular stickers,
thanks to heavy-duty glue.

**MAKING IT:
STICKER MATERIALS**
For the "solid stickers"
Ckoe uses MDF,
markers, oil pastels,
paint, and Bison Kit
Construction Glue.

Above and opposite top left:
CKOE
Parasite stickers.
Opposite top right:
CKOE
Solid stickers, made of MDF
or cardboard.
Opposite bottom:
CKOE
"Bees in Zobe" project.

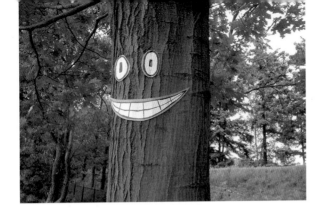

So, are you aiming to improve the permanence of street art?

No, not really. All I'm trying to do is go in another direction. But it's nice to see a sticker that I stuck somewhere four years ago still in good shape. With another project, "Bees in Zoos," I knew the bees would be gone within hours. So it's not important to me how long something stays. I just try to make things I like and surprise people, and entertain someone for a few seconds.

TOASTER CREW

Although they started out getting their toaster image around via stickers, the Toaster Crew were more interested in creating a subversive brand than in just using one medium. Now their toaster is going for maximum exposure, thanks to maxing the scale and getting on the TV.

Why a Toaster?

Three people in a kitchen in Wolverhampton, UK, on New Year's Eve 1998 decide to create an infamous image. And we cherish it more as every year passes.

We have been writing since we first saw the film, *Style Wars*, back in the day. To see it was to want to paint. The toaster came about as we grew up and wanted to add concept to our work. We wanted an image and not a word. This would simplify what we were doing and yet, ironically, complicate the public's perception of graffiti. The toaster exists to pose more questions than answers.

The toaster is a good example of how some street art becomes so familiar via repeated exposure that it becomes like a brand, but without selling a product. Was this part of your original purpose, to create something that is recognizable but a complete mystery at the same time?

Absolutely. That is the essence of the project. In a sense it is a game, but one that we take very seriously. We deliberately dodge a lot of questions, as we want people to conjure up a story in their heads and convince themselves that their explanation is the true explanation. If something exists on the street, it exists for the public, so we respect the public's perception of our image.

Top:
TOASTER CREW
Banner at Wolverhampton Wanderers
soccer match.
Above:
TOASTER CREW
Installing large-scale toasters,
after dark.
Opposite:
TOASTER CREW
Borrowed billboard.

The sticker was your first medium. What appealed to you about stickering? Was it simply the speed of it?

We can put stickers up quickly, easily, and at any time of day or night, without too much suspicion. We can always put them up faster than they can be taken down. It's also a massive nod to our roots in graffiti; back in the 1980s we were putting a lot of paper stickers up featuring our tags. It was a huge scene in the West Midlands, before it happened anywhere else in the UK.

Big sporting occasions have thousands of people in attendance, get huge, live television audiences, and extensive press coverage. We wanted to exploit this and open up our image to a new audience. So, we made a banner for the Wolves [Wolverhampton Wanderers] versus Sheffield United, [soccer] play-off final at the Millennium Stadium in Cardiff, in 2003. It was shown live on TV; pictures and articles appeared in national newspapers. *The Daily Mail* even asked for anyone who knew what the toaster meant to call a phone number that they printed in the paper. All this reinforced our belief that sports grounds could be used like the street, as a vehicle to get up. Since then, we have taken toaster banners to the FIFA World Cup in Germany, The Ashes cricket tests in Australia, and other cricket tests in South Africa and New Zealand. The response from the public inside the stadiums is a mixture of bemusement and curiosity. "Why the toaster?" is a common question. →

You also make art featuring the toaster. Which came first, the sticker campaign or the art?

Initially it was just all about the toaster. This was a conscious decision. We wanted to establish the image before we used it in conjunction with other artwork. Only when we started to understand the makeup and structure of the image could we do this. We started painting toasters over pieces and tags, so that the "fill in" of the toaster would be the existing artwork underneath. Far from negatively crossing other people's work, we were framing and highlighting it by using the toaster outline. This was our first step to using other artwork.

You all have other jobs. Many street artists have realized the potential power of the brands they have created for themselves, and have turned their art into business. You guys don't seem so enamored in going down this route; is there a sense that some of the fun would go out of it?

We would never see it as a business even if it completely took over our lives (and it's close to doing this). We always want to have fun doing it, but this is not to say we can't also be disciplined and totally committed. No humor no point, is a great way to approach life.

TOP:
TOASTER CREW
Toaster Crew at work indoors at the
Upper Gallery project
LEFT:
TOASTER CREW
Banner at a soccer match in
Berlin, Germany

FELIX KIESSLING

Not a sticker, not a flyer, defying definitions and reclaiming the least likely spaces for art, Felix Kiessling leaves his cheeky calling cards in nightclubs, pubs, and alleys, while commenting on how our avid taste for entertainment impacts the city and its inhabitants.

What's the concept behind the "Dead Hoxton Girls" project and where did the inspiration come from? What's the message?

I worked in a bar in Hoxton, [a trendy area in east London] for a year. I have never seen so many empty bottles, empty faces, and full garbage bags in my life. I'm intrigued by how we go through life without asking questions, and how we live with neither responsibilities nor consequences. Having said that, I am happy for you to meet the girls, and take away whatever you want from the project.

You developed a very novel way of publicizing your work—using fake cocaine wraps. How did that idea come about?

Coke wraps are intriguing objects people tend to pick up and open.

Has walking round with fake cocaine wraps got you into any trouble or created any misunderstandings?

No trouble. Misunderstandings maybe. I do get begging looks sometimes.

Your work is outside the mainstream graffiti movement. Is that a conscious decision on your part?

I'm just creating things, and at the same time, I'm not trying to fit into any particular scene. You could call me a street artist, but that's just because that's where I do my work. Often the street seems to be an interesting platform to make things public and get a reaction. It's instant and convenient, and it means people definitely turn up to my shows.

DATA FILE: FELIX KIESSLING
After graduating from Farnham Art College, UK, Felix Kiessling moved to London to absorb inspirations and spill out work. He has been restlessly working on graphic, illustrative, and art projects ever since. Commercial and editorial commissions include cover art for Sasha and illustrations for Ditched magazine.

www.vectorkraft.com
www.deadhoxtongirls.com

Top:
FELIX KIESSLING
"Dead Hoxton Girls," the coke wrapper flyers.
Above:
FELIX KIESSLING
"Dead Hoxton Girls," this project combined mixed-media, photography, screen-prints, stencils, and collage.

STENCILS AND PRINTS

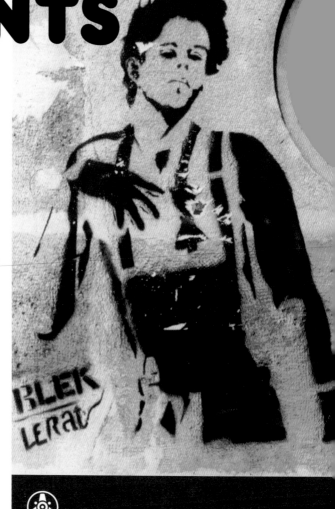

Whether "pulling" a print, or spraying paint over a stencil, the process is similar—you're forcing pigment through a cut shape, that may be reused on a different surface, a wall or paper, for sale or for free. That crossover has led some artists to explore and combine both means, bringing their screen-printed, wheat-paste posters into the streets, or creating highly elaborate, multiple stencils, layering colors and content. Others combine multiple posters and stencils into large-scale murals, adding hand-painted and spray-painted details and finishes. For these artists, the stencils and posters provide versatility, coverage, and maximum exposure, at speed.

BLEK LE RAT

What sparked the idea for stenciling, and then for making posters?

In 1981, when I started to make graffiti in the streets of Paris, I did not want to imitate the American style that I had seen in 1971 in New York City during a trip over there. In Europe, our culture is different to America and I felt anachronistic making the same kind of graffiti. I really love American graffiti but I love it in an American environment. Maybe I am wrong, I don't know…

I make posters for a simple reason because, in 1990, I was arrested by the Paris police and it went really bad for me. I was thrown in jail and I went to court. It took a year until the trial was over. Fortunately I did not stay in jail for a year, but I had to pay a big fine and remove the graffiti I had painted. That was the worst time of my life; I felt that my personality had been deeply attacked, along with what I believed was the most important thing in my life, my art.

It took me two years to recover. After that life-changing situation, I decided to spray my characters on to pieces of paper, cut them, and paste them on walls. Now, if the police catch me I can say, "Excuse me sir, I am going to remove the poster right now, no problem." And usually the police don't bother me more than that.

I love to leave a part of me (because I really have the impression that my characters are a part of me) in different locations around the world. Of course, each time I travel abroad I try to create characters according to the country I am visiting, and this way of working provides me with huge creative possibilities.

TOFER

Based in Los Angeles, Tofer has developed large-scale poster interventions, designed to impact the city's car-bound population.

Wheat-pasting, posting, and painting in public serves its purpose for my artistic practice. It is an avenue that made a major impact on what I am currently doing (as a painter), and allowed my work to reach a worldwide audience. My career wouldn't be where it is today if it wasn't for me utilizing guerilla marketing tactics and creating site-specific public installations.

Is this a form of guerilla advertising?

My initial reason for producing public work, specifically "wild postings," nationally and internationally, was to get my name out there. I then became fascinated with using the street as my canvas, creating works specific for each location. The billboard placed in the entrance of Barcelona's airport is the biggest visibility ever! →

MAKING IT: TOFER'S MATERIALS
I use pretty much anything I can get my hands on: acrylic paint, spray paint, pencil, pen, wood, canvas, paper, and a variety of Canon cameras.

Opposite and above:
BLEK LE RAT
Tom Waits and *Last Tango in Paris*.
Right:
TOFER
Large-scale billboard in Los Angeles.

HUTCH

Taking his skills onto the street, Hutch employs
both screen prints and stencils for work he
exhibits and posts for free.

I've been a screen-printer since the 1980s,
but have always played with stencils too. Before
everyone started using computers for artwork
output, most of it was hand-cut in rubylith, and
I still do some hand-cutting. I started screen-
printing my designs onto T-shirts, stickers, and
any flat surface I could get hold of; so using
stencils lends itself nicely to making limited prints.

**Street pieces have impact due to the space
they occupy in public and their scale. How do
you maintain that impact when working within
the confines of a rectanglar piece of archival
paper; is it even possible?**

I'm not sure if the impact you get on the street
can be maintained through to a print. But if an
image that is seen on the street by hundreds of
people is then spotted as a print or canvas, the
recognition factor will trigger a reaction.

How did you get into making street art?

After doodling, screen-printing, and painting
for many years and feeling the need to show
off finished artworks, but finding no galleries
or outlets that were interested, I started

making my own stickers for the street. With the rise in popularity of street art, boosted by the many massive online communities, it became obvious that the street was the only honest gallery space available. That prompted me to produce more stickers, stencils, and paste-ups, which were hand-drawn, printed, photocopied, or spray-painted.

When and why did you start using stencils as your main medium?

What appeals to me is the permanence of spray paint on a surface, and the fact that you can use the same stencil over and over again. Also, it's a cheap alternative to screen-printing, and creates pretty much the same effect. I haven't always had my own screen-printing setup, but using spray paint at home was becoming silly.

How do the creative processes differ for each medium?

With a paste-up, it's a more studio-based process; I treat the image as if it's a canvas to be hung in the street, so with my life-sized figures I try and blend them with the surroundings. The beauty of the paste-up is that it'll stick to any surface, of any color. With a stencil, the wall that you are stenciling onto becomes a part of the piece, along with its colors and textures. For a paste-up I tend to stencil onto blank newspaper, so they are less permanent than a stencil painted straight onto a wall.

How does working with stencils affect the content and style of your work?

It can produce a very clean and graphic style, which is what I like when creating realistic human figures. Also, the effect on the viewer is instant, you don't need to wait for it to sink in.

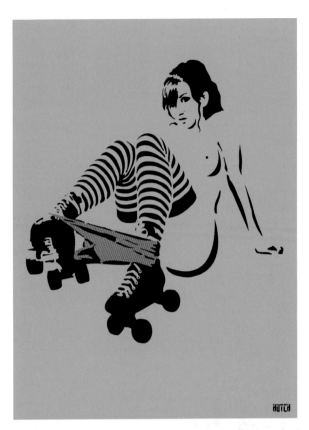

Opposite top:
TOFER
Billboard in Barcelona, Spain.
Opposite bottom:
HUTCH
Cangirl

Top:
HUTCH
Roller Girl
Bottom:
HUTCH
In action, creating a wallpaper through repeated use of a stencil.

LOGAN HICKS

A master of detail, Logan Hicks also began his image-making career as a screen-printer; now his super-detailed stencils defy belief, as he combines the multiple layering of screen-printing, with the versatility of stencils.

How did you get into making art, and street-art related activities in particular?

Dumb luck. I was a screen-printer working on corporate T-shirts and miscellaneous printing jobs. I knew graf writers, but graf wasn't really my thing. I met Shepard Fairey and saw his wheat-pasted posters and something about that resonated with me. Soon afterwards, I tried my hand at screen-printing my own posters and wheat-pasting them. It went well, but that eventually morphed into the stencils I now make.

Has stenciling always been your preferred medium?

No, I've worked in many media, but none of them really stuck like the stenciling. At college, I was a photography major, then a graphic designer. I also worked with layered glass. Once I started stenciling though, it was love at first cut.

What's the appeal?

I'm not completely sure. I guess when I find the answer to that question I will start something else. I enjoy the dirtiness of it. I like the fact that it is a pretty crude medium that is capable of producing polished results. I like that there is a work ethic behind it, because even if a person doesn't like the aesthetic results, they cannot argue with the man hours that went into creating it.

DATA FILE: LOGAN HICKS
Logan Hicks was originally a screen-printer, but sold off his equipment to finance a migration from the East to the West Coast of the USA, where he turned to stenciling. One of the most detail-oriented of artists, he's known for his meticulous, multilayered renditions of urban spaces and landscapes. Logan has worked with companies such as Levi's, Disney, and Sony, and Royal Elastics. He also finds time to teach workshops.

www.workhorsevisuals.com

Top:
LOGAN HICKS
Logan Hicks at work during *Primary Flight*, Art Basel Miami.
Right:
LOGAN HICKS
Nerve System
Opposite:
LOGAN HICKS
Land Rash

Your work is really layered and complex; one of the main advantages of stenciling, its speed and simplicity, doesn't really apply to your work. Has it always been so complex, or has it grown more so as you try to reach new levels of realism?

I think it is just my way of seeing things. Some people can see a complex subject and refine it to its essence. For me, I tend to see the microscopic details in every subject. I am envious of those who can boil it down to the bare minimum, but that's not how my brain is wired. I have a nasty habit of complicating situations by thinking about everything. My art reflects that approach.

Do you add finishing touches by hand?

Rarely. I prefer to have a clean print. There is something a bit ritualistic about making the stencil and having that be the sole testament to your vision. If I go back in by hand and touch up and add things, I think that it loses something.

MAKING IT: CUTTING A STENCIL
Using my computer, I scour all my resources for images, then cut and paste them together to make a whole. Then I turn up the brightness and contrast in grayscale, and work out the bridges and islands of the stencil, so it doesn't fall to bits once it's been cut. Then I print it out onto paper.

Next is the hands-on bit. I lightly spray-mount a piece of acetate and then lay it over the top of the print-out, and cut out the stencil (the black area) with a very sharp scalpel. I use a 10A blade which I renew every five or 10 minutes. Then it's ready to be painted through. Never use a blunt knife; it'll make you hate the whole process.

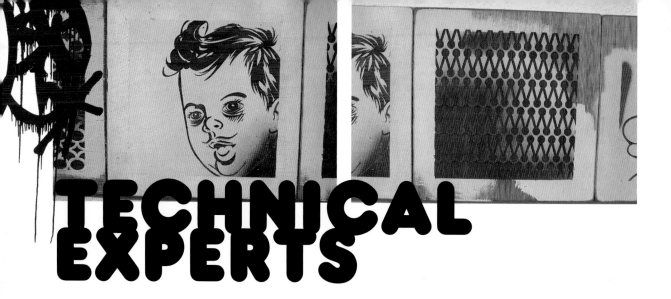

TECHNICAL EXPERTS

BLACKBOOKS STENCILS

Started by two artists, Blackbooks Stencils is a full-service street art supplies and fabrication facility; it's also a gallery, publishing house, curation team, and a creative partnership.

How did it all start?

Blackbooks was born out of necessity. We needed a stronger, more durable stencil. At the time BOOKSIIII was working full time on street-level branding in Miami, and Black was working for a fabrication company that utilized lasers as a main source for engraving. Both crossed paths and Blackbooks was born.

Are you guys artists?

Yes, Blackbooks is represented by Spinello Gallery in Miami; Blackbooks Collective is a younger project, our private art careers have allowed us to showcase our work nationally for the past decade. Our work is based on the traditional hand style as well as a glimmering interest in industrial design, specifically tension-stress furniture. If we can fabricate the piece in-house and liquid nail the sucker to the street, we will take every chance we get to do that, although, we don't go out of our way to make that happen. We have a "quality versus quantity" ideal when it comes to street works.

Where does all your expertise come from?

Both of us are self-taught; specifically our expertise comes from our drive for perfection and innovation. When we realized the many directions we could go with laser fabrication, it was only natural to apply these methods to

our love of hand styles and graff. We knew that if we were to half-ass any step of our production or branding process, anyone else could come out of the woodwork and try to rob us of our number one spot. We insist on being known for tip top execution and if you have worked with us, you will know that to be very true.

Your business is a mix of specialist services and supplies and equipment sales; how did those two "branches" come together?

Originally our company was based on how we paint. Before the company began, we were heavily into hand-cutting stencils and patterns, making our own business cards, a DIY take on self-branding and art. When the company came into being, we took what we knew best and sold it as a brand. No stencil artist in their right mind wants to cut out 1,000 little circles on cheap material, so we step in. When we had the capability to offer these superior tools and printing options, we decided to make it a full-time job, with spare time to work on our art.

Tell us about some of the artists you've collaborated with, and their projects?

We have worked with a very wide range of artists, from the Seventh Letter Crew to Hank Willis Thomas, ObeyGiant, Tes One, and Chris Robinson. We have worked for major corporations such as Mountain Dew and Red Bull, and for advertising giants such as Crispin Porter + Bogusky. As long as the project is solid, we want in. Many times, private artists or corporations approach us with projects because they know we will find a way to materialize their

vision; that's the main reason that we're separate from the pack of typical laser fabricators. We are the greatest middle ground between the technology and the art.

Your website is so extensive, is that the main way you market yourselves to artists?

Our website is extensive because we are always coming up with new concepts. We refuse to slow down or become stagnant. We believe that you're only as good as your last project; but that doesn't mean what is old isn't still good. People always want to see new things; we try to supply them with this regularly. Sometimes we wonder if having such an extensive website hurts us.... Perhaps giving folk too many options confuses the best ideas right under their nose. For now we are happy with having such a wide variety of choices though, and the plan is to continue to add new brands and concepts, some for customizing, others as specific products.

What are your best-selling products?

If I had to choose a specific product, I would say (stencil) patterns. But for the most part we sell everything pretty evenly. Custom work is where we make most of our coin. Sometimes custom work is a headache, and other times it's a god-send. Either way, we love it and are always on the search for the perfect product that will supply us with the capital to walk around with a wheelbarrow of precious gems.

DATA FILE: BLACKBOOKS

LIMITED-EDITION PRINTS

 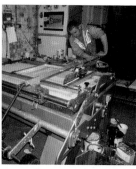 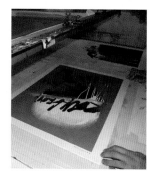

With the aim of creating affordable artworks and allowing fans to become collectors, a host of print-based galleries, based around the world, are working with artists to create limited-edition screen-prints and digital prints. Selling through online galleries, "pop-up" stores, and special events, with emailed newsletters announcing new editions, these galleries are helping to generate a much wider audience base for art of all kinds.

Silk-screen printing is one of the oldest forms of printmaking. Versions of similar processes date back centuries, most notably to the Japanese form of printing known as katazome, used for decorating cloth via stencils. The method we know today was industrialized via a patent registered in the UK by Samuel Simon in the early 1900s.

A screen is made from fine mesh fabric, traditionally silk but, these days, usually polyester. Areas of the screen are blocked off with a nonpermeable material, leaving a stencil of the image to be printed. The whole is attached to a frame and laid on top of the paper (or fabric) to be printed. Ink is forced through the fine mesh of the screen, onto the paper. Multiple screens are created to print various different areas and colors; when each layer is dry a new layer is printed on top, with two layers of color often being "mixed" to create a third color.

Top:
Screen-printing: the process.
Above:
O.TWO
Hells Angel; edition of 150, signed, screen-print.

Opposite top:
HAMPUS ERICSTAM
Che Couture; edition of 130, signed, screen-print.
Opposite bottom:
DANNY SANGRA
The Hills are Dead; edition of 150, signed, screen-print.

RIC BLACKSHAW AND SCRAWL EDITIONS

The founder of the UK's Scrawl Collective, Ric Blackshaw, explains the process by which a new Scrawl Editions print is produced.

The process of making a screen-print starts with the artist designing a piece of work, or me sitting down with an artist and choosing some work from their recent paintings that might be suitable for printing. Paintings usually need a bit of reworking, but once the artwork is selected it's a case of getting the files to our printers and discussing with them how we want to proceed. Once the Pantone color references (for the inks) have been selected and we've sourced some suitably rarefied stock to print on, it's down to the skill of the screen-printer, working in collaboration with the artist. On printing day the artist will be at the print studio and proof the first few prints, just to make sure everything is as it should be. Another scenario is that some of our artists have the skills and equipment to make their own print editions, which obviously adds a bit of value for the buyer, knowing that it's handmade by the artist.

Certain prints may have hand-finished touches added to them or be a mix of both. Some customers are looking for something extra special and there are two ways of providing this: you can go for ever more involved printing techniques, specialist pigments, etc., and you can create prints that are hand-finished by the artist so they are closer to an original, each one being unique. For instance, with our last Yeti edition by PhlAsh, the artist prepainted about 30 pieces of paper before we printed the Yeti image over the top.

Once we have finished the editions the artist signs and numbers them and we add the Scrawl stamp. All the prints are issued with certificates of authenticity and we keep records of these. The decision as to what to print is always down to our own tastes and sensibilities; at some point you just have to learn to trust those instincts.

www.scrawlcollective.co.uk

THE BLACK RAT PRESS
Nick Tucker tells how this London-based print studio got started.

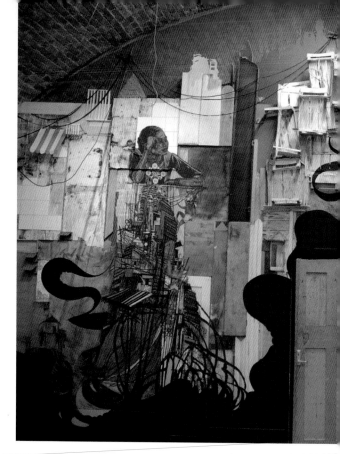

You started off trading online only; what prompted the decision to set up a gallery on a real street?

We operated out of a small, cramped office tight to the roof of a railway arch. Our intention was always to open a gallery, but finding the right space was tortuous. On the plus side, the delay allowed us to open the gallery with an established market presence.

There is a rarefied air around print editions right now, with rare stock, diamond dust, more colors, and special pigments being used. What is fueling this tendency? Isn't the actual image more important?

Obviously, the quality of the actual image is foremost, but we don't believe that means that you have to scrimp on the printing process. The question of colors, diamond dust, etc., makes it sound like these are smoke screens to obfuscate the quality of the image. We don't see it that way. It's more that prints these days can command quite high prices in the primary and secondary market, and if people are going to pay that kind of money it's nice to reward them with something that warrants the outlay. We treat prints as works of art in their own right and not just the poor relations of the original. A 21-color screen-print is always going to be far more vivid and offer much greater depth than a giclée. Yes it costs more to make, but it's not all about the highest margin. We used gold leaf on D*Face's *Cli-Che* print, not to compensate for the paucity of the image, but because an image like that, which is powerful and punchy, calls for something a little extra. Essentially, we also believe in our artists and the works they produce, and we want to create prints that endure along with the artist. Prints are not always lavish copies or reproductions of extant pieces, but can be original works in their own right. For example, Matt Small's recent etching, *Etched Moses* that he created at the Black Rat Print Show.

Some artists make work with a clear message, an iconic image that grabs the attention; they fit the current zeitgeist. But what about the more decorative, abstract street art that takes a bit more work on the part of the viewer; are you exposing your audience to the less accessible forms of street art, to widen the genre's horizons?

Blek Le Rat, D*Face, and Nick Walker are all artists whose work has an immediate visual impact, which is more the form European street art tends to take; it's arresting and it does lend itself to ready assimilation, exactly because it's created to grab your attention as you go about your day. Perhaps the market is simply responding to, and buying, the art that it sees around it, and therefore has the most personal response to. For example, there is still a huge demand for works by Nick Walker and Banksy from their hometown of Bristol, UK, and I'd argue that's not because people from Bristol dislike or distrust abstract works, or because figurative art is hardwired into people's art receptors in that region, but simply because they have a history with these artists, and a day-to-day experience of their work.

www.blackratpress.co.uk

POW

Pictures On Walls is a UK-based print studio that has had great success making and selling prints by Aiko, Banksy, Bast, Eine, Jamie Hewlett, Invader, and more. Banksy prints sell out immediately, via the online gallery and newsletter alerts. POW pioneered this most effective web-based method of selling affordable prints, outside the fine-art gallery system. Many of their prints (especially those by Banksy) have resurfaced on eBay, and resold at vastly inflated prices. Increasingly, the authenticity of these eBay-traded prints is being questioned, with the POW team advising, "Don't buy them!" POW's annual Santa's Ghetto seasonal store, which opens in a vacant shop during the run-up to the holiday season, is usually located in Soho, London. But, in 2007 Santa went to Bethlehem, garnering much publicity, and stoking discussions about how street art proclaims political messages, while prices for "take home" pieces soar.

www.picturesonwalls.com
www.santasghetto.com

FIND MORE: ONLINE GALLERIES

Sign up to the sites of these galleries, which publish prints and feature original artworks.

Lazarides Gallery has a permanent home in London, UK. Steve Lazarides is the photographer who has documented Banksy's work around the world.
www.lazinc.com

BLK/MRKT Gallery and Editions, based in Culver City, California, is run by artist Dave Kinsey and Jana DesForges.
www.blkmrktgallery.com

The legendary Shepard Fairey runs a design studio, print works, magazine, and gallery in Los Angeles, while also creating print editions and large-scale exhibition installations.
www.obeygiant.com
www.subliminalprojects.com

Top:
Heap, the first exhibition at The Black Rat Press' new gallery, in a renovated railway arch, was a joint installation between Swoon, Monica Canilao, and David Ellis.

Above:
D*FACE
Cli-Che; edition of 150, signed. This is a six-color screen-print, with two varnishes and hand-applied gold leaf.

GICLÉE PRINTS

Giclée (pronounced zhee-clay) is a relatively new printing method by which fine-art prints are created from a digital source.

The history of the process has been lent a bit of rock and roll glamour by the fact that one of the early pioneers of this technique was Graham Nash, of Crosby, Stills & Nash.

Like silk-screen printing, giclée has its roots in an industrial process. Nash, a collector of early photography, began using an Iris printer to make high-quality reproductions of his collection. Up to that point, Iris printers were mainly used at the prepress, proofing stage on industrial print projects, where color matching was critical.

Nash was so impressed with the quality of the reproductions that he began to print entire editions using the digital printer, changing the name from the commonly used "iris print" to "digigraph" to distinguish his fine prints from the industrial term. In the early 1990s another printmaker, Jack Duganne, coined the term "giclée" from the French "gicleur," to describe the fine-art application of the process.

COSH

UK-based printmaker, Cosh, uses the giclée process, operating from a gallery and basement studio in Soho, London. Working closely with artists and illustrators from around the world, Cosh adopted the giclée technique because it best suits the multimedia approach of their stable of artists. Their use of continuous tone, photographic qualities, and pattern work, featuring millions of flat colors, is often too complex for silk-screen printing or lithography.

Here, Cosh explains giclée printing, step by step.

First, the artist sends us the digital file he or she has created. Prints that are produced from an original piece of art (such as paint on canvas) firstly need to be scanned, or a photographic transparency made of the piece, which can then be scanned.

Scans are made up to 2,750 dpi to accommodate enlargements for prints up to A0 (33 by 46³⁄₄in) size. Our scanner is fully calibrated using GretagMacbeth's Eye-One color-profiling software. We also run a gray balance on a weekly basis to ensure that the scanner is working at peak performance. We use custom hardware ICC* profiles for all reflective scans to ensure constant color.

Using Photoshop, and ensuring we are working in RGB (as it has the larger color gamut), we prepare the file for the artist's proof. At this point some color correction may be needed, especially if working to match an original. The most common adjustments are with tone and hue.

Our screens are calibrated to the give true color to match our printer's custom ICC profiles. Each paper type has its own color profile, to get the best results from each paper stock. Our chosen paper for fine art printing is Hahnemühle, the finest digital art watercolor paper on the market.

Once the artist has approved the proof we are ready for the print run. Each print is kept for 48 hours to cure, before shipping or framing.

Every print is checked before leaving and then wrapped in acid-free tissue and placed in a postal tube or sent flat, in between two sheets of board.

* ICC stands for International Color Consortium. An ICC file is a color template of sorts. It relays information between design software (Photoshop, etc.), scanners, and printers, so that what you scan, see on your screen, and output through your printer all look the same.

www.coshuk.com

Opposite bottom:
Paper and inks used in producing giclée limited-edition prints.
Opposite top:
View of the Cosh gallery.
Top:
RAY SMITH
Symmians (detail); edition of 75, signed. Archival giclée print on Da Vinci paper.
Middle:
GREGORY GILBERT-LODGE
Murakami
Bottom:
STEVEN WILSON
Bird

CHARACTERS: CUTE AND SPIKY

Back in the 1980s graffiti writers began adding characters to their signature throw-ups, borrowing from pop culture cartoons and comics and inventing their own—sometimes as alter-egos. When computer games hit big, there was another source of inspiration. Artists continue to adopt characters as points of recognition, and the audience loves them.

Over the past decade there has been an explosion in character art, which has manifested itself in 3-D, as the designer toy phenomenon. Much of it derived from drawings of critters and fantastical landscapes created by street artists.

Unique and handmade, batch-produced in limited-editions, or mass-produced by international toy manufacturers, these toys (made from plush, nylon, yarn, cardboard, ceramic, cast metal, but mostly vinyl), are realized either with the help of experts, or by their creators, with newly-acquired skills. Feeding into a market for collectibles, and "grown-up" toys, these bring 2-D drawings to life, and the artists to a much wider audience.

Above:
MISS VAN
Atame. Acrylic on shaped wood (detail).
Left:
MISS VAN
Atame. Acrylic on shaped wood.
Opposite:
MISS VAN
Atame 4. Giclée print, edition of 60 on watercolor paper, numbered and signed by Miss Van.

MISS VAN

Her super-refined images featuring sexy, dangerous females, guarantee Miss Van a high profile in the male-dominated art world. Here she explains how the characters she first painted on walls as a teenager have evolved from self-portraits into more mysterious creatures and explorations of identity.

How did your distinctive female figures, your dolls as you call them, evolve?

They have evolved a lot since I started them. At first, my dolls had much more simple and graphic lines; they were very childish. Their forms were simple and round; now the lines are more precise, and I have added details. My dolls have become more realistic and expressive. As I always paint with sincerity, they have grown up with me.

Are your dolls self-portraits?

At the beginning, my dolls were self-portraits. Graffiti has a very megalomaniac side; instead of writing my name, I chose to represent myself through my dolls. I felt a real need to affirm myself, maybe because I have a twin sister and I had to show that I was different. Later on, I didn't feel this need to mark my identity. The idea of provocativeness has also been a part of my work. I have always liked painting a sexy doll in an inappropriate place, as I want to provoke strong reactions.

What are the different ways that you make marks, what tools and materials do you use?

In the early 1990s, I started discovering graffiti with friends of mine, tagging a little bit and following them, taking photos and stuff. I chose to use acrylic paint because that's what I was using while studying, and I found it more comfortable than spray cans, even if it wasn't a graffiti style. I still have this need for street painting and even if the laws have changed I've adapted my technique, making collages in a faster way, for instance. There is always a way of achieving what you want; if I can't spend three hours painting a wall I'll do it another way.

MUJU

By sharing their skills, Mr and Mrs Muju
have created a world for their creatures.
The signature Muju creature is a sort of slightly
scary, cheeky, monkey-monster who appears
either as a hand-embroidered doll made from
found pieces of vintage fabric or as magic-
marker drawings on reclaimed wooden blocks.
"We're lo-fi," Mr Dave Muju stresses.

**You've got some very unique characters
that pop up in all sorts of artworks that you
make.How do those characters evolve and
how have you changed them from one
medium to another?**

The development of Muju has been intuitive,
and new aspects appear out of freestyle
drawings; staying focused on the end of the pen
or brush or spray can. Katie, Mrs Muju, applies
the same focus when cutting felt or fabric for
the toys. Inspiration and vibes come from each
other's work and the characters easily cross over
from 2-D to 3-D forms.

**You're a creative partnership; how does that
work? Do you each do distinct jobs, or do you
share duties?**

We have distinct roles within our creative
partnership. The Muju world flows from the pen/
paintbrush of Mr Muju, who produces all the
drawings, paintings, and graphic designs. The
world is brought to life in 3-D by Mrs Muju. The
Muju plush toys are limited and handmade; in
recent years they have been exhibited worldwide,
giving them a life and momentum of their own.

**Mujuworld evolves across walls, canvases,
prints, T-shirts, and wood blocks, while the
characters come to life from fleece, recycled
denim, leather, felt, and paper, in all sizes
(from a 3ft/0.9m tall furry Muju yeti, to
intricate 3in/7.6cm felt Mujus). You've
literally created a world, Mujuworld; how
do you keep it spinning?**

Mujuworld has its own momentum and evolution.
We just keep exploring the infinite creative
possibilities that Mujuworld presents. The
growing relationship between us as two artists
keeps the workflow fresh and constantly moving
in new directions, and into new media. Music is
also a constant source of inspiration and vibes.

Opposite top and above left:
MUJU

The various Muju characters begin life as drawings, and then blossom into handmade plush toys made of various materials, including these new, super-decorative felt versions.

Opposite bottom:
MUJU

Everything starts with drawings from Mr and Mrs Muju, who populate MujuWorld with an array of characters.

Left:
TOFER

Tofer creates a family of rock-and-roll eggs, with crazy hair and scary teeth, to populate a series of dioramas, complete with hungry dinosaurs. Some eggs are big enough to fight back though.

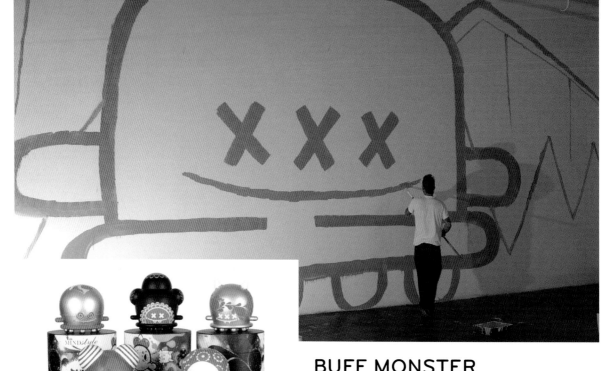

BUFF MONSTER

Buff Monster's work has evolved from stickers and posters, to gallery installations and now a collectible family of vinyl toys.

Explain the evolution of Buff Monster? When you first drew him did you think of how he might translate into color, 3-D, or into such a large scale?

Yes, actually the flexibility of the character was an important aspect of the creation of it. I wanted something that could easily be drawn at any size and reproduced in a million ways.

You've created a make-believe world, Lollipop Land, which at first sight looks very kid-friendly, but on closer inspection is actually quite sexual. Are you catering to an adult audience, but disguised as child-friendly?

I don't think my work is all that sexual, or offensive, or grown-up. Some elements look like special body parts, but that's just par for the course. When you're born, no part is any more special than the next. As you grow up, your body gets politicized and certain parts start to mean more than others. I think that's a weird process. That's why porn, conceptually, can be pretty interesting. To me, it's an active denial and abandoning of the unnatural "norms" in society. I think our bodies are natural, wonderful things, and so is sex. There is nothing dirty or scandalous about it. So among other things, I look at my work as a celebration of life, everything is free and happy.

Tell me how your characters progressed into vinyl toys.

Collectible vinyl toys were obviously my destiny. I met with most of the companies in America that put out the figures. They all wanted to make my figures, but I wanted to find the right fit. In the end, I signed a contract with MINDstyle.

Buff Monster has many incarnations; how do you decide on a mood or persona for your characters?

The mood is pretty much all the same; super happy. Some are a little more mischievous and others are a little more innocent. They all have a slightly different character.

VÅR

Characters that move = animation. Vår make sets and characters inspired by street culture for MTV, using almost anything.

When collaborating on a "set" piece, play is very important to us. We have an overall idea of the concept, what we are trying to portray, and then make the details up as we go along. We try not to be limited by being two separate minds (or more) at work, but rather use that as an advantage; styles merge and one idea leads to another. Things might not always turn out the way we first planned but that is what makes it interesting.

MAKING IT: VÅR'S MATERIALS

We use, basically anything, but we have been working a lot with meat, bones, roots, and vegetables.

FIND MORE: TOYS

The designer toy revolution has been stoked by the Pictoplasm community, a resource where artists can show their work and get published.
www.pictoplasma.com

London store PlayLounge stocks Pete Fowler's Monsterism critters and much more.
www.monsterism.net
www.playbeasts.com

Zakka Corp brings all manner of Tokyo and Euro toys to Brooklyn.
www.zakkacorp.com

Kid Robot is the toy and clothing emporium that has reinvented how to design, market, and sell collectibles, in Los Angeles, San Francisco, New York City, Miami, and a nightclub in Toronto.
www.kidrobot.com

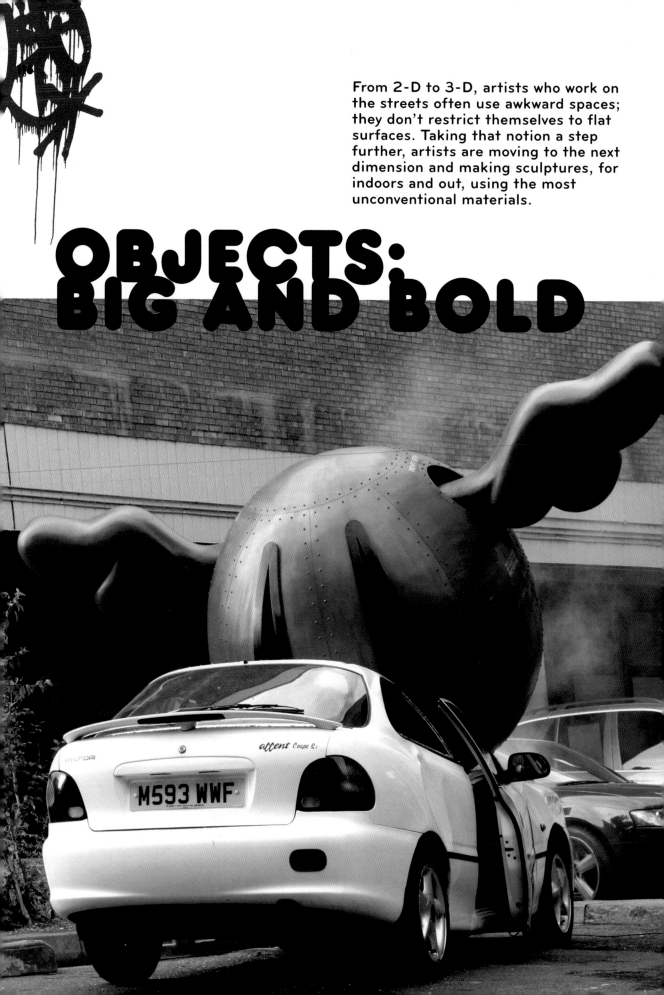

From 2-D to 3-D, artists who work on the streets often use awkward spaces; they don't restrict themselves to flat surfaces. Taking that notion a step further, artists are moving to the next dimension and making sculptures, for indoors and out, using the most unconventional materials.

OBJECTS: BIG AND BOLD

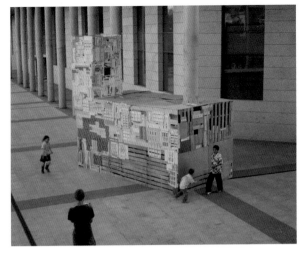

MICHAEL DE FEO

I curated a show, *Behind the Seen* at Ad Hoc Art in Brooklyn, and my contribution was a life-sized, self-portrait bust made entirely of Black Cat firecrackers. I'd like to continue working with fireworks in a sculptural way and on a larger scale. The sculpture is wired together with wick to enable it to blow every firecracker if it were lit. I love the relationship this sculpture has with street art, it's ephemeral. There's also an obvious connection to my youth and being mischievous.

www.adhocart.org

RONZO

Using concrete to make figurines that he then plasters into place, in the very same streets he drew his inspiration from, Ronzo makes a point, with a bit of attitude.

I was always scribbling and drawing, doing comics and character illustrations. At high school my graffiti-painting friends were traditional letter writers. They needed some characters to go with their lettering, so I went along to paint.

When did you realize you could make a living doing it?

On the day I painted some weird Martians on a company's garage. It took one afternoon to do but the pay was a month's salary, plus lots of spare spray paint. I trained as a graphic designer, and the money I make from that goes into my art projects. I'm keeping it real that way...I've got the skills to pay the bills.

Are the statues you leave around the city a progression on the tradition of tagging or stickering?

I like to move things on so I don't get bored. Tagging, bombing, and stickering are all good, but why not put up 3-D stuff? I got the inspiration for the mini statues from various monuments in different cities; there are lots, for various reasons. There's a crazy-looking monument, *For the Animals at War*, on Park Lane in London, for example. And in Japan I saw a Godzilla monument, and a dumpling statue. There's probably a statue for everything, somewhere in the world. We pass them by on a daily basis but don't even notice, nor know who →

put them there and why they're there. What I thought was missing, in this vacuum of ignorance and over-looked knowledge, is a statue dedicated to street life; monuments for the forgotten individuals, outside society. Nobody bothered to give them a monument, so I thought I could do that.

I came up with a set of three characters. First, Ed van Tag—Dirty Vandal. He tags ruthlessly on the walls of our beautiful city. Second is Lolita Longtime—Lady of the Night. She is an underage, crack-addicted prostitute who works in East London. Third is Bad Luck Joe—The Tramp. He's a pretty normal guy who, through an unfortunate chain of events, ended up on the street as a homeless bum.

So, I put them in locations relevant to each character; in an alleyway or opposite another monument. They're small, so they go unnoticed a lot of the time. But people who do see them might get the idea or have a laugh. They are unwanted objects, just like the real life characters that they represent. But the fact that they are there gives them a bit of an attitude, that's what I've always liked about street art or graffiti.

There is also a little dragon-frog statue, which is the mascot of the City of Ronzo. Just as its bigger dragon brother is the mascot for the City of London.

SOURCE BOX: MONSTERS

I watched too many Japanese monster movies when I was a kid; since then all my characters have come out twisted. Also fellow artists and people I work with inspire me; I learn and get motivated by them.

DAVID EARL DIXON

Making a point about consumer collecting habits, David Earl Dixon gets messy with papier-mâché.

"Crap Toys for Poor People," where did the idea come from?

It's kind of a lame joke on all this big hoohah about little toys right now; don't get me wrong, I love collectible stuff, I have a bunch of Moomins and Marvel figures, even some of Peter Fowler's and James Jarvis' vinyl figures; but the prices people put on some wack stuff! I thought it was all getting over-hyped, so I started messing round with making some heads, in the most naive and basic way that I could.

Why do you use cardboard and papier-mâché?

My wife reminded me how to make papier-mâché; I wanted my pieces to be lo-fi and really shonky, and then show them with some stupid small price tag on them; but at least these are one-offs. I know if I were to do a real vinyl toy, I would make it worth all that money they stack on them, and not bring out six billion colorways of the same thing. Perhaps just two.

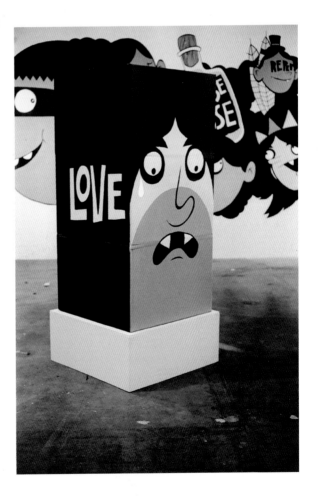

Opposite top:
RONZO
Making a concrete Lolita.
Opposite bottom left:
RONZO
Ed van Tag
Opposite bottom right:
RONZO
Dragon Frog

Top:
DAVID EARL DIXON
"Crap Toys for Poor People,"
papier-mâché figures.

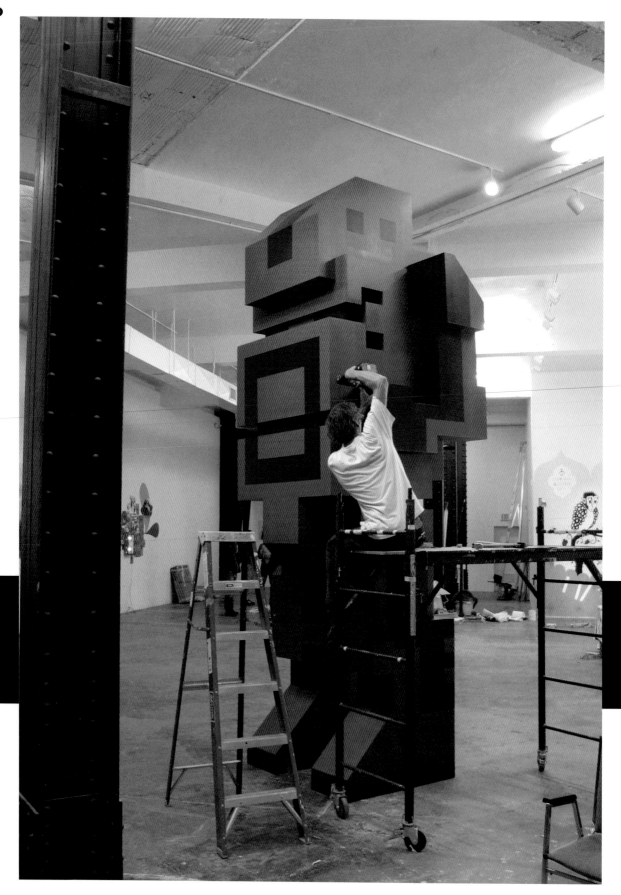

DELTA

An artist who deftly navigates between materials, media, scale, and process, Delta demonstrates that a print can be 3-D, a sculpture can hang on a wall, and that characters can be far from cute. His precision making, employing a range of tools so skillfully as to defy the term handmade, plays with surface, light, and dimensions.

Back in the early-1980s, Delta began his career tagging the streets of his native Amsterdam, the Netherlands. Inspired by the New York City scene, he quickly graduated to painting full-sized pieces. After studying Industrial Design Engineering, which focused on 3-D Product Design, Delta incorporated his new-found skills into his painting.

Taking graffiti-style typography to new levels, he abstracted the letterforms into objects; playing with the viewer, his 3-D style is so pronounced that viewers often mistake his paintings for sculptures. Making installations from wood has been a natural progression, and employs a number of the model-making techniques that Delta learnt at college. These pieces require absolute precision for them to fit together and have maximum stability.

How do you explore new materials and combinations of materials and techniques?

By trial and error, and with little steps. I have found out that it is better to make some mistakes at the beginning of the process, otherwise I tend to be too careful and restricted. By messing things up a little, I tend to be more loose and open to experiment.

MAKING IT: MATERIALS

Media: paint, pencil, charcoal, ink.
Surfaces: paper, cardboard, wood, canvas.
Tools: brush, knife, saw, fingers.

Opposite:
Delta adding finishing touches during an exhibition installation.
Top:
Delta painting outdoors.
Above:
A large-scale sculpture takes shape in Delta's studio.

JEWELRY

DAISUKE SAKAGUCHI

A number of artists have adapted their character art and lettering style to create jewelry pieces, including Tofer and Miss Van.

Here, Daisuke Sakaguchi creates miniature 3-D collages, partnering with a world-class brand.

Daisuke Sakaguchi's graffiti jewelry creations have become much sought after with clients of the caliber of the Beckhams and Kelis lining up for bespoke pieces. One limited-edition project was commissioned by Nike to celebrate 25 years of the legendary sneaker range, Air Force 1. Consisting of 25 individual pendants, realized in sterling silver, when arranged together they create the number 25; the laser and acid etchings on the surface of each component represent an interpretation of the Air Force 1 sole.

A unique example of the street art aesthetic being translated into a new medium, Daisuke's jewelry demonstrates its adaptability beyond the usual context. The fact that Air Force 1, hip-hop culture, and by association graffiti, have a shared history adds another layer of cultural significance to this particular project.

DATA FILE: DAISUKE SAKAGUCHI

Daisuke Sakaguchi feels strongly about personal identity; he sees the streets as a public catwalk, inviting you to display your work and show off your style. After earning a BA in Jewelry Design from Central Saint Martins College of Art and Design in London, UK, Daisuke's Collection One sold in Comme des Garçons's concession in the city's Dover Street Market. He has worked with major brands, promoting Run-DMC's Adidas Collection, Nike's Air Force 1 anniversary, and developing luxury products with Vauxhall Motors' VX Collective. Daisuke's signet rings, bracelets, pendants, sneaker tags, hoody tags, and phone straps have been showcased in exhibitions worldwide, and in catwalk presentations at Tokyo and London Fashion Weeks. His commissions extend to original graffiti pieces and customized clothing. He lives in London, UK.

www.daisukesakaguchi.co.uk

Opposite and top:
DAISUKE SAKAGUCHI
Nike Air Force 1, 25-year anniversary project.
Right:
DAISUKE SAKAGUCHI
Doodle and Sketch bracelet.
Far right:
DAISUKE SAKAGUCHI
Semtex. Collaboration with DJ Semtex.

FASHION AND STREET ART*********

CHAPTER THREE

Street art and fashion are a natural fit. From T-shirt graphics to the latest customized sneakers, the potential for turning garments into walking canvases and giving brands added edge means that partnerships are mutually beneficial.

Here, SheOne explains the finer points of how artists and clothing designers interact to create collections, packaging, and one-off garments.

SHEONE

Art into fashion is no new idea. Dali designed fabrics for Chanel, Steven Sprouse tagged bags for Louis Vuitton in 2000. Fashion, by its very nature, is a reflection of the cultural zeitgeist and graffiti is now just another social expression, like hot rods in the 1950s, or long hair in the 1960s; it's advertising shorthand for teenage rebellion. Putting my artwork onto T-shirts was a very natural step, I doubt I even had to think about it. Look at Keith Haring and his POPSHOP in New York. He skipped over Andy Warhol's idea of a factory and went straight to retail. He said look, if you like my paintings then buy a badge, a postcard, or a T-shirt, be involved, art shouldn't be exclusive. People want to feel included.

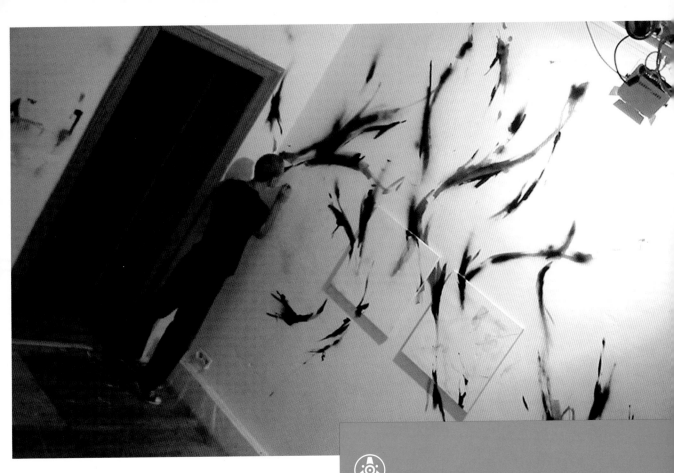

An important factor is accessibility. A kid who likes my work but can't afford a painting off the gallery wall, can buy the T-shirt; he can participate. However, by the time he has grown up, he may be in a position to purchase a painting. What we see now is a generation becoming influential within business, creative media, technology, and fashion, which grew up with graffiti. Some may have even dabbled as a kid, and if they didn't they probably knew someone who did.

On a personal note, I actually love the T-shirt as a canvas. It is a very exacting space to work in, that transcends cultures and allows for ideas that would not necessarily work as a painting.

Streetwear is a relatively new sector in fashion. However, one of the first brands attached to this label was Stüssy. Sean Stüssy, a Californian surfer and surfboard builder, decided to make some T-shirts featuring his surf company logo. The logo was Sean's signature written in graffiti-style calligraphy. For the second series, he made a set of black-and-white collages and expanded the signature, handwritten-tag style. These T-shirts were instantly picked up by skateboarders, graffiti writers, and stylists, and were popping up in fashion editorials worldwide. Back then →

DATA FILE: SHEONE

SheOne's own brand of abstract typography is rooted deep in the graffiti era of the early 1980s, but his uniquely expressive approach to painting keeps him firmly in the present. His signature aesthetic has crossed over into fashion, most notably for Addict, and 3-D design, in the form of hand-painted interiors and objects. He lives in London, UK.

www.blackatelier.com

Opposite:
SHEONE
Installation for London department store Selfridges' menswear section.
Above:
SHEONE
Painting an interior in Berlin, Germany.

if you saw someone wearing a Stüssy T-shirt, firstly it was kind of rare, as they were only available in select places, and secondly only people who were up on skate culture would know about them; it was like a kind of club. For subsequent streetwear brands, Stüssy is an exacting model, and one that started with a tag. The cofounders of Addict actually met because they were both wearing Stüssy T-shirts, which got them talking.

On a wider stage, streetwear is a generational thing. The clothing is designed by and made for people who grew up skateboarding and/or making graffiti, and it's only natural that graffiti artists should design the graphics for these garments. Streetwear, by its very nature, is led by graphics; it is the power of a brand, each brand being either more or less exclusive than its rivals. When you wear the apparel you are either in or out of the club.

The downside for the consumer is that this makes for a very fast turnaround in product choice; decisions have to be made about brand allegiance. On the plus side for designers, there is a hungry audience waiting for the next limited-edition release. This situation is expedited by the explosion of the internet as the number one source for information about brands, products, artists, and availability. The internet successfully creates anticipation by releasing a teasing amount of information about a product, which will spread like pixel-fire through blogsites and forums until the product is virtually sold out before it is even released.

Artists represent such an overwhelming creative influence these days that luxury brands are rushing to align themselves with certain names. Stores have become galleries; the most extreme case is Louis Vuitton, which commissioned Takashi Murakami to design a fabric for its range of bags, becoming the most counterfeited fabric in history. Recently, it came full-circle, with the concept of the "pop-up store" within the Takashi Murakami retrospective at MOCA (Museum of Contemporary Art, Los Angeles) selling Louis Vuitton products.

Top right:
SHEONE
Installation for London department store Selfridges' menswear section.
Opposite:
SHEONE
Painting on glass.

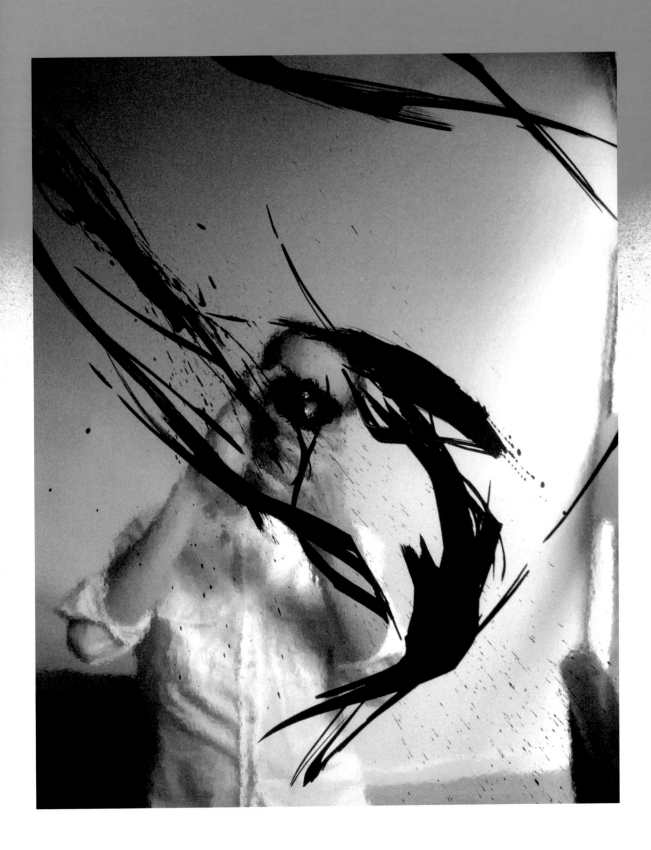

FASHION PARTNERSHIPS

Collaborating with friends from various creative industries often sparks commercial projects, and street artists regularly work in the fields of apparel and sportswear design, adding a youth-oriented twist to both up-and-coming and well-established brands. By turn, the expertise that artists gain from working in the commercial industry may spur them on to start their own businesses.

Here, a cross-section of artists talk about working with fashion brands, and share their opinions on the crossover between street art and streetwear.

VÅR

Tell us about the clothing brand, Cheap Monday.

We run Cheap Monday with four of our friends. We do the art direction and design all the prints, patterns, labels, and other graphics. Sometimes the images are based on black-and-white Sharpie drawings but we also work in color, with collages.

www.cheapmonday.com

CHEAP MONDAY ORIGINAL LOGO

CHEAP MONDAY LL VINTAGE SKULL

CHEAP MONDAY KOSTYM SKULL

CHEAP MONDAY BABY SKULL

CHEAP MONDAY WKND SKULL

Above:
VÅR
Animal sweater; knitted, allover pattern created from the world's logos.
Far left:
VÅR
Octoshawl, Cheap Monday pattern.
Left:
VÅR
Logos for Cheap Monday. Each part of the collection is represented by a different skull.
Opposite:
VÅR
Allover. "This is an ongoing project; an allover pattern that we build on with new pictures every year. All the imagery is from the world of symbols we are developing for Cheap Monday."
Opposite inset:
VÅR
Drawn installation at London department store Selfridges' menswear section.

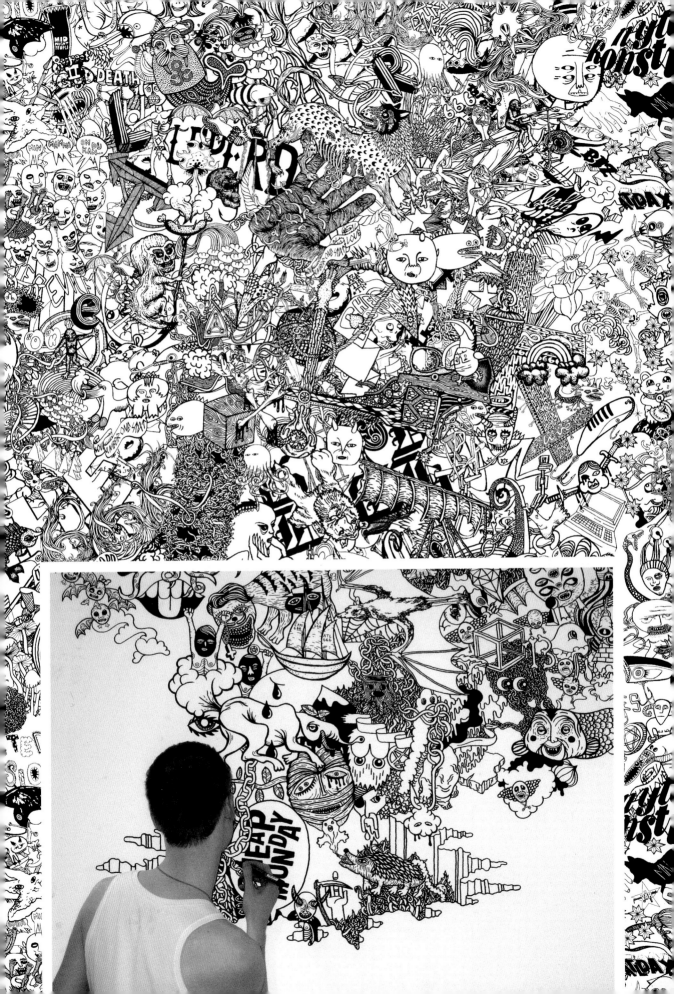

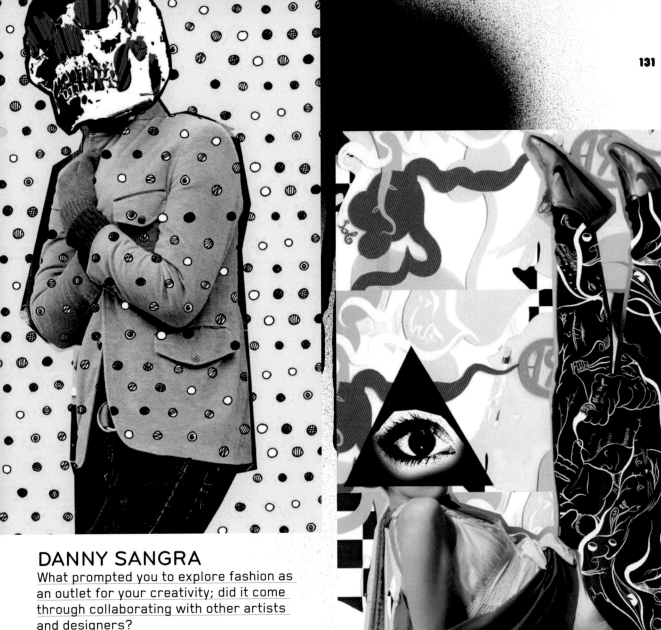

DANNY SANGRA

What prompted you to explore fashion as an outlet for your creativity; did it come through collaborating with other artists and designers?

I have always been really interested in fashion. I suppose that because of the art school I went to, Central Saint Martins in London, I was surrounded by people working in various areas of fashion, and most of my close circle of friends are fashion-based. When we left college we started to work together. Some of them own shops, make clothes, do knitwear, have started jewelry labels, etc., so it makes collaborating more interesting; they just gave me an outlet to use my visual imagery.

This spread:
DANNY SANGRA
Mixed-media collages using
fashion photography.

SHEONE AND ADDICT

I was asked to design a T-shirt for the Artist
Series. Each season Addict release a range of
tees designed by artists, packaged in a special
box with a swing ticket of information about the
artists. The collectible product introduced the
artist to Addict's customer base, and conversely
introduced fans of the artist to the brand.
Contributors include familiar names from the
so-called street art set, Mode2, The London
Police, Mr Jago, and Stash.

Then Addict asked me to design a fabric pattern
to be used for technical outerwear. Camo was
a big factor in streetwear and I designed an
abstracted, black-on-black pattern using my
painted strokes and hand styles, which became
known as the SheCamo. Although only intended
for one jacket, this pattern is still being produced
six seasons later and has graced many variations
of outerwear, accessories, snowboards, even
a range of underwear, and is an iconic and
intrinsic aesthetic element of the Addict brand.

Subsequently, I designed three more patterns,
but the original remains the most successful;
some have even been copied by mainstream
stores. For each design I wanted the wearer
to feel included, a participant of counterculture.
The camo acts as a signifier of graphic
awareness, without having to shout out loud.

Addict and I have regular meetings to discuss
the application of my graphics to products and
garments, and to figure out how we can optimize
the use of the camo patterns. As there are
two collections a year, there is a fast turnover
of graphics, particularly because we don't want
to repeat ourselves. I actually produce many
graphics and fabric designs that never see the
light of day. We work one year ahead, so have to
consider how the fashion market will be for any
particular season.

www.addict.co.uk

This spread:
SHEONE AND ADDICT
Packaging, camo print, and jacket
designs for Addict.

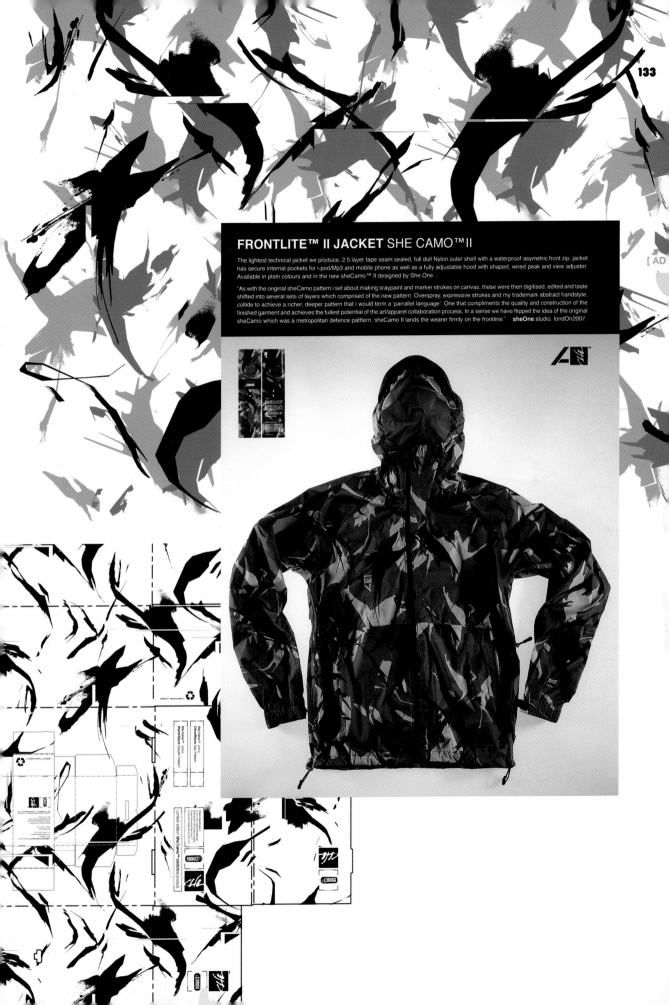

[AD

FRONTLITE™ II JACKET SHE CAMO™ II

The lightest technical jacket we produce, 2.5 layer tape seam sealed, full dull Nylon outer shell with a waterproof asymetric front zip. jacket has secure internal pockets for i-pod/Mp3 and mobile phone as well as a fully adjustable hood with shaped, wired peak and view adjuster. Available in plain colours and in the new sheCamo™ II designed by She One…

"As with the original sheCamo pattern i set about making sraypaint and marker strokes on canvas, these were then digitised, edited and taste shifted into several sets of layers which comprised of the new pattern. Overspray, expressive strokes and my trademark abstract handstyle, collide to achieve a richer, deeper pattern that i would term a 'parrallel language'. One that compliments the quality and construction of the finished garment and achieves the fullest potential of the art/apparel collaboration process. In a sense we have flipped the idea of the original sheCamo which was a metropolitan defence patttern, sheCamo II lands the wearer firmly on the frontline." **sheOne**.studio. londOn2007.

Not Bad For a Girl™ XAddict

DATA FILE: KAREN JANE
NOT BAD FOR A GIRL

With her tongue-in-cheek humor and a love of typography mixed with a deep knowledge of pop culture, Karen Jane has won some big-name clients, such as Nike and Sony, since gaining her MA at London's Royal College of Art. With an extensive network of collaborators and a keen entrepreneurial sense, she has launched her own clothing label, Not Bad For a Girl. Karen Jane is based in London, UK.

www.karenjane.com
www.notbadforagirl.com

ADDICT®

PHOTOGRAPHY BY ETHEL

KAREN JANE, ETHEL, AND ADDICT

In another Addict project, the issue of gender imbalance in the streetwear genre was addressed, via this collaboration with the artist, Karen Jane, and the photographer, Ethel.

How did the collaboration come about between Karen Jane, Ethel, and Addict?

Karen Jane: I was approached by Addict to work on a collaborative project with them. Since producing the designs, the wheels have been in motion leading up to the product launch. I usually work on projects with a faster turnaround, and it had been some time since I designed the print, so I wanted to mark the launch by creating a new work; the image with Ethel.

Eloise at Addict: For us, the main attraction of Karen's NBFG (Not Bad For a Girl), is that it's a stand-alone brand created by a female artist representing in an overly male-dominated industry. NBFG is clever, understated, and quirky, all of which make her brand British, through and through. It goes its own way, has appeal through color and strong graphics, and a sense of humor, that if you understand you get it, and if not, it doesn't matter as it's still an amazing product. This is the first print pattern collaboration Addict has produced exclusively for the ladies-only limited edition, which was a statement in itself in this market. To take it to the next level, the project needed another collaborator with skills, who could share and execute that vision.

Who played what role in the collaboration?

Karen Jane: I designed three different prints for one of Addict's staple pieces, the Method Zip Hoody, and they picked the one they thought would work best. After that, refining the final print, colors, and repeat tile was an organic back and forth process between Eloise, the guys at Addict, and myself. Then Addict went through the process of sampling and production. The idea for the image led on from the print, inspired by playing card suit icons. Ethel and I talked it through and had an idea of how it would work before she shot anything. Then we both worked on putting the final image together. It was a beautiful Photoshop duet!

Eloise at Addict: Our main role in the collaboration was at the garment stage, so once the ideas had been bounced around and the graphic had been developed, we discussed color, sizing, and print finishes with Karen Jane. We oversaw all product development from fabric, to fit, to finished garment.

Ethel: My role was as the photographer. It was a cool image to work on. Me and Karen have similar attitudes so it was easy to work things out. I was really pleased with how the whole thing turned out, particularly because Karen's graphics are so dope!

How do you think that a clothing project relates to the practice of street art?

Karen Jane: It depends on the project, who is doing it, and the knowledge, experience, and methods that they bring to the table. That's a complex question!

Eloise at Addict: I think a clothing project gives a different spin on it, you're changing the medium, and the clever thing is to get the project to work as a whole, not only as a representation of the artist's work, but as a garment as well. Not wanting to sound pretentious here, but I think fashion is about your own expression, whatever you're into. It's a bit naff to be blatant about stuff; big brands jump on all sorts of things that are the flavor "du jour," especially in sub culture, and it's hard to find rare things now. So, it's about being subtle and clever, with the ability to have a finished product that is stellar in all aspects.

Opposite:
KAREN JANE, ETHEL, AND ADDICT
This promotional image for Karen Jane's collaboration with Addict was photographed by Ethel. Print and graphic designed by Karen Jane.

YOUR OWN LABEL

This spread:
ANDY MUELLER, THE QUIET LIFE
Various T-shirt designs and logos.

ANDY MUELLER AND THE QUIET LIFE

Andy Mueller started up a clothing line as an outlet for his own design and illustration, and then got his extensive network of creative friends involved. Here, he tells how the company operates, and how he curates a special edition of T-shirts by some familiar names.

How did The Quiet Life clothing label grow out of your personal and professional art and design practice?

I started The Quiet Life in 1997, long before the T-shirt craze. I was living and working in Chicago at the time and running a small design/ photo/film production studio called Ohio Girl. The Quiet Life really spawned from the fact that you don't always get the final say with client/ commercial jobs; even though Ohio Girl was really creative and it was "ours" it was still a client-based studio. One of my Ohio Girl coworkers and I were talking about doing our own thing…starting our own brand, doing whatever we wanted whenever. We wanted complete control.

It was pretty easy to start, we had the resources and connections through our client work and had tons of artwork, doodles, and ideas that some of our clients hadn't approved. So it was a natural fit; we were making art and designs all the time and this was a great outlet for it.

It's taken a long time to get to where it is today; it's grown at a snail's pace, but I've really enjoyed the journey and am proud of what it's become (and is becoming.)

Explain the process of commissioning a T-shirt collection from a bunch of different artists. How do you keep your own "brand" identity while working with contributors? How do you think their own projects and personal work reflect on your joint projects?

We put out two seasons a year and I do all of the designs but one, which is reserved for a guest artist. But to celebrate our 10th anniversary we decided to mix it up a bit, and invited 10 of our favorite artists and designers to do the 10-year anniversary collection. It was great. We invited Cody Hudson, Todd St. John, Andy Jenkins, Evan Hecox, Megan Whitmarsh, Ben Loiz, Rick Myers, Flo, Katsuo Design, and Ryan Waller, and they each did an amazing design for us. We also made a "10-year" zine with a spread by each of these artists that was packaged with each T-shirt.

We branded this project as the "QL10" and made a new logo for it. I think that's one of the ways that helped tie it all together, even though all of the shirt designs were a bit different. We just let them do their thing knowing that the spirit of their work would fit in with what The Quiet Life is all about. We didn't really worry if our own identity got lost; we wanted to do this as an art project and have our guests treat the project as a blank canvas. I love how it turned out. And all of the designs actually fit in with our brand quite well. The response has been great; big thanks to all of the artists for getting involved and to everybody else who has supported it.

Do you feel the "exposure" helps both ways?

Definitely! I got quite a few emails from the artists telling me how much interest and hits they got from this project; we linked all of their websites from our site. So I definitely think these sort of projects work both ways. →

www.thequietlife.com
www.ohiogirl.com

138

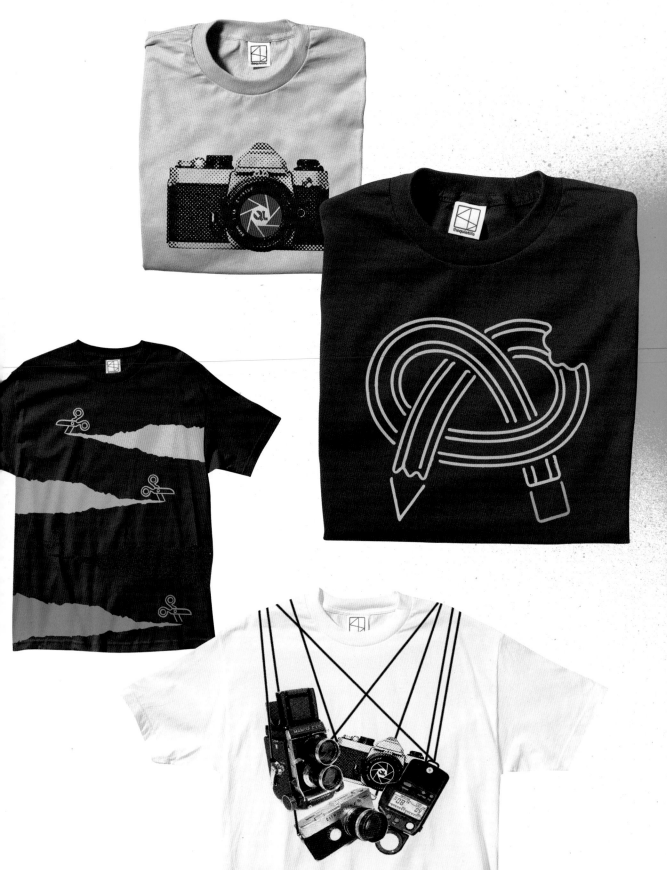

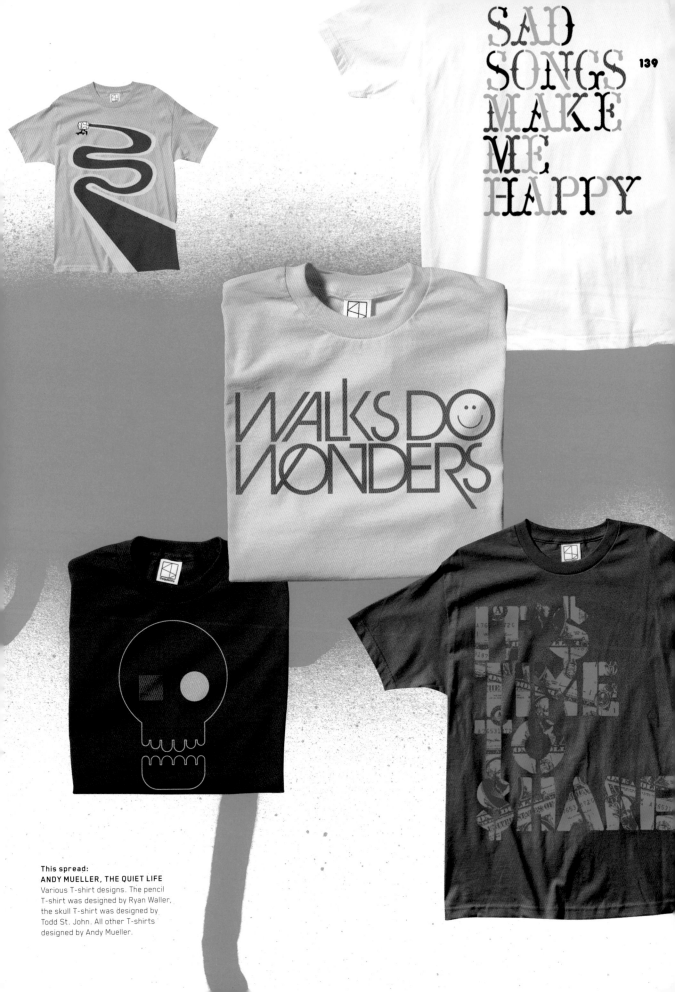

SAD SONGS MAKE ME HAPPY

WALKS DO WONDERS

This spread:
ANDY MUELLER, THE QUIET LIFE
Various T-shirt designs. The pencil
T-shirt was designed by Ryan Waller,
the skull T-shirt was designed by
Todd St. John. All other T-shirts
designed by Andy Mueller.

I-SAW

Making the leap from street art to setting up a fashion business often stems from meeting the right people, at the right time, who share your aesthetic outlook. When Chum101 met Rachael, I-Saw was the result.

Chum101 has been drawing for as long as he can remember, and was involved in the first wave of UK hip-hop, breaking, and graffiti in the mid-1980s. Chum101 co-founded one of London's earliest crews, The Majestic Outlaws, with his brother (Ollie Teeba of the band, The Herbaliser) and their friend, SheOne.

Fuelled by a love of music, dancing, and the culture that surrounds it, style and different ways of wearing clothes has always been important to him. With earlier dreams of being an archaeologist, his love of mythology, Egyptology, and ancient artifacts led to a BA in Fine Art Sculpture. All of this fed back into his visual style, along with 1960s psychedelia and the history of comics and cartoons, finding its creative outlet in I-Saw Clothing.

Rachael Taylor grew up in Bristol in the UK; while at university in Newcastle, studying Fashion Design, she created two collections that were sold in Europe and the USA. Rachael worked in Hussein Chalayan's design studio, and began DJing on pirate radio stations and in clubs. She did PR and marketing for a number of fashion and streetwear brands including Mickey Brazil, Conscious Earthwear, and Rude, while programming launch events and club nights.

Rachael met Chum101 at the Blue Note's "Stealth" club nights, back in the 1990s. Shortly after that she booked him as a B-Boy dancer at a fashion show. Within six months they were a partnership, promoting the club night, Inner Spaceways Incorporated.

This incubation period saw ideas around experimental, graffiti-oriented concepts combined with multimedia, such as projections, animation, performance, and sculpture. Firstly through customization, with an emphasis on embroidery and appliqué, Chum101 discovered how to use the sewing machine as a drawing tool, which spilled over into textile artworks. Original ideas for prints followed, especially continuous all-over prints and unusual garment shapes, adding up to the fully realized design concept of I-Saw.

Above left:
CHUM101
Painting windows and interiors
for a promotion.
Opposite:
I-SAW
The collections include garments for
men and women, footwear, and bags.

Explain the process of working as a partnership to design and make clothing.

We have very similar interests and ideas about fashion, art, and graffiti, which have allowed us to crossover and form a close working relationship, especially in the initial stages of concept and design generation. This aesthetic overlap and shared vision means that each garment comes from a unified idea, to which we both add our particular embellishments, going back and forth until we reach a mutually agreed end result. It's as if the combined eclecticism of our perspectives creates something new and unique; a fusion of graffiti and fashion.

Chum101 designs the graphics and Rachael designs the garment shapes and some of the ideas for additional products, such as The Graffiti Patches™. The final development of the textile applications for production, and the sales, marketing, and the general running of the business, are approached as a partnership.

How do Chum101's paintings translate into fashion graphics?

I took a strand from my graffiti—natural forms and the influence of the ancient cultures of the Mayans and Aztecs—and developed these further. We also delved into the history of print and ornamental design, looking at William Morris, art nouveau, and the psychedelic poster artists. So while these forms push further out into the realm of illegibility, they also get stripped down and reduced to the essence of a style, usually presented as a one-color print, an outline, or a solid fill (with the outline being created through the negative space). That sense of line is close to the fluid "hand styles" of continuous line throw-ups and tags.

I've taken my personal interpretation of graffiti into different media before; I've built graffiti sculpture, and developed a hand-engraved application, Engraviti. I'm currently learning to tattoo. It's a hunger for getting up and conquering alternative territory, just not in the literal, geographical sense. So I define myself by the entirety of what I do, not as strictly a graffiti or street artist. My aesthetic is nearly always based on letterforms, rather than the spray can, or marker; and the challenge is to arrive at a form that is universally applicable.

www.i-saw.co.uk
www.i-sawcuriosityshop.com

DATA FILE: DAVID WALKER

British artist David Walker works in the crossover between graphic design and illustration, and has recently returned to pencil drawing and cut-and-paste activities for inspiration. A member of Scrawl Collective, his work has been featured in group and solo shows. David also focuses on the fashion industry, creating work for seminal UK clothing label, Gio Goi, as well as for The Prodigy, Maharishi, Supremebeing, and Firetrap.

www.scrawlcollective.co.uk

Top:
DAVID WALKER
Annika
Above:
DAVID WALKER
Self Destruction
Opposite top:
DAVID WALKER
T-shirt design.
Opposite bottom:
DAVID WALKER
Smoker; edition of 120, signed.
Screen-print for Scrawl Editions.

DAVID WALKER

Launching a label, whether you intend to produce apparel, skateboards, or whatever, isn't easy; but it's not impossible either. After setting up a clothing label and producing designs for other brands, David Walker describes how working in fashion requires a different set of criteria than working solo.

You've run your own label, Subsurface; what advice would you give an artist who's thinking of starting up a clothing line?

Be fearless, research everything, labels take time to build, and marry someone rich or famous or rich and famous.

Describe the process of developing a graphic to be used on clothing.

The graphics I create for clients are about selling a story, communicating an idea, or promoting a lifestyle or scene. Brands are targeted at specific groups of people, so if I'm designing for a rock label then I'll draw from the graphic language and culture of that scene. This dictates the handwriting, color palette, scale, and processes. Fashion is largely about referencing what has already happened, which is why it moves in

circles; the trick is to add a twist and make it your own. I work from mood boards and I'm a big believer in using sketchbooks and scraps of paper before going near the glowing box.

When you make art, how does your working method differ?

The only constraints you have are your own, within your own skill set, ideas, budget, or whatever; this freedom changes everything. However, I think setting self-imposed parameters can be rewarding. I work with limited color palettes and processes; I've been doing pieces based on punk song writing, which only uses three chords as standard. After the initial drawings, I make the work using three colors and three techniques: photocopies, spray paint, and vinyl. The results were really effective and helped to focus the work.

What influences your work in streetwear and street art?

Music, dive bars, being restless, getting lost in cities, living in London, and all my friends, enemies, and idols.

DAVID EARL DIXON AND THE HARMONY

Turn your obsession into your own brand, but be prepared to receive feedback; what you do with it is up to you.

Tell me about your skate company, The Harmony. How does skate culture impact your artwork?

Heavily for sure, in terms of how much I go out skating, and how much I obssess over artwork that affected me when I was growing up. Pushead on the Zorlac and Metallica albums; all the Powell stuff, Marc McKee, Mark Gonzales, Todd Francis, back when line work and detail meant something. I basically love the medium that the skateboard deck offers; it's neat, compact, and limiting in the right sort of way. Nowadays, some graphics are just bogus. I just wanted to do stuff that I could look back on and say, "that's pretty cool."

How did you decide to take the leap to make your obsession your career?

A lot of sit-down time thinking and asking the question, "Is this somewhere I want to be?" It's pretty out there in terms of public opinion, when you're in charge of whether a brand makes an impact or sinks without trace. It's nerve-racking, but right now it's working nicely. I came to a decision in terms of the company, and my own work for shows, just to stick at what I love to do, and see what people say. If they are feeling it, then great, if they're not, at least I was honest and stuck to what I love.

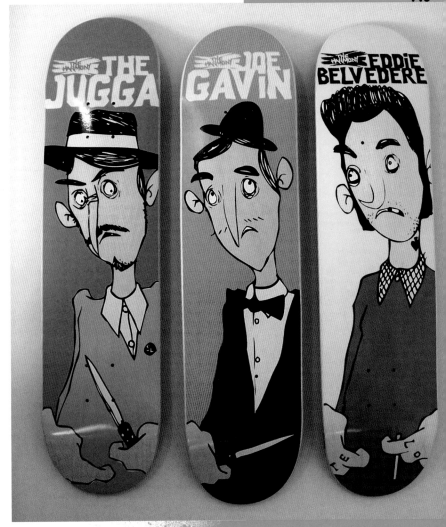

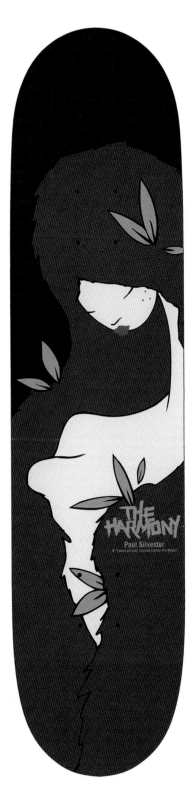

DATA FILE: DAVID EARL DIXON/DIST

A self-proclaimed skate-nerd who refuses to grow up, David Earl Dixon practices karate and voodoo, and comes complete with his own wrestling mask. His drawing is inspired by comic books, advertising, and graffiti. He is also the founder of skate brand, The Harmony. He lives in Colchester, UK.

www.distone.co.uk
www.theharmony.co.uk

Opposite top:
DAVID EARL DIXON
The Harmony T-shirt graphic.
Opposite bottom:
DAVID EARL DIXON
Elephant Technique wall painting.
This page:
DAVID EARL DIXON
Lost Forever and Paul Silverster, skateboard graphics.

YOUR OWN STORE

Specialist retailers—not a store nor a gallery, but a hybrid of the two—are a big part of the street art scene, building communities by hosting exhibitions, sponsoring projects, and selling artworks, clothing, and products —from limited-edition prints, to vintage sneakers, specialist art supplies, and must-have toys.

Opening a store is another way of supporting yourself and other creative talents financially; you'll meet and do business with lots of artists and designers as you source content—quirky items, handmade one-offs, and must-have brands—the choice is yours. It's a major commitment of time and energy though, so learn from the experience of these intrepid individuals.

MUJU AND TOYLIFE
How do you combine running a shop, painting, making films, sewing handmade toys, designing T-shirts, and the rest?

By having a passion for what we do and a total need to be independent. It's a struggle at times, but so worthwhile when we make things happen and put them out into the world. We've turned our life into a total creative mission rather than chop life into "work," "play," "rest." This means working every day but choosing what you work on, and not having the choice made for you.

Does running a business, as a partnership, impinge on creative expression?

With ToyLife, the shop and gallery [in Brighton, UK], we share different aspects of the business. Our jobs range from the day-to-day running of the shop, talking directly to customers in the store, sourcing new stock from artists, and keeping the paperwork together, to organizing shows and running the bar at our micro exhibition openings. We also share the role of documenting the shows, our lives, and artwork, as we both have a passion for photography and film. This is an understated but important part of ToyLife and Mujuworld; keeping the websites updated with artwork, toys, products, and news.

Left:
MYSTERIOUS AL
Frank poster for an exhibition held at ToyLife in Brighton, UK

This page top and opposite:
MUJU
ToyLife is Mr and Mrs Muju's small but perfectly formed store in Brighton, UK. When they're not selling their own and their friends' work, this creative couple are painting, printing, drawing, and sewing. They also regularly update the window display and add murals to the walls.

Running a business takes more time than you can imagine but also develops your perspective, and grounds you in the reality of surviving independently. ToyLife also serves as a venue for our own work and helps to show it in a broader context; and being surrounded by such a variety of high quality work is an inspiration to keep developing our own style. The rewards are worth the investment, as it's a constant learning curve to see what people think and how they react to the artwork.

At ToyLife, Mr and Mrs Muju have built up a worldwide community of contributors, by stocking artwork, toys, books, and more, from... Belio, Btoy, Bue, Byroglyphics, Dalek, Elph-1, Peter Fowler (Monsterism Island), Friends With You, James Jarvis (Amos Toys), Jawa, Kid Robot, Kozyndan, Mars-1, MCA. Muju, Mysterious Al, Parquerama, Parra, PinkyVision, Richt, RocketWorld, RolitoLand, San, Sat-One, Matt Sewell, Strange Co, Super7, The London Police, Toy2R (Qee), Toykyo, and Uamou.

www.toylife.co.uk

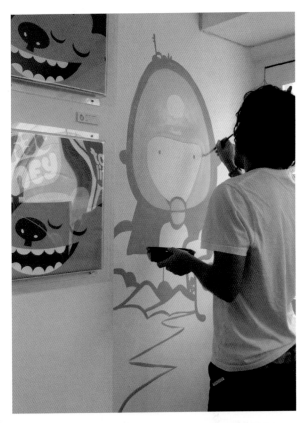

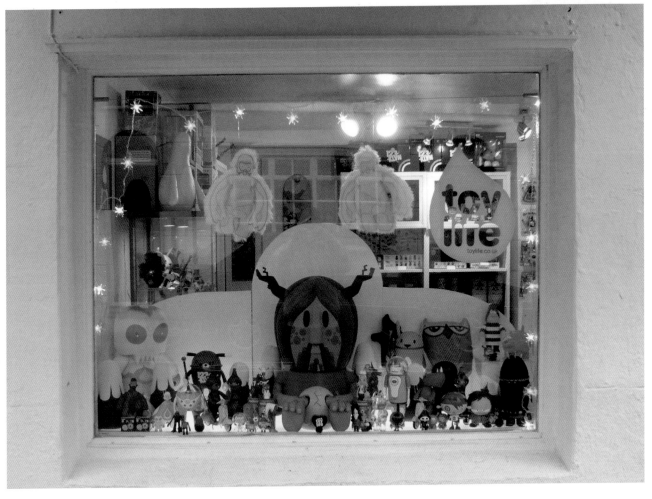

DAVID SAMUEL AND THE RAREKIND GALLERY

Meanwhile, just around the corner (I kid you not!) is another manifestation of artists at the helm.

Tell us about the range of activities RareKind are involved in; the shop, the gallery, clothing, prints, commissions?

The RareKind Gallery [in Brighton] is the only graffiti art gallery in the UK; open since 2003. We only sell canvas and prints from UK graffiti artists, real ones who have done plenty of illegal work. We also sell clothing from different companies from around the world who are involved in graffiti and illustration. We're working on doing more prints...there's only a few to date. We sell canvas, clothing, spray paint, books, magazines, DVDs, toys, all involved with graffiti culture.

DATA FILE: DAVID SAMUEL

David Samuel is the owner of The RareKind Gallery in Brighton, UK, which grew out of selling paint from his shared apartment. David is also a graffiti writer and artist, and works with the local council, beautifying the city, and making it a haven for writers/painters, who travel from all over the world to work on a number of legal spots around town.

www.rarekind.co.uk

Tell me about the process of running the shop; does the "open door" foster a network, a family?

I own the store but get other graffiti artists to help me on these projects. RareKind started as a graf crew in North London, with myself, Hotone, and Roser, and spread to Vibes, Intro, Jimi Crayon, Odisy, Leet, Asure, Soleo, and a few others. Now we're working alongside The Legendary Zoomby, DDS, Diet PFB, ATG, Astek, Inkfetish, Insa, and others. The Family.

Did the shop grow out of the need to have a space to exhibit?

Myself, Hotone, and Roser, moved to Brighton and started to sell paint from our house. I applied to the Prince's Trust [a charity that helps young people with their businesses] to get a loan, to open a gallery.

What about painting on a large scale, in the streets, and in Brighton?

Commissions have taken us around the UK; we've been asked to paint walls in the Sci-Fi Channel offices; at the Goodwood Festival of Speed; in the MTV offices and studios; and for sets on *The Bill* [TV show], to name a few. I've been working alongside Brighton and Hove City Council since 2005, getting spaces and getting them painted; this is now split between myself and Paul Barlow.

OLIVIA ONGPIN AND FABRIC8

On the other side of the ocean, a different neighborhood equals a different vibe; but the concept of family is very much to the fore at fabric8.

fabric8 was established in 1995 by Anthony Quintal and I as an online boutique featuring independent designers; then we opened the San Francisco shop and art gallery in 2005 with the idea of creating an international venue for like-minded street artists and designers to market their products.

How important is it that small businesses exist to serve the local art and design community?

Shops and galleries are an important element of community, as they present as well as represent what's happening for residents and tourists alike. While artists can certainly promote their own creations, merchants, curators, and dealers are a nice intermediary between them and the general public. In addition, artists would most likely rather be creating than marketing or promoting anyway. One thing that fabric8 does in lieu of monthly art openings is live painting events, where artists come to create a series of affordable paintings during an afternoon, either solo or in collaboration with other artists. This creates a kind of interaction that might not happen otherwise. →

Above:
The logo, interior, and exterior of The Rarekind Gallery are in a constant state of flux. All the artists involved at Rarekind have literally left their mark.

How many local artists are linked with fabric8?

We show 40 to 50 painters, plus another 20 to 30 designers of graphic T-shirts, toys, homewares, and kidswear. The website features more clothing designers and record labels. We've worked with over 150 individuals, companies, and labels since we started.

The look of your store is pretty unique; explain the barbecue theme?

The design of the store was an organic process but was rooted in the idea that we wanted something playful and colorful, that could stand next to the other one-of-a-kind stores in San Francisco's Mission District. We started with a few ideas of our own but ultimately it became a collaborative effort, thanks to the many artists we work with. We knew we wanted murals in the gallery area, but we didn't want them to detract from the art for sale, so the concept of using wood stains seemed interesting. Brian Barneclo and Sirron Norris were the first to experiment, with the floor, and did a phenomenal job. Thereafter we recruited Ferris Plock, Ursula Young, Nomzee, and Damon Soule to complete the project.

We also wanted grass on the floor of the main store area, as well as a modern take on Victorian style. We decided to go with textured wallpaper as well as lit acrylic baseboards. Once the grass was in, we decided to complement it by making the ceiling look like the sky. Romanowski's idea of using a barbecue grill for the cash register seemed like a natural solution, particularly as the grills were all on clearance since it was the dead of winter. A bit of modification and business was cooking!

Some of our artists we work with are Sirron Norris, Ursula Young, Reuben Rude, Romanowski, Brian Barneclo, and Ferris Plock.

www.fabric8.com

Top:
FERRIS PLOCK
fabric8 store, painted entrance floor.
Above:
fabric8 store interior, showing hand-painted elements created using wood stain.
Opposite top:
JEST
Sticker by Jest from Alife, on Lower East Side Street, New York City.

Opposite bottom:
BRIAN BARNECLO
Block-long mural, painted in three weeks, in the Mission District, San Francisco. Brian sells canvases and painted objects at fabric8, but is equally at home working on a massive scale, in this instance, depicting the complicated intricacies of the food chain.

FIND MORE: RETAILERS

Other stores that sell a mix of artwork, clothing, toys, books and magazines, art supplies, and more, include:

Giant Robot in Los Angeles, San Francisco, New York City, and online.
www.giantrobot.com

The Reed Space, an offshoot of New York City's Staple Design.
www.thereedspace.com

Upper Playground, the clothing specialists, and their off-shoot galleries, Fifty24SF, in San Francisco and Portland, Oregon.
www.upperplayground.com
www.fifty24sf.com

Since 1999, Alife, the store and design team, have been instrumental in launching KR's Krink, and enlivening New York's Lower East Side, with a store/gallery and a sleuth/secret sneaker store around the corner. In 2003, Alife teamed up with Deitch Projects for a group exhibition that transformed the Grand Street gallery. Featuring work by over 60 artists, it introduced a whole raft of street artists to a wider art public. A trail of stickers by Jest, of Alife, will lead you to their door. Alife stores are now open in four cities around the world: AlifeNYC, AlifeLA, AlifeVancouver, and AlifeToyko.
www.alifenyc.com
www.rivingtonclub.com

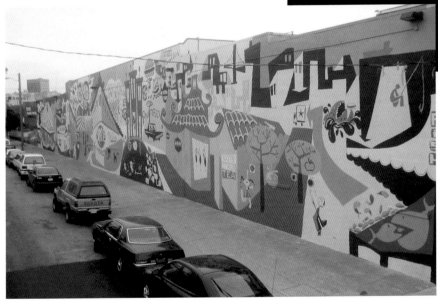

GALLERIES AND CURATORS

MAGDA DANYSZ AND GALERIE MAGDA DANYSZ

Running a successful gallery in Paris, France, that features many international street artists, Magda Danysz assesses the interchange between the art world and the street art community.

How did you start the gallery, and how is it evolving?

I started the gallery when I was still a student; it's been in its current form since I finished studying, back in 1999. From the beginning I wanted to promote street art but without creating another ghetto; I wanted to bring it to the mainstream. I work with street artists as well as other [kinds of artist], and they're all a team, nourishing and inspiring each other. The most beautiful thing is seeing an artist evolve, and that defines the gallery's evolution. And I am happy to say that Miss Van and many others I've been showing for a long time are getting better and better.

You've hosted many interesting group and solo shows featuring street artists; what draws you to this area?

Street art was the initial reason I opened the gallery. I was young but already I saw the potential of this movement. I strongly believe it is the most important artistic movement at the turn of the century. Art history will tell...

Do you think that working in the street and showing in galleries encourages artists to experiment more, or widens their fan-base and gets them more publicity, or can it put off really serious collectors and museums?

Above all, I think that for artists, expression comes before the medium. For accomplished artists wall painting or painting on a canvas, or even drawing, are complementary things. It is the true nature of an artist to be able to express themselves in different ways. I like that street art is so diverse; it's richer and more profound because of that. And as some say, "The message is the medium."

Are the audience and market for street art changing?

We all wish acceptance came earlier, when we were all just kids and needed some support. But what doesn't kill you makes you stronger. And I see almost all the people from back in the 1980s and 1990s are still here, active and proud of what is going on. The recent evolution in the art market is, to my eyes, still very timid and the best, I hope, is yet to come. I believe the bigger the audience the better. The more the merrier...

www.magda-gallery.com

FIND MORE: STREET ART IN GALLERIES
Two other galleries that specialize in discovering, nurturing, and exhibiting talented artists who also make street-based works, are Elms Lesters Painting Rooms, in London, mixing UK, European, and American artists in dynamic group and two-person shows; and Deitch Projects, in New York, who have staged some of the most seminal street art shows of the last decade. Sign up for email alerts, and keep an eye on some of the world's best artists. Also check out Forsters Gallery in London, Galerie L. J. Beaubourg in Paris, and The Merry Karnowsky galleries in Berlin and Los Angeles.

www.elmslesters.co.uk
www.deitch.com
www.forsters.com
www.galeriebeaubourg.net
www.mkgallery.com

Opposite top:
MISS VAN
Miss Van at Galerie Magda Danysz, Paris, France.
Opposite bottom:
SWOON
Installation view. Deitch Projects, 76 Grand Street, New York City.
This page top:
SWOON
Installation at Newton Building, Miami Design District.

STOLENSPACE GALLERY

Things don't always go to plan, but make sure you learn from the experience. Here, a spokesperson recalls how the infamous Outside Institute morphed into the successful StolenSpace Gallery.

Tell us about how the idea of running a gallery evolved.

The idea of showing street art in a gallery started with the "Finders Keepers" events, where we chose an abandoned space, invited artists to paint on found objects, kicked back, had a party, and gave all the work away for free. We were doing those from 2002 to 2003. At the time there weren't any galleries showing street art or urban art...I mean it's "art" whatever "catchy title" it's given, and it's far more interesting than the art I was seeing in stuffy galleries.

On my travels I was meeting some incredibly talented and passionate artists, passionate enough about their work to want to display it for free, and illegally. Most of these artists also painted canvases to sell, to provide income to continue to work. Most also had jobs in order to survive, myself included; I struggled to pay bills and felt like I was working every second of the

day to just keep afloat. I realized that a space where artists could legally show their work offered further avenues of experimentation for those artists, but the idea for a space—call it a gallery as people understand that word as a space to show artworks—meant more to me; it was a space that lives and breathes.

Through a distant connection I was offered a space rent-free so long as we covered the bills, in exchange for a partnership in what would be called the Outside Institute. That took a year to agree and a further three months to set the space up and arrange the first show. The major problem with the space was that it was down a back street in Paddington in London, in a very quiet mews. We'd get lost going out for lunch and not be able to find our way back, so how anybody else was going to find it was questionable. But the space was amazing and it was something I wanted to do passionately, so I took the offer with both hands.

The immediate problem was running the space. This was left to me, my partner (who was also working full-time in order for me to pursue this dream), and my brother-in-law. The space had three floors, 2,000 square feet, and we staged a show a month; so to say that we lived there for a year is no exaggeration.

Setting up a gallery is a big challenge; what made you take it on?

I didn't think that at the time, it was just something I felt had to happen, and I was determined to put everything I had on the line to pursue it. I feel that artist-run galleries deal with artists, shows, and the sale of artwork,

from a pure perspective, as they have the artists' interests at heart. The thing that made me take it on was a passion for the art.

The Outside Institute was well received but short lived. What problems did you encounter with this first venture, and what were the lessons learned?

It was a struggle from the moment we opened. I look back on it and it literally makes my stomach turn. We opened with SEEN, and his first ever show in London, and we massively underestimated the turn out. No security, three people to run the whole show, and just about every graffiti writer in the country came to the opening. The basement door was kicked in, and the paint we stocked was stolen. The neighborhood got tagged. It was amazing; in the morning we had the whole Neighbourhood Watch team turn up, and we weren't welcome from that point on. Undercover police came down, plus Westminster Council's anti-graffiti task force, there was a warrant for my arrest. Everything you can imagine to shut us down. In the end we got a lawyer to act on my and the gallery's behalf.

As we had no public funding the only way of continuing was selling artwork. SEEN's show did well and covered the next show, but every show after that ran at a loss. Each month I was spending more and more time at the gallery, putting more money into keeping it going. Sleeping there on the couch for weeks on end and trying to do everything to keep it alive. But the simple truth was that we didn't make enough sales of artwork to keep going. In hindsight, the gallery was premature in comparison to the interest this genre now has. We didn't →

This spread:
D*FACE
Drive by Shooting. Hand-painted architectural hoarding, featuring the world's corporate giants, repurposed. D*Face is represented by the StolenSpace Gallery, London, UK.

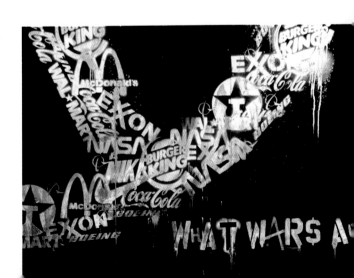

have enough staff, we had a big legal bill, the police on our backs, and many many more problems. But running so many amazing shows was such an experience; I learned things you can only learn when you're knee deep in it. Everything I learned about how not to run a gallery I used to ensure that the new gallery, StolenSpace, was correctly set up, right from the beginning.

Why did you change the name of the gallery?

Mainly because the Outside Institute had ran its course, and I wanted to bury that. It carried with it a year's worth of preconceptions. From a business point of view, there had been three partners in the Outside Institute, and after running it for a year, and using so much of my own money, we didn't close the space as the best of friends!

I felt burnt out and I wasn't sure I wanted to open another gallery; so I kicked back and concentrated on my own work. I knew that if I was going to do it again I was going to do it alone. StolenSpace was a name and an idea I'd had since 1999; it was really a no-brainer to open with that.

What are the new challenges?

Making sure I didn't make the same mistakes again and that it could cover costs, no matter what. I wanted it to eventually be able to run itself, without my constant input, and it's now on that path.

What is your approach to the job of curator? What criteria do you use when selecting who to exhibit? Is there a sense that if you have a show with a big-name artist, such as Shepard Fairey, that you can then afford to do shows with lesser-known artists who you want to support?

I wrote this statement to use as a benchmark for what StolenSpace should stand for, at least to me:

"StolenSpace exhibits the art of a genre yet to be defined. Influences from skateboard graphics, graffiti, comic books, and tattoo art prevail in the controversial work by these infamous and unknown artists, whose work embraces the urban environment and aesthetic, and is influenced by these underground subcultures, with few rules, and where anything is possible. StolenSpace lets in the life-giving vitality of this environment that has long been overlooked by galleries and museums."

StolenSpace has always been about showing the lesser-known artists along with the more well known, so the criterion is simple; are we into the artists' work? How does an artist's work make us feel? Do we get that instant buzz from seeing their work? Is it unique and original? But really it's about showing amazingly talented artists, the work should speak for itself.

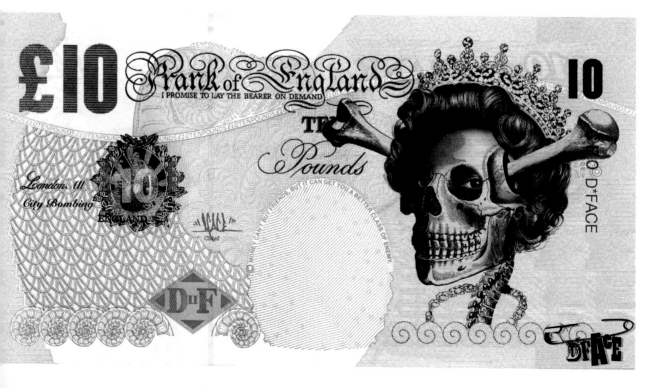

When we do group shows it's important we show the lesser known artists alongside the more known names. We want the people who come down to see the known names to be introduced to the new artists and to be blown away by the discovery of these amazing new artists. I want StolenSpace to be a springboard for emerging talent.

Obviously what I learned from the Outside Institute is that the gallery has to survive on its own. It's also important to show that with the more known artists, that we represent from the heart and will ensure that the artists' interests are put first and the show will be exactly as they wished. We're lucky to be in a position where we have access to other spaces within the Truman Brewery, so while the permanent space isn't huge, we have access to other spaces that can be used to suit that artist, like the 20,000 square foot space we took on for Shepard Fairey. That show was testament to the path we've trodden and the lessons we've learned as a gallery. The biggest private gallery in London for the show's duration and a sell-out show of over 150 original pieces of work. Doing the big, successful shows like that allows us to invest as a gallery in emerging artists, it's really important the two coexist.

It's also important that people don't see us as a "street art" gallery; we want to show amazing art, whether it's a street artist or an artist making light installations. There's a thread that connects all our artists and I think that's visible in the shows that we hold, I guess how they connect is really down to StolenSpace's collective vision.

www.stolenspace.com

Opposite:
D*FACE
Dead Queen
This page top:
D*FACE
Pop Tart
This page bottom:
D*FACE
Drive by Shooting. Hand-painted architectural hoarding in New York City.

COMMERCIAL CLIENTS $$$$$$$$$$

Opportunities to apply creative talent to commercial ends manifest as all kinds of projects, from collaborations with peers, to start-up businesses, and commissions from larger organizations. Worldwide brands, which aim to connect to young consumers, have been avid supporters of the street art scene, either by working directly with artists on new products and events, or by sponsoring exhibitions or publications.

Here, three artists share their opinions and experiences, and the reasons why they lent their names and talents to commercial brands.

D*FACE
At what point did you think, "there's money in this?"

My incredibly understanding girlfriend said, "why don't you quit your job and concentrate on your artwork?" I didn't need persuading. At about the same time I was asked by Eastpak to design a set of bag patterns for them, so I knew I could cover my rent for the next few months and give the work my full attention and energy.

You've done commercial work and worked with brands in the past. How did you find that crossover; was it restrictive in any way?

I've worked with a few brands, but I've turned down more projects than I've ever taken. I only work with a company if I can have complete creative control; that way they get the best from me and I give them, hopefully, something that they wouldn't have considered, so they've never been restrictive. Eastpak, Kangol, Polydor, and

DATA FILE: MATT SEWELL
Whether working on the street or for a gallery show, Matt Sewell describes his work regime as "straightforward: everything starts in the sketchbook, then goes into the computer or directly onto a wall or canvas." Matt's influences include children's book illustrations from the 1950s and 1960s, Polish film posters, and Swiss graphic design. His work has been featured in numerous publications including *Designed to Help*, a book launched to raise funds for the tsunami relief appeal. Based in Manchester, UK, his clients include Honda, Manchester City Council, and the 3 cellphone network. Matt works from a studio best described as "a mess that only I can decipher," although he's currently touring the world, sketchbook in hand.

www.mattsewell.co.uk

Penguin: they are the only brands I've worked with, and they all support artists and culture. The people I've turned down, I feel didn't understand me, or have the best interests of my work or the scene in mind. The most commercial thing I've done recently is a set of skateboards for a small UK skate company called Enuff, but I didn't get paid. I wanted to give back to the skate culture that has inspired me so much.

MATT SEWELL AND THE GRAVIS COLLECTION

Several footwear brands have asked artists to customize sneakers; but Gravis took it a stage further by taking a hand-painted canvas, and cutting it up to make a limited-edition series, "The Gravis Collection." Matt Sewell explains how it worked.

I was asked to paint a 2 by 2m [6½ by 6½ft] canvas, which I made and painted in my then shack of a studio in Manchester, UK. The only brief was "keep it very busy, do something on every part of the canvas." I found that pretty strange as I'm used to making strong compositions. Also, I was asked to minimize the layers of paint, as we feared it would crack; and I was given a choice of colorways (for the sole and stitching) to work with.

But the thing was so big I couldn't get it out of the building. So my mate, Big Ruse, had to drop it down the side of the stairs, down two stories, and I had to catch it at the bottom. It was displayed at different trade shows, starting at the streetwear trade show, Bread and Butter in Manchester, then on to London, Berlin, and Barcelona. The canvas was taken to Austria (this was for Gravis Europe) and cut into enough panels to make a numbered edition of 32 Comet

Mids. Then the finished sneaks went back on the road, to the round of trade shows, and eventually sold off for many pounds in some posh shops. Due to the success of the first project, Gravis America asked me to paint another canvas that would be made into sneaks and bags.

SOLO-1

How do you feel about the appropriation of certain aspects of graffiti and street art for promotional purposes?

Marketing is what it is and we live in a system that puts image and hype above truth and reality. I am saddened by the way graffiti is used as a way into the youth market, but then you can see why it is that way. Graffiti is an important tool for building a person's self-confidence, especially those at the bottom of the pile. Promoting things that are good is important. Promoting bad products using graffiti writers—I hope we catch those writers, put them in the stocks and throw wet sponges at them. Shame on them. You have to live with your conscience.

COMMISSIONING ARTISTS

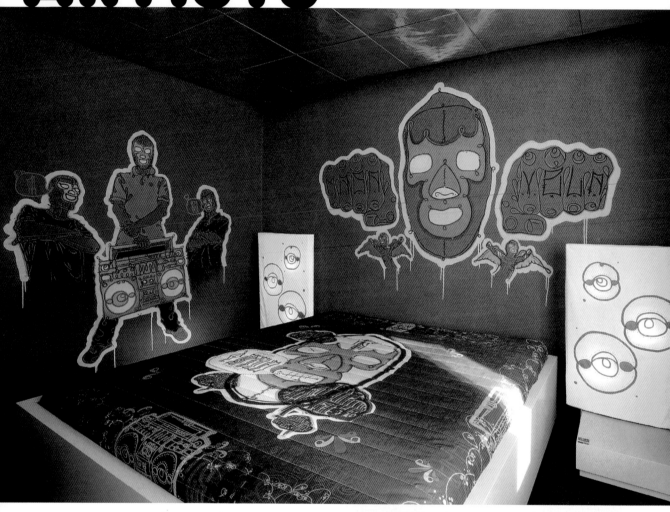

Above:
Hotel Fox room by MASA,
from Venezuela.
Right:
Hotel Fox room by Friends With You,
from Florida, USA.
Opposite top:
Hotel Fox room by Tinkp Eepe,
from Spain.
Opposite bottom:
Exterior of Hotel Fox in Copenhagen,
Denmark, with decorated blinds
by various artists.

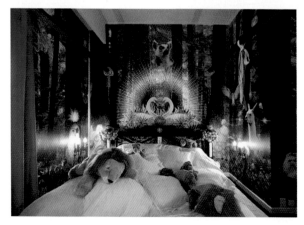

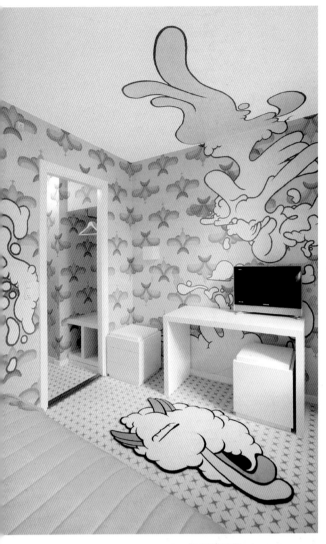

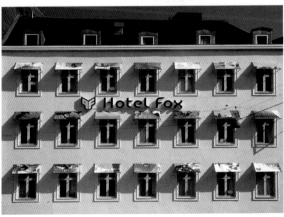

FABIAN TANK
AND EVENTLABS

Providing the interface between brand managers who work for multinational corporations selling household names and creative individuals, PR and marketing companies need to understand not only the needs of their clients, but of the "talent" too.

Fabian Tank of German marketing agency eventlabs demonstrated his understanding of the street art scene during his management of the successful Project FOX, the most noncorporate car launch ever, for Volkwagen's no-frills car, aimed at young drivers.

<u>Give me a potted history of eventlabs, and how the company got involved with street art?</u>

eventlabs was founded by me, Fabian Tank, and Holger Pütting in 2000. The Hamburg agency represents a new form of marketing, whereby the brand's event represents the focal point. eventlabs offers entire, individual, and integrated communication solutions in a finely adjusted ensemble of three core disciplines: event, corporate architecture, and design and strategic communication. Presently we have a core team of 30 employees.

<u>Staging events that showcase street art, what's your most memorable success?</u>

Project FOX [for Volkswagen].

<u>How do you make contact with street artists?</u>

That depends on the project. In the case of Project FOX we asked the publishers, Die Gestalten Verlag, from Berlin, to recommend approximately 50 artists and street artists. Out of those, we finally chose 20 artists for the project. We are always on the lookout →

[for talented artists], and we can fall back on our international network that we have built up over the years. Quite frequently we receive recommendations and tips from the scene.

Which artists do you work with?

WK Interact, Martina Nievergelt, Geneviéve Gauckler, Antoine + Manuel, Container, Rinzen, Kinpro, Friends With You, E-Types, Freakklub, Pandarosa, Kim Hiorthøy, Tokidoki, Speto, Masa, Birgit Amadori, Akim, Zasd & Bus, Benjamin Güdel, Boris Hoppek, Hort, Viagraphik, Neasden Control Centre, and more.

Connecting artists and brands, what do you think the two parties gain from the association?

Lifestyle brands have established new forms of below the line communication. Ambient marketing is entering public space and adopts codes from the street. They connect to subcultures and pretend to be subcultures. The artists, on the other hand, have the chance to present themselves and their art to a big audience, very often to follow new lines, and due to the cooperation obviously they also participate financially. The cooperation ends in success for both sides, if authenticity and mutual respect is preserved.

Have you had any crazy disasters? No need to name names! What sort of thing can go wrong?

The realization of large projects engaging multiple artists, whom one has never worked with before, especially under great financial and time pressure, always involves a risk that cannot be calculated. Obviously, things don't always run according to the original plan. We often minimize the problems by engaging "artist coordinators" as project managers or as an interface between the agency (customer) and the artists. Usually they come from the artists' scene or have the necessary access and understanding, but at the same time they are professionals in project management.

What sort of range of reactions do you get from the audiences at these events?

The feedback on Project FOX was out of this world, for all participants. Media exposure to 3.5 billion people throughout the world speaks for itself. There are, however, always the classical points of criticism; art and commerce, globalization, capitalism, monopolizing of scenes and brands. A brand has to be open to these subjects and be prepared to discuss these issues openly.

(Project FOX included a forum for just such a discussion with artists, journalists, and VW personnel).

www.eventlabs.com
www.hotelfox.dk

Opposite:
Detail of a hotel room by Neasden
Control Centre, from London, UK.
Top:
Hotel Fox room by Speto, from Brazil.

Above:
Project FOX art cars by Speto,
from Brazil, WK Interact, from
France/New York, and Container,
from the UK.

SPONSORING EXHIBITIONS

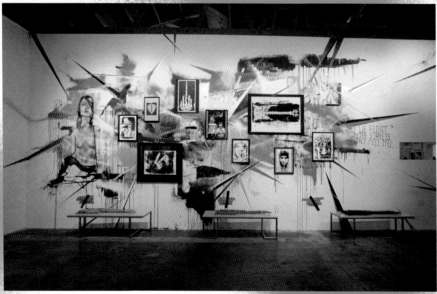

Top:
Opening night and a crowded gallery.
Middle:
PHIL ASHCROFT
Bottom:
DAVID WALKER
Opposite:
DAVID EARL DIXON

JERI YOSHIZU AND SCION

Why does Scion sponsor and support art activities in the USA?

When Scion launched in 2002, the target market was designated as male, urban, 18 to 24 years olds. Art, as well as music, was a major part of the lifestyle that the psychographic was highly accepting of, regarding creativity, expression, and innovation. Art is, and will always be, a natural outlet for the Scion target market. Now, if we get into more detail, at the time of launch, street art, or graffiti, was core to the marketing executions.

What is the thinking behind a marketing strategy that puts so much time and money into supporting art, and in particular, street art?

Scion believes in artist development, whether in art, film, music, or fashion. Our main goal was to have the artists participate within the Scion marketing strategy, by placing their artwork and their names in the forefront of the commercial work. We incorporated live paintings, art shows, even merchandise; for example, both Saber and David Choe have designed Scion T-shirts, and Kenton Parker designed an antenna ball.

Is there a particular brief for Scion Installation LA (your permanent gallery venue in Culver City)? Do you control the kind of art shown there, or did you appoint an independent curator and leave it to them? Does the company have any artistic control over what is shown in the space?

We leave the vision up to the individual curator, with obvious corporate limitations, such as political statements, graphic nudity, drugs, alcohol, etc. Since the gallery has a lot of creative freedoms, from a corporate standpoint, it is very important to have the conversation with the curator as to the limitations ahead of time. We respect all points of view, but will not allow an incident to get in the way of the entire project.

What other art initiatives do you support apart from the Scion Installation LA?

We curate a year-long tour with over 40 artists. This is a mixed-media collaboration project, with painting, photography, and sculpture.

Is your support of the arts a long-term strategy?

Yes, we include art, as well as music and film, as a part of the culture of Scion.

From the point of view of Scion, has it been a worthwhile endeavor?

Extremely worthwhile as it has allowed Scion to connect with working artists in the real world, as opposed to only commercial artists. We have a reputation for being respected by artists due to our respectful attitude. We strive to give them an opportunity to work and be creative within realistic situations. We don't ask artists to place cars in their artworks, which surprises a lot of them.

www.scion.com/space
www.scion.com/installation

ARTISTS' COLLECTIVES

RIC BLACKSHAW AND SCRAWL COLLECTIVE

Rather than simply signing on with an agent, some street artists have joined together and set up collectives to stage joint exhibitions, hire bigger studios, open galleries, launch print-editions, and function as support networks.

The Scrawl Collective grew out of the research and contacts from the Scrawl books in 1999. The work that Mr Jago, Steff Plaetz, and Will Barras were doing really excited me, it still does. So, the idea was to be a new kind of agency. Part of the inspiration for how it was set up was Factory Records; no contracts, total control for the artists. It's an informal arrangement that works because I think Scrawl is greater than the sum of its parts. All the artists at Scrawl can and do work with other people, but they stay within the circle because they want to, and because over the years we've built a name for ourselves and at the same time developed everyone's individual careers. We have built slowly; we started out doing commissioned work for the likes of Swatch and Nike, illustration and graphics jobs, but we were soon getting more involved with exhibitions and live mural painting shows.

We found a very receptive audience in Japan and this brought Scrawl artists into contact with American and Japanese painters, such as David Ellis and Kami (of the Barnstormers), who were stylistically very different but were from the same post-graffiti world. The cross fertilization of ideas going on at this time was really exciting for all involved. Everyone worked so differently, but they were really getting a buzz off each other's creativity.

This period between 2000 and 2004 was when Scrawl began to get an idea of what it wanted to do, and we become more directly involved with the public and selling paintings. At the same time we got pickier about the commercial work we did. The culmination came in 2006 when we revamped our website, started the online shop, and began releasing our Scrawl Editions screen-prints.

www.scrawlcollective.co.uk

Above:
WILL BARRAS
Robopage; edition of 150, signed.
This screen-print uses silver ink to
emphasize the metallic nature of the
Manga monster.
Opposite top:
STEFF PLAETZ
Hectic; edition of 150, signed screen-
print. Steff is one of the founding
members of the Scrawl Collective,
along with Mr Jago and Will Barras.
Opposite bottom:
MR JAGO
Silk Print Bug; edition of 150, signed.
This is a screen-printed interpretation
of a technique unique to Mr Jago;
painted by dripping ink onto silk.

NETWORKING

MARC AND SARA SCHILLER AND THE WOOSTER COLLECTIVE

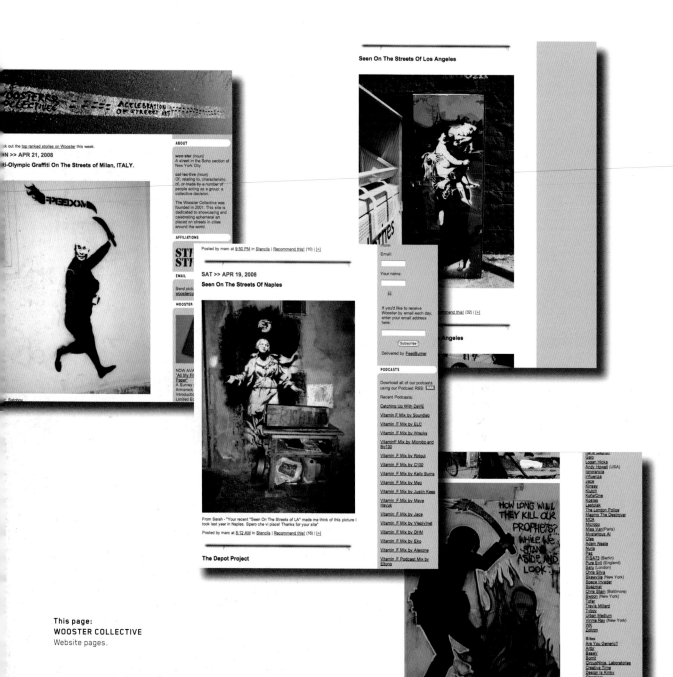

This page:
WOOSTER COLLECTIVE
Website pages.

The street art community is international, and growing, with the internet making it easier for artists to collaborate, communicate, and share images and experiences. Perhaps the most widely visited and aesthetically democratic online network, Wooster Collective, is a continually updated blog and archive that links to thousands of pages of images, reviews, interviews, invites, "how to" videos, and even more sites. Its crucial role in creating and sustaining the street art community is unprecedented. Welcome, Marc and Sara...

How did you get the idea for the Wooster Collective?

We were walking around SoHo [in New York] with our dog, Hudson, and a digital camera. We were amazed and inspired by the street art, and took thousands of photos over the course of a year. Eventually our hard drive filled up but, lucky for us, blog technology was emerging and a blog seemed like a good place to put everything we were seeing. Sure enough, hundreds of people started coming to the site and it has grown ever since. The goal, however, has remained the same—be an inspiration.

How has the site evolved over the years?

The site has evolved along with the art. Initially we were putting up everything we saw, wheat pastes, stickers, etc., because Flickr and sites like Streetsy weren't up yet. However, as the artists have evolved we now put up fewer things, just the stuff that stands out and inspires people. We also put up other types of things, things that inspire us; they don't always have to be things from the street.

How do you think the street art scene is evolving?

Street art is evolving because the artists are moving into galleries and producing more fine art. They are thinking about space differently. The artists also have less time to work on the street and the police in many cities have come down hard on artists. It is funny because this coincides with a greater acceptance of street art at all levels. Just a few years ago the *New York*

Times wrote about street art as vandalism; now they write about it in the travel section as a reason to visit New York. Street art is also evolving with technology. Artists such as GRL are using technology to make ephemeral art that lasts moments. It is also interactive and fun.

And the last word...how do you define street art?

Street art consists of stencils, wheat-pasted paper, stickers, or sculpture installations illegally placed in public places that make one question the urban environment. Street art is ephemeral and disappears over time. It can catch people by surprise, it can make people think differently, and it can bring a smile to your face.

www.woostercollective.com

FIND MORE: STREET ART RESOURCES

A book can only ever offer a snapshot of what's going on out there; here are some more places to look.

For a daily dose of new images and lots of links, go to:
www.streetsy.com

All the contemporary art you can handle, and in print form too.
www.beautifuldecay.com

Need an update of current news on obsessions, from art to sneakers? Check out:
www.slamxhype.com

This gallery and publishing house concentrates on street art and artists' books:
www.kitchen93.fr

Bringing you street art and culture:
www.mumblemagazine.com

Totally techie, breaking all the rules:
www.graffitiresearchlab.com

You want links to more and more artists, this is where you'll find them:
www.knowngallery.com

Selling prints and artwork, with a dose of attitude, too:
www.filthymodernart.com

STREET ART AND THE LAW

THIS IS A WARNING.
AND WE REALLY MEAN IT...

In some places, making marks on walls, in the street, is illegal, even if you have the permission of the wall's owner. Bear that in mind, and learn from the experiences of the artists in this book, some of whom have been arrested...

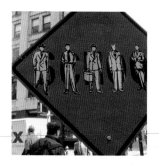

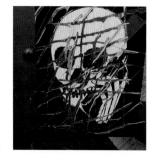

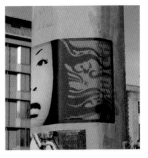

ROADSWORTH

<u>Tell us about the legal difficulties you got into
in Montreal, and the debate that developed
about the nature of the work you were doing
in the streets.</u>

The legal difficulties seemed more serious when
I first got arrested than they proved to be in the
end but this probably had to do with the public
support I received and the favorable media, not
to mention my lawyer Jean Phillipe Desmarais,
who provided his services more or less pro bono;
and a local gallerist, Chris Hand, who started
a "Save Roadsworth" campaign. When I was
arrested, I was disappointed that the game was
up, and that I wouldn't be able to execute some
of the ideas I had been thinking about. There
were a few rough days where I felt like I was in
deep trouble and that my life was over, but those
feelings subsided when I realized how much
support I was getting. A debate was prompted
by my arrest, but it always seemed to end in
my favor, despite some weak arguments about
security issues and legal precedence. I was
disappointed by the lack of opposition, because
I was hoping for more debate; it was never
resolved, no real change happened, except
in my personal life and career as an artist,
which I am thankful for.

<u>Since the case have you continued to make
work that is illegal, in Montreal or elsewhere?</u>

I have not done illegal work in Montreal since
my arrest, mainly because I have had to maintain
"good conduct," as a condition of the legal
settlement. But I have elsewhere in the world.

This spread:
Images found on the streets of
London, New York, San Francisco,
Los Angeles, Tokyo, Melbourne,
Vancouver, Barcelona, Antwerp,
Stockholm, Milan, Paris, and Brighton.

BIBLIOGRAPHY

More words to read; these books are by and about street artists; plus magazines, zines, and websites about the scene.

BOOKS

Alphabet City: Out on the Streets
Michael De Feo. Gingko Press, 2004.
The Flower Guy's ABC book for children, spelled out in street art installations around New York City.

The Art of Getting Over: Graffiti at the Millennium
Stephen Powers. St. Martin's Press, 1999.
Espo shares his insider experiences and names his idols.

Barry McGee
Germano Celant. Fondazione Prada, 2002.
To date, the most comprehensive exhibition catalog of Barry McGee's extensive career.

Blek Le Rat: Getting Through the Walls
Sybille Prou, King Adz. Thames and Hudson, 2008.
The godfather of stencils and wheat-paste poster art, Blek Le Rat presents his amassed work, the culmination of a sustained career traversing the globe, adding his unique version of street art to the mix.

BLK/MRKT One
Dave Kinsey, Jana DesForges. Die Gesteltan Verlag, 2006.
BLK/MRKT Two
Dave Kinsey, Jana DesForges. Die Gesteltan Verlag, 2007.
Two volumes of this showcase publication from BLK/MRKT Gallery in Los Angeles, curated by artist Dave Kinsey and his partner Jana DesForges. This annual publication is setting the standards for contemporary art across various media.

Beautiful Losers: Contemporary Art and Street Culture
Aaron Rose, Christian Strike. D.A.P./Iconoclast, 2004.
An exhaustive compendium of street art practitioners; includes essays and artwork from painters, filmmakers, photographers, designers, and more.

Delta
Kodwo Eshun, Boris Tellegen. Elms Lester, 2008.
A beautiful compendium of Delta's mixed-media work at various scales; the variety is staggering.

Futura
Ben Drury, Liz Farrelly, Futura, Andy Holmes. Booth-Clibborn Editions, 2000.
This visual biography of one of street art's most innovative and legendary practitioners, designed by the art director of Mo'Wax, set new standards in illustrated publishing and revealed the ups and downs of Futura's career and life.

KR: It's All in My Head
Craig Costello. Also Known As, 2006.
Close-up on the artist and mad inventor, who developed a new street art medium—the drippy yet colorful, Krink.

Phil Frost
Phil Frost, Carlo McCormick, Pushead. Damiani Editions, 2008.
Many artists have now published monographs, but this artist really deserves the pages. Phil Frost has been painting his truly unique characters onto all sorts of surfaces and objects since the early 1990s, and is revered as a street art original.

Pictoplasma: The Character Encylopedia
Lars Denicke, Peter Thaler. Pictoplasma, 2006.
A vast, online database of characters, Pictoplasma has also published a number of books, this being the most recent and extensive. Check out their back catalog for examples of animated, 3-D, vinyl, and plushy characters.

Scrawl: Dirty Graphics and Strange Characters
Ric Blackshaw, Mike Dorrian, Liz Farrelly. Booth-Clibborn Editions, 1999.
Pinpointing the crossover between "street-inspired artist" and all forms of design, their pop culture influences, and their cut-and-paste output. This was the first book to look at the wider cultural significance of street art, and not just feature grainy photos of throw-ups and tags.

Scrawl Too: More Dirt
Ric Blackshaw, Mike Dorrian, Liz Farrelly, David Recchia. Booth-Clibborn Editions, 2001.
A follow-up to the original Scrawl book, this edition spread the net wider, featuring practitioners from around the world and working in all media, from fashion to filmmaking, producing stickers, wheat-paste posters, and full-on installations.

Spraycan Art
Henry Chalfant, James Prigoff. Thames and Hudson, 1986.
The follow-up to Subway Art, featuring wall pieces and a wider cast of characters. More classics.

Stick 'Em Up
Mike Dorrian, Liz Farrelly, David Recchia.
Booth-Clibborn Editions, 2002.
The first book to document sticker art on the streets, worldwide.

Street Market: Twist, Espo, Reas
Barry McGee, Stephen Powers, Todd James.
Little More, 2000.
The joint installation exhibition that blew street art wide open, ushering the genre into galleries, literally in a big way, this show-stopper went for overkill, and achieved maximum impact. Shown at Deitch Projects, New York City and, in spin-off form, at Point of Purchase, Parco Gallery, Tokyo.

Subway Art
Henry Chalfant, Martha Cooper. Thames and Hudson, 1984.
Legendary collection of photos, quotes, and biographies of New York's first generation of subway-carriage-painting graffiti writers. Classic.

Wall and Piece
Banksy. Century, 2005.
A collection of Banksy's three previous mini books, *Wall and Piece* is a best-seller, and helped turn Banksy into a household name, and the favorite street artist of celebrities and fine art collectors.

Young, Sleek and Full of Hell: Ten Years of New York's Alleged Gallery
Aaron Rose. Drago, 2005.
Opening his kitchen as a gallery for artists, filmmakers, photographers, and more, Aaron Rose gave some of the street art stars their first wall space. This book chronicles his adventures.

MAGAZINES, ZINES, AND WEBSITES

Arkitip
The legenary art zine that publishes new, previously unseen work by a cross-section of street-inspired artists and illustrators. A collectible must-have, it appears in different formats for every issue, and often comes with limited-edition give-aways.
www.arkitip.com

Beautiful Decay
In 1996 Amir Fallah and Jay Littleton started a small zine; today *Beautiful Decay* is a publishing and cultural empire, with a clothing line, an impressive online presence, a magazine (themed via letters of the alphabet), and regular curating and gallery outings.

Featuring a wide range of contemporary art, this magazine regularly takes the pulse of the art world; and the title is borrowed from a Barry McGee quote!
www.beautifuldecay.com

Found
This website is dedicated to found objects and images, the scraps you pick off the street for inspiration. Many artists are collectors (and scavengers), and work with images and objects actually sourced from the street. This site talks their language.
www.foundmagazine.com

Giant Robot
A website, magazine, and a string of galleries/stores (in New York City, Los Angeles, and San Francisco); this US magazine, that looks toward Asia for inspiration, features art, music, fashion, toys, graphics, and more.
www.giantrobot.com

Graphotism
Billed as "The International Graffiti Writers' Website," *Graphotism* is also a big, glossy magazine. This is the mother lode for graffiti-inspired artists, and those who follow the scene.
www.graphotism.com

Juxtapoz
The alternative art magazine, covering everything from hot rod culture to tattoo aesthetics, street art and graff, board art, cute, scary, and weird, with a West Coast bias.
www.juxtapoz.com

Mumble Magazine
From features on artists and musicians, to city guides and cartoons, this online magazine crosses stylistic boundaries, but is always fresh.
www.mumblemagazine.com

Peel
Coming out of Indianapolis, this magazine is totally dedicated to the sticker, and comes packaged with lots of covetable stickers.
www.peelmagazine.com

Slam X Hype
On-trend website dealing with all aspects of street culture, from music and fashion, to art and sport; it's an education.
www.slamxhype.com

INDEX

ACKNOWLEDGMENTS

Ric: "I would like to thank Dave, Gina, and Sonny for putting me up when I needed a quiet place to work, and thanks to Sonny for the football lessons. All my good friends, Woz, Barney, Mike, Jonny, and Ian. Everyone at Scrawl Collective for keeping me so inspired; and of course to Liz for kicking me up the arse when I needed it..."

Liz: "I would like to thank Jane Roe for her editing expertise and unflinching patience, and for putting up with daily chit chat. Everyone at RotoVision and Collins Design for backing this project and making it work. Patrick and Sara Morrissey for their playful but organized design, and for squashing in every bit of content. Gregg Virostek for all his support and being the best husband ever; and of course Ric for graciously doing everything he said he would..."

"And we'd both like to thank all the artists and contributors who gave their time, input, and personal views to this project."

Photography Credits

8 (top), 64–65 Krink®

8 (third from top) Smith and Lady Pink

8 (fifth from top) Heather McGrath

24 (bottom), 25, 152 Tom Powel Imaging. Courtesy of Deitch Projects

27 Courtesy of Forster Gallery

33 (bottom), 161 (bottom), 162 (top), 163 diephotodesigner.de

34 (top), 35 Michael Simon

34 (bottom), 96, 97 (top) Sybille Prou

36–37 Bonny Squaire and David Boyle

42 (top) Cory Berkbigler

42 (bottom) Dan Oetting

46–49 Ana Alvarez-Errecalde

53, 55 Peter Gibson

54 www.photogenicimages.com

77 (top) Anthony Lam

88 (top) L. Belluteau

88 (bottom) Invader

106–107 Wallkandy.net

108–109 Courtesy of Cosh

110–111, 152 (top) Courtesy of Galerie Magda Danysz

122, 123 (top and right) Luke Jennings

123 (left) Holly Jolliffe

130–131 Chris Brooks @ CLM UK

150 fabric8 interiors by Ferris Plock, Sirron Norris, Ursula Young, and Brian Barneclo

153 Jasmine Levett. Courtesy of Deitch Projects

164–165 Ric Blackshaw and Colin Wolff Young

170–171 Liz Farrelly and Gregg Virostek